DATE DUE

NO	00			
DE	00			
DE	00			
MY	7 01			
MO	8 04			
NO 2	04			
FE 10 05				

DEMCO 38-296

PAUL GAUGUIN
Tahiti

PAUL GAUGUIN
Tahiti

Edited by Christoph Becker
Essays by Christoph Becker, Christofer Conrad,
Ingrid Heermann and
Dina Sonntag

Verlag Gerd Hatje

CONTENTS

the light of Gauguin's life and work. Apart from this introduction, which establishes a biographical context and develops the thesis in greater detail, the volume features three other essays, each of which illuminates a different aspect of the subject. The article by Dina Sonntag provides an in-depth look at the prehistory of Gauguin's journey to Tahiti and the impressions he gained from the Paris World's Fair of 1889, an experience which had a formative influence upon his own insights and responses to exotic cultures. Christopher Conrad presents the complex body of prints created by Gauguin during his sojourn in Brittany and particularly following his return to Paris as a quintessence of his creative work. Gauguin's encounter with contemporary Tahitian culture, with the lost and rediscovered myths of the Tahitian people that contrasted so markedly with the world of the French colonial rulers, is the focus of the concluding essay written by the ethnologist Ingrid Heermann.

Gauguin's South Sea paintings have been reproduced more often than any of his other works of art. The list of publications includes countless illustrated volumes, most of them quite general in scope, containing texts without theses and characterised by a marketing-oriented tendency that is not subjected to closer scrutiny here, particularly as Gauguin would probably have welcomed such an approach himself. Our objective here, it should be emphasised, is not to propagate and perpetuate the selective, popular view of the artist's work but instead to sharpen our historical gaze. This should in no way detract from the extraordinary aesthetic quality, the beauty, of these works of art. Indeed, the effect should be quite the contrary.

The traveller

Paul Gauguin was a traveller. The course of his life, which took him around the entire globe, was most notably affected by two significant interludes – his two long stays in Tahiti and the Marquesas (1891 to 1893 and 1895 to 1903). The importance of the first journey to Tahiti within the context of Gauguin's biography can be established on the basis of a review of several important dates and events in his life prior to 1891. A year after the birth of Eugène Henri Paul Gauguin in Paris on June 7th, 1848, his family emigrated to Peru, where Paul lived with his mother Aline and his sister Marie (his father having died the same year) at the home of a great uncle. The family returned to Paris in 1855. During a period of military service Paul signed on as a sailor on a ship bound for Rio de Janeiro, and he journeyed aboard another ship to South America a year later, receiving news of his mother's death while underway. He began drawing and painting in 1871. In the same year he met his wife-to-be Mette-Sophie Gad, of Copenhagen. He exhibited his paintings for the first time in 1879, alongside a number of Impressionist painters. During this period he earned a living working for an insurance company. In 1885 Gauguin moved to Copenhagen, where Mette and their five children were living, but returned to Paris only a few months later. Yet another major journey took him to Panama and from there to the island of Martinique in June of 1887.

Gauguin's stay in Martinique witnessed the first significant change in his creative work. He lived a few kilometres from Saint-Pierre in a hut on the beach, where he drew and painted, but was forced by an attack of malaria to return to Europe in October of the same year. Among the twelve paintings in his luggage was a particularly impressive work, his *Tropi-*

CONTENTS

GAUGUIN AND TAHITI

Christoph Becker

Paul Gauguin was born in Paris in 1848 and died on the island of Hiva Oa in the Marquesas in 1903. His entire oeuvre encompasses some 800 works, including paintings, sculptures, ceramics and prints. Gauguin gained fame through his South Sea paintings, of which some have been reproduced so frequently that one might ask whether they were not created specifically for that purpose – luminous, colourful landscapes, exotic young women, palm-lined beaches, works of art whose formal integrity and richness of colour exude strength and serenity. To think of the South Seas is to call to mind paintings by Gauguin. It appears that his art fulfilled a dream that was informed by collective pre-conceptions and wish images as long as a hundred years ago and has since become a widely accepted cliché. Gauguin's extraordinary paintings made him an artist-legend. Every exhibition and every reproduction of his works exploits the cliché, and there is nothing wrong with that, in principle. Our aim in putting together the present volume is to describe the origin and growth of this unparalleled (and thus exemplary) artist-legend. It is indeed an extraordinary one, particularly because it grew forth within a relatively short period of time from an interesting process of interaction between the artist and his public. Gauguin himself deliberately fostered and influenced its development. We shall examine the process, its outcome and – although this may appear paradoxical – its ultimate failure.

Much, very much, has been written about Gauguin. Articles by contemporary critics and writers appeared in French journals during his lifetime, and they provide valuable evidence for the theses developed here. This is not the proper place, however, for an exhaustive review of research on Gauguin. Still, because this book is devoted to the artworks and the history of their critical reception, it is appropriate to say a few words in advance on the subject. The history of Gauguin research is characterised by a wavelike pattern. Early critics saw Gauguin as a precursor of modernism, a view that has become a part of accepted tradition based primarily on an interest in his South Sea paintings. After the turn of the century broader insights and sound assessments of his literary statements, most notably of his novel *Noa Noa* and the essay entitled *Ancien culte mahorie*, were added to the picture. The prevailing view changed again during the forties and fifties in response to the editing of his letters. No longer was Gauguin seen as the noble savage who sought and found his way with the apparent surety of a dreamer. The image of a wanderer in paradise proved to have been an illusion. Some scholars took a more critical stance, which intensified and culminated in the complete destruction of the idol and his legend during the sixties. The following years witnessed the emergence of more differentiated approaches. The great retrospective exhibition presented towards the end of the eighties provided a first impressive comprehensive view of Gauguin's complete oeuvre.

The point of departure for the following studies is primarily an historical one. The artist-legend is accepted as a fact; the conditions under which it thrived are to be examined in

the light of Gauguin's life and work. Apart from this introduction, which establishes a biographical context and develops the thesis in greater detail, the volume features three other essays, each of which illuminates a different aspect of the subject. The article by Dina Sonntag provides an in-depth look at the prehistory of Gauguin's journey to Tahiti and the impressions he gained from the Paris World's Fair of 1889, an experience which had a formative influence upon his own insights and responses to exotic cultures. Christopher Conrad presents the complex body of prints created by Gauguin during his sojourn in Brittany and particularly following his return to Paris as a quintessence of his creative work. Gauguin's encounter with contemporary Tahitian culture, with the lost and rediscovered myths of the Tahitian people that contrasted so markedly with the world of the French colonial rulers, is the focus of the concluding essay written by the ethnologist Ingrid Heermann.

Gauguin's South Sea paintings have been reproduced more often than any of his other works of art. The list of publications includes countless illustrated volumes, most of them quite general in scope, containing texts without theses and characterised by a marketing-oriented tendency that is not subjected to closer scrutiny here, particularly as Gauguin would probably have welcomed such an approach himself. Our objective here, it should be emphasised, is not to propagate and perpetuate the selective, popular view of the artist's work but instead to sharpen our historical gaze. This should in no way detract from the extraordinary aesthetic quality, the beauty, of these works of art. Indeed, the effect should be quite the contrary.

The traveller

Paul Gauguin was a traveller. The course of his life, which took him around the entire globe, was most notably affected by two significant interludes – his two long stays in Tahiti and the Marquesas (1891 to 1893 and 1895 to 1903). The importance of the first journey to Tahiti within the context of Gauguin's biography can be established on the basis of a review of several important dates and events in his life prior to 1891. A year after the birth of Eugène Henri Paul Gauguin in Paris on June 7th, 1848, his family emigrated to Peru, where Paul lived with his mother Aline and his sister Marie (his father having died the same year) at the home of a great uncle. The family returned to Paris in 1855. During a period of military service Paul signed on as a sailor on a ship bound for Rio de Janeiro, and he journeyed aboard another ship to South America a year later, receiving news of his mother's death while underway. He began drawing and painting in 1871. In the same year he met his wife-to-be Mette-Sophie Gad, of Copenhagen. He exhibited his paintings for the first time in 1879, alongside a number of Impressionist painters. During this period he earned a living working for an insurance company. In 1885 Gauguin moved to Copenhagen, where Mette and their five children were living, but returned to Paris only a few months later. Yet another major journey took him to Panama and from there to the island of Martinique in June of 1887.

Gauguin's stay in Martinique witnessed the first significant change in his creative work. He lived a few kilometres from Saint-Pierre in a hut on the beach, where he drew and painted, but was forced by an attack of malaria to return to Europe in October of the same year. Among the twelve paintings in his luggage was a particularly impressive work, his *Tropi-*

cal Landscape of 1887 (Cat. no. 1), a view of the bay of Saint-Pierre as seen from the Morne d'Orange volcano. The peak in the background is Mont Pelée, another volcano. The composition of the thoughtfully selected nature scene rendered in beautiful colours evokes the image of an idyllic park landscape. *Tropical Landscape* represented Gauguin's summation of his Impressionist painting technique. The picture was the point of departure for his approach to landscape painting. Green, ochre, turquoise and blue are the colours that return again in his Tahitian landscapes. By emphasising prominent details of vegetation, such as the tall papaya tree on the left, and surrounding them with dense, for the most part undifferentiated vegetation in concentrated hatched segments of the painting, he created a kind of primal image of an "exotic landscape" that we later recognise in some of the paintings done during his subsequent stay in Brittany.

Gauguin spent most of the next two years in Paris and Brittany. The works produced during this period have always been somewhat overshadowed by his Tahiti paintings, unjustly it should be noted, as it was in Brittany that he developed the aesthetic foundations for his most important works. Early in 1888 Gauguin travelled to Pont-Aven and took rooms at the Gloanec Hotel.[1] In May he received a letter from van Gogh proposing the establishment of a communal studio in which Maurice Denis and Paul Sérusier would also participate, and Gauguin departed for Arles to visit van Gogh in October. The most noteworthy painting completed during his stay there is *Blue Trees* (Cat. no. 4, 1888), a work whose composition and coloration clearly reveal the influence of van Gogh. Following the sale of some ceramics and paintings arranged by van Gogh's brother Theo, Gauguin began planning his next trip to Martinique in November. A dispute with van Gogh in December brought on a profound emotional crisis, and Gauguin returned to Paris.

Gauguin's previously vague plans took concrete shape in Paris during the two years prior to his departure. His destination was to be a distant land in which he could live the life of an artist in an unspoiled natural environment. His interest in such places, already nourished by his experience in Martinique, was heightened by his experience of the 1889 World's Fair in Paris, by his readings in literature and not least of all by his desire to make himself and his art more familiar to a broader segment of the public. In short, he wanted to become famous.

The Paris World's Fair opened its gates in June 1889. It was an event that would greatly influence Gauguin's understanding of exotic cultures. The Café des Arts Volpini, located on the exhibition grounds, hosted an exhibition of the "Groupe impressionniste et synthétiste" at which Gauguin showed 17 works, including nine landscapes from Le Pouldu. He also took the opportunity to present a folio of zinc prints.[2] From the autumn of 1889 until the summer of 1890 Gauguin commuted back and forth between Paris and Brittany but painted almost exclusively in Le Pouldu. Towards the end of 1890 Charles Morice introduced Gauguin to the circle of writers associated with the poet Stéphane Mallarmé. Gauguin made new plans for journeys to Tonkin, Madagascar or Tahiti. His dream was a "studio in the tropics – and anyone who wishes to see me will have to come there."[3]

Gauguin's knowledge of exotic cultures was quite fragmentary and unsystematic at this stage. Contemporary ethnography only occasionally made pure factual information available. Colourful travel accounts provided reading material for the public of the day, and the most recent, highly fashionable products of fantasy and reality consistently attracted the greatest attention. The most potent stimulus for Gauguin came from Pierre Loti's very pop-

ular novel *Le Mariage de Loti*, which had originally appeared under the title *Rarahu: idylle polynésie* in 1879. Loti described the distant, exotic setting as a lost paradise, full of colourful adventure and erotic suggestion, in which the public found both its confessed and its concealed prejudices reflected.

The studio of the tropics remained a utopian dream for another full year. When Gauguin travelled, it was to Pont-Aven, where he worked closely with Paul Sérusier. The low hills of the seaside landscape, the isolated small farms and villages in which time appeared to have come to a standstill and the simple peasant people in their plain traditional Breton garb epitomised rural life per se, and the distant stillness of the Breton countryside made Paris seem like a strange, faraway world. The artists who gathered there stylised their self-imposed retreat as an escape from urban civilisation, and they encountered what they supposed to be an original state of nature inhabited by a similarly unspoiled people. Yet Pont-Aven only seemed isolated from the rest of the world. The painters who had settled there ultimately sought success, major success in the galleries of Paris and among art critics. The exhibitions at the Gloanec Hotel featured paintings of differing styles, and critics responded with scorn directed towards the artists' colony and comparisons with the art on exhibit at official Paris academy shows. Passing through Pont-Aven somewhat later, Paul Signac found the landscape with its little brooks and waterfalls nothing less than ridiculous, as if staged for the benefit of those infamous English lady amateur painters with their boxes of water-colours.[4] (The village tobacconist had just put up a new shop sign – in the shape of a palette.)

Thematically speaking, the paintings done during this phase can be located between landscape and genre depictions; their style relates to the late Impressionism of the Martinique landscape. Two of these works from Brittany, presumably completed in Pont-Aven during the early summer months of 1889, *Among the Lilies* and *The Gate* (Cat. no. 2, 1889), the latter with close affinities to a painting by Sérusier, combine late Impressionist technique with a symbolic pictorial language. Barrier-like, the wooden gate marks out an area of refuge and stillness. The figures are relatively small and almost disappear amidst the vegetation in what may be seen as an appeal for a unity of nature and mankind. A melancholy silence is evoked not least of all through the absence of interaction among the figures in the paintings. None of these paintings reflects a spontaneous impression. *Among the Lilies* (1889, see page 9), for example, is a carefully planned studio composition similar in scheme to the Martinique landscape. The impression of harmony and peace is achieved through the deliberate use of formal resources. Each of the somewhat larger motifs in the foreground creates what is known as a *repoussoir*[5] behind which the pictorial space develops. In spite of this conventional approach to composition Gauguin manages here to avoid naturalistic illusionism. Foreground, centre of focus and background are rendered in the same brush technique using short, parallel strokes. Figures and individual motifs such as houses, trees or stones are outlined in dark contours which delineate them, while the same colours appear in both the sky and the vegetation. The flat quality of the representation and the subtle coloration create the effect of simplicity and absence of artifice, as if the painter had intended to present himself in total harmony with nature. The dramatic props – the dog and the little girl in the background of this particular painting – give the picture the sense of being charged with symbolic content: the large dog as the guardian of childlike innocence. In Brittany, these paintings suggest, the world was altogether in order.

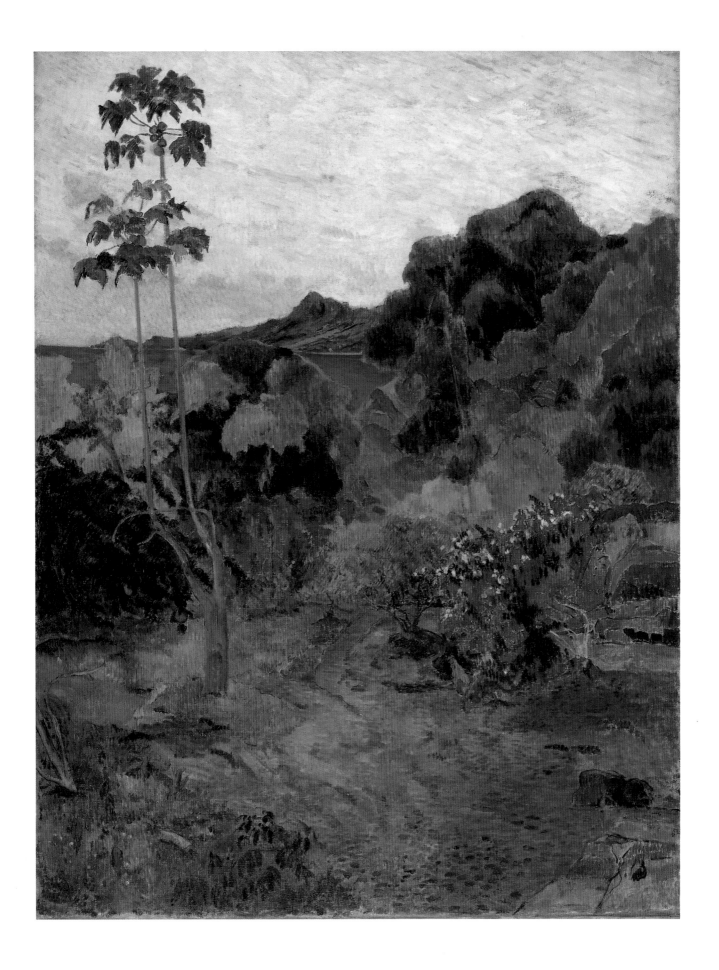

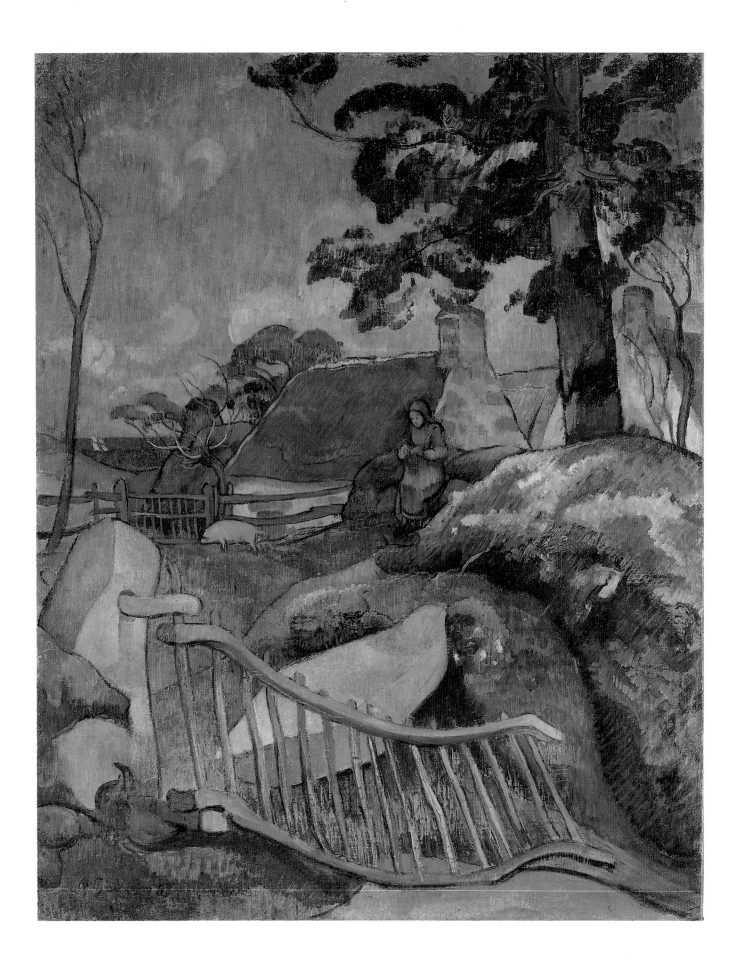

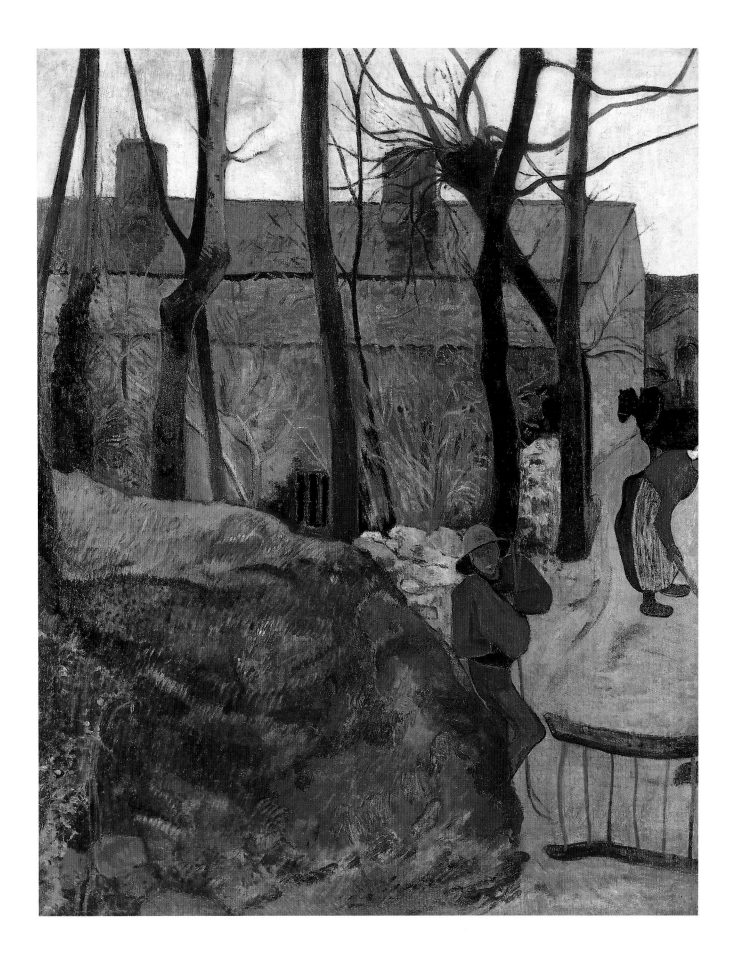

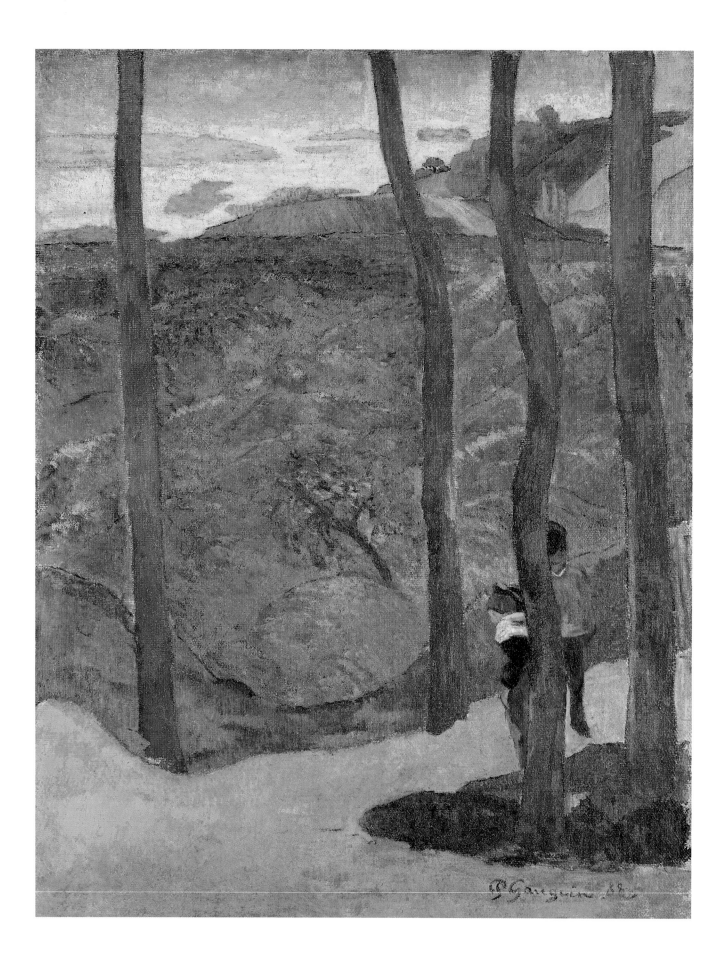

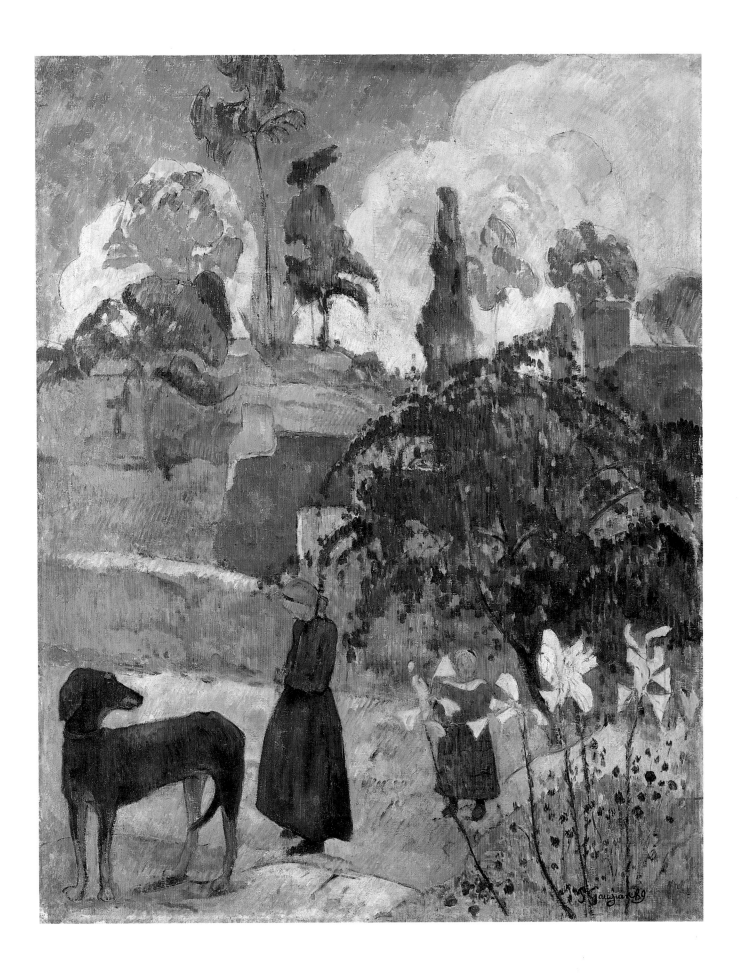

Cat. no. 5
Breton Landscape, Le Pouldu
1889
Oil on canvas, 72 x 91 cm,
W 356
Nationalmuseum, Stockholm,
Inv. no. NM 2156

Cat. no. 6
Fields near Le Pouldu
1890
Oil on canvas, 73 x 92 cm,
W 398
National Gallery of Art,
Washington, Collection of
Mr. and Mrs. Paul Mellon,
Inv. no. 1983.1.20

Cat. no. 7
Seaside Harvest: Le Pouldu
1890
Oil on canvas, 73.5 x 92 cm,
W 396
Tate Gallery, London, Inv. no.
T00895

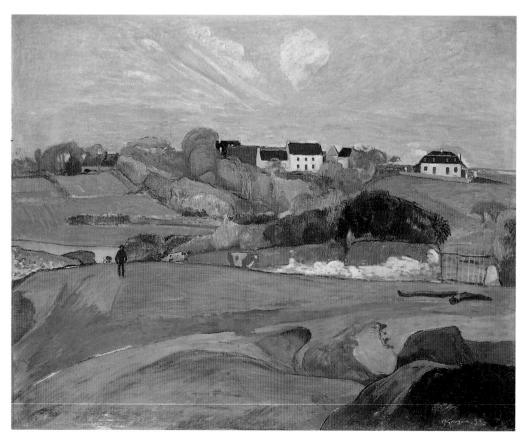

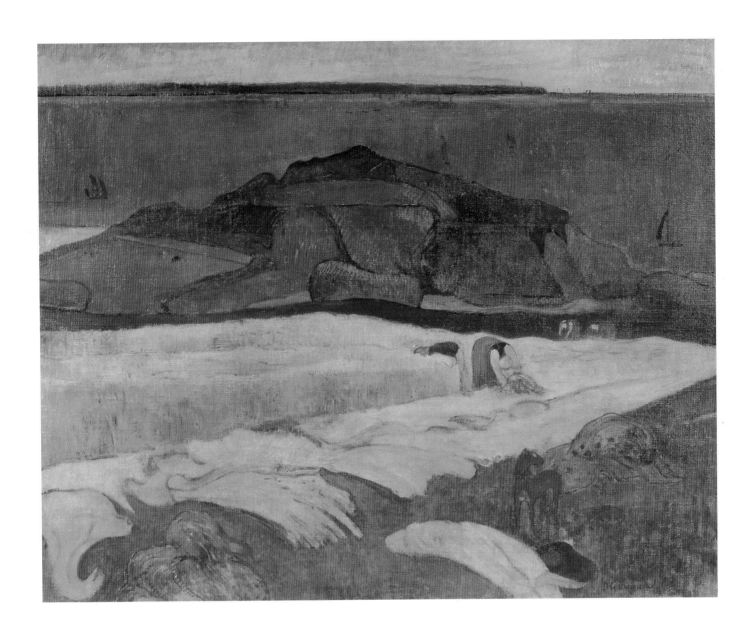

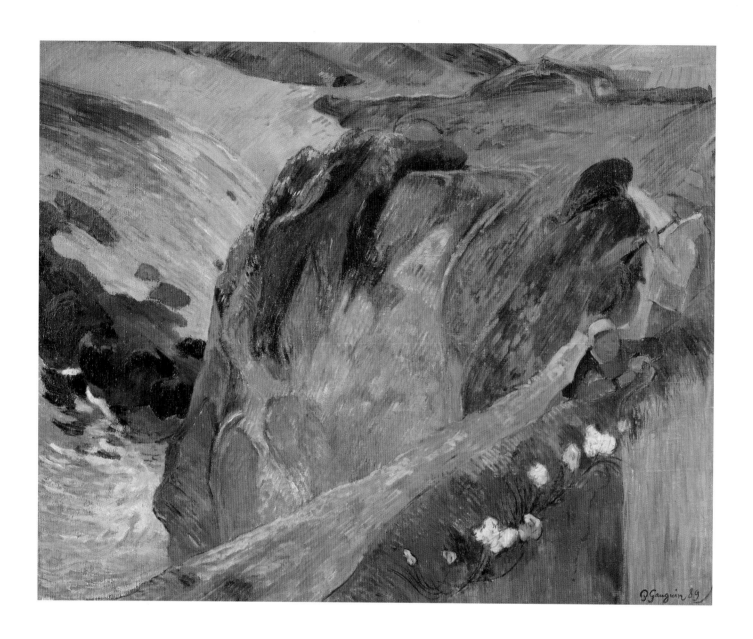

Cat. no. 8
Flutist on the Cliffs
1889
Oil on canvas, 73 x 92 cm,
W 361
Josefowitz Collection

Cat. no. 9
Landscape with Cow among
the Cliffs
1888
Oil on canvas, 73 x 60 cm,
W 282
Musée des Arts Décoratifs,
Paris

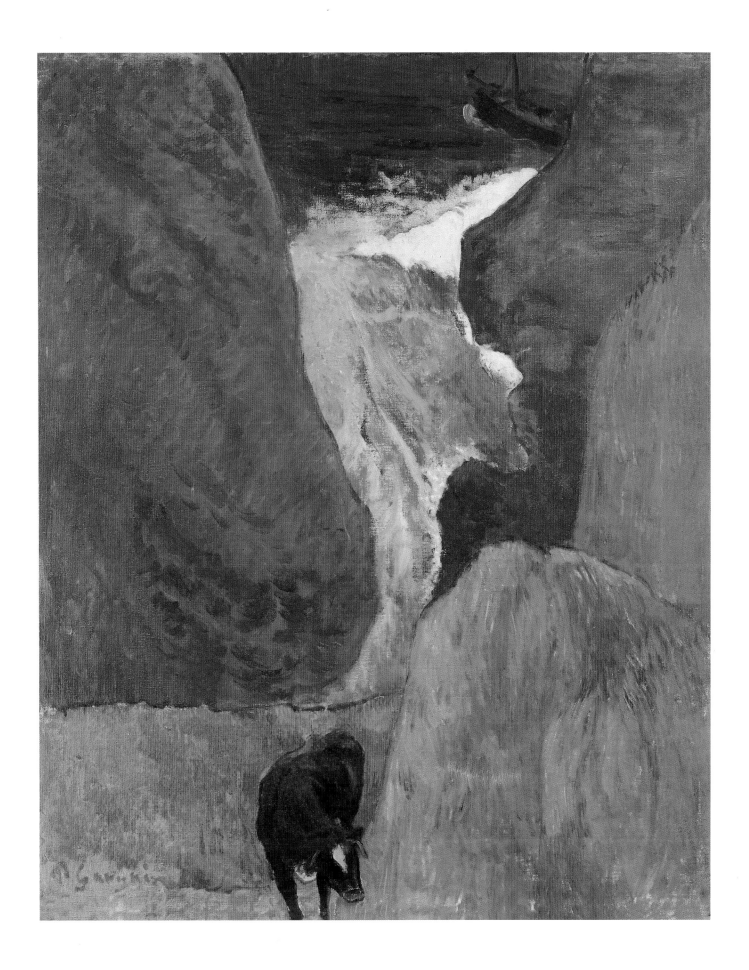

As mentioned above, idyllic Pont-Aven had changed so rapidly and dramatically that some of the painters from the flourishing artists' colony turned their backs on the town and moved some 20 kilometres away to a village at the mouth of the River Quimper. Here, in Le Pouldu, Gauguin rented rooms in the smaller of the two inns owned by Mademoiselle Marie Henry.[6] Le Pouldu consisted of no more than a few stone houses; its few inhabitants were poor and lived primarily from fishing and the gathering of flotsam from the beach.

The barren surroundings are depicted in a number of views of the village. *Houses in Le Pouldu* (Cat. no. 3, 1890) is a painting composed according to almost abstract principles. Vertical and horizontal lines in its upper portion create a graphic screen pattern towards which the amorphous shapes in the foreground move. Only the picture's coloration unites the strange conglomeration of surface areas and lines into a compositional whole which looks somewhat like an oriental print translated into a painting.

Life in Le Pouldu was a spartan affair for the artists as well. Yet the painters engaged in a lively and intensive exchange in their discussions about literature and art theory and their conversation about their newest works. It was during this phase, one year before his departure for Tahiti, that Gauguin completed a series of works that gave new direction to his art. These, interestingly enough, were landscapes and still lifes.[7] Two stylistically distinct groups can be identified, the one comprised of peaceful scenes in reserved coloration of the fields surrounding Le Pouldu, the other featuring dramatically energised views of the rocky coast. The landscapes done in Brittany are characterised by a tendency towards calmer colours and compositional balance. They are all executed as horizontal formats in accordance with quite similar principles of composition. This group includes *Breton Landscape, Le Pouldu* (Cat. no. 5, 1889), now in Stockholm, and the two paintings entitled *Fields near Le Pouldu* (Cat. no. 6, 1890), Washington, and *Seaside Harvest* (Cat. no. 7, 1890), London.

In these paintings the pictorial space is structured by horizontal colour areas which are given rhythm by vertical accents. Gauguin develops a great cornucopia of colour in these unspectacular views of gently rolling hills, mowed fields, farm houses and large mounds of hay amongst which only few people and animals appear, almost as an afterthought. Pink, yellow and orange hues intermingle with green and ochre, injecting undertones of an exotic vegetation into the authentic seaside landscape of Brittany. These Breton landscapes in particular, as images of mood and local colour, are often underestimated. A closer look reveals that Gauguin developed in these paintings an experimental approach to colour that he would take up again in his first Tahiti paintings the following year. Here as well, his starting point was always nature, although he was not concerned at all with mimesis. In the short period covered by the years 1888 to 1890 he abandoned Impressionism almost entirely. The Le Pouldu landscapes can be seen as a kind of shell, in which a new aesthetic formula could ripen.

The face of the otherwise quiet landscape changes in an area near the sea not far from Le Pouldu. Deep chasms among the luminous reddish-brown and orange cliffs open up picturesque vistas to the sea, revealing an abundance of diverse motifs and colours. Gauguin painted several unusual pictures along this rocky coast in which influences of non-European styles of art, most notably that of the Japanese woodcut, are evident. A good example is the brilliant *Landscape with Cow among the Cliffs* (Cat. no. 9, 1888). The composition consists of large, amorphous shapes cut off by the edges of the painting. The expansiveness of the sea contrasts with the claustrophobic closeness of the bay in an approach to composition that was entirely new in his work. Gauguin's tendency to force naturalism to recede from the

Cat. no. 11
Ondine (II)
1889
Pastel, 12 x 36.5 cm, W 337
Josefowitz Collection

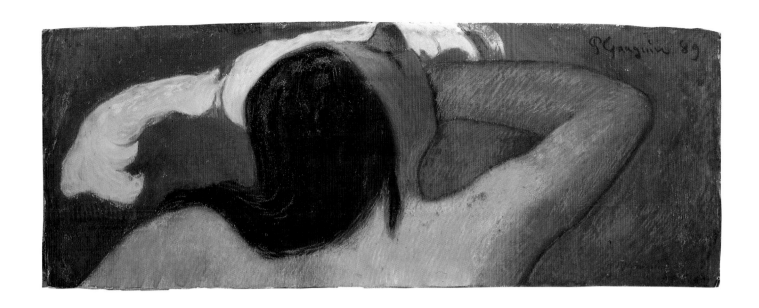

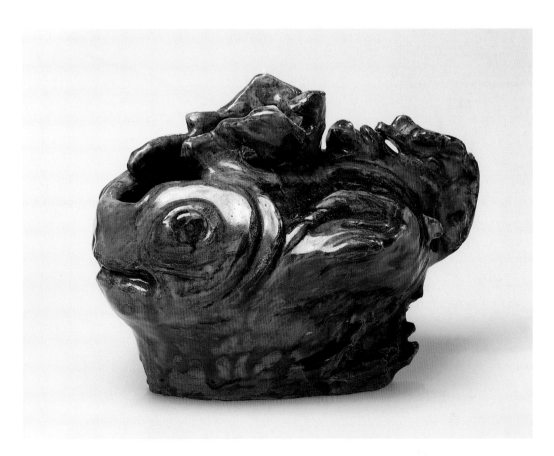

Cat. no. 10
Vase in the shape of a fish
1891
Clay, glazed, 23 x 32 cm, G 93
Kunstindustrimuseet, Copen-
hagen, Inv. no. B3/1931

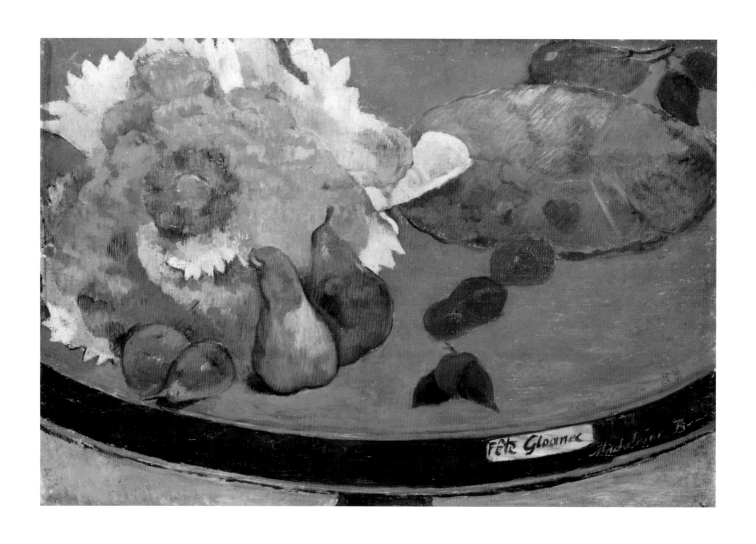

Cat. no. 12
Still Life Fête Gloanec
1888
Oil on wood, 38 x 53 cm,
W 290
Musée des Beaux-Arts,
Orléans, Inv. no. MO 1405

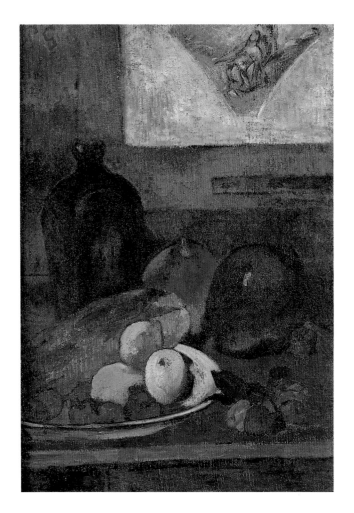

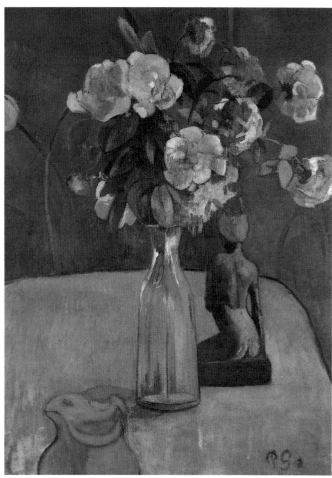

Cat. no. 13
Still Life with Print after
Delacroix
1888/89 (1895?)
Oil on canvas, 40 x 30 cm,
W 533
Musée d'Art Moderne et
Contemporain, Strasbourg,
Inv. no. 55.974.0.662

Cat. no. 14
Roses and Statuette
1890
Oil on canvas, 73 x 54 cm,
W 407
Musée des Beaux-Arts de
Reims, Inv. no. 943.1.1

Pages 18–19
Cat. no. 15
Portrait of Aline Gauguin
1890
Oil on canvas, 41 x 33 cm,
W 385
Staatsgalerie Stuttgart,
Inv. no. 2554

Cat. no. 16
Self-Portrait with Idol
1891
Oil on canvas, 46 x 33 cm,
W 415
The Marion Koogler McNay
Art Museum, San Antonio,
Texas

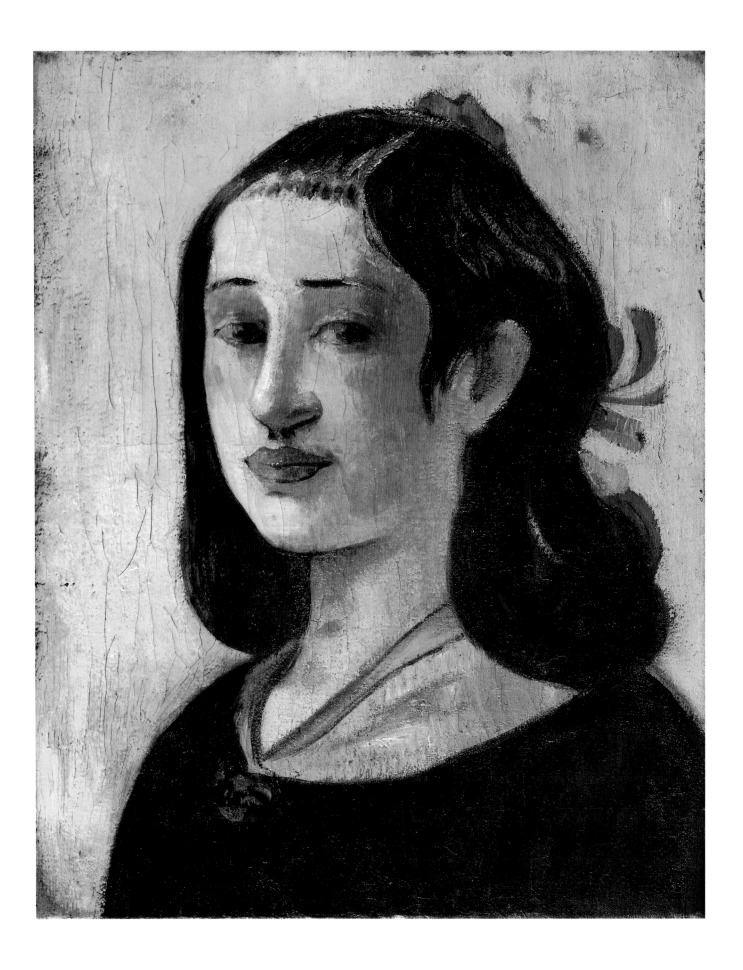

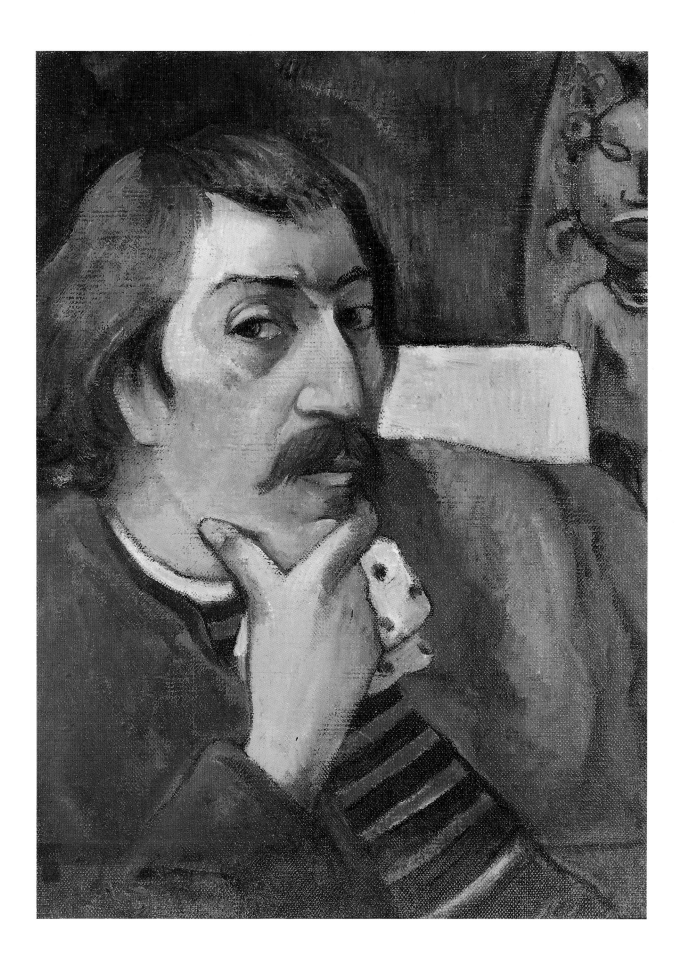

landscape is counteracted by the black cow with the white patch on its forehead at the lower edge of the picture. The harmonious interaction of the monumental coloured forms, which have an almost abstract appearance, with the anecdotal, naturalistic elements has quite rightly been described as "decorative", a term that – unlike its German equivalent – has no negative connotations in French. A comparable piece is found in a similarly experimental and decorative landscape entitled *Flutist on the Cliffs*, (Cat. no. 8, 1889). This painting is so rich in colour that it appears ornamental in some places. Water, sky and cliffs flow together as the colours of the sky, the cliffs and the sea reappear again and again in the hatched segments and distribute themselves over the entire surface as tiny particles. As in *Landscape with Cow*, the illusion of spatial depth is virtually eliminated here, resulting in an almost surreal side-by-side arrangement of differing distances that tends to confuse the viewer.

The reduction to a very few clearly delineated motifs and surface-oriented compositions suggests a comparison with the still lifes completed during the same period. The *Still Life Fête Gloanec* (Cat. no. 12, 1888), is associated with an anecdote. Marie-Jeanne Gloanec, the owner of the inn of the same name, received the painting from Gauguin in 1888. Placed next to the inscription "Fête Gloanec" near the edge of the plate is the odd signature "Madeleine B." Madeleine Bernard was the quite charming sister of the painter Emile Bernard, who was engaged to marry Gauguin's friend and fellow painter Laval. Gauguin wanted to give the still life to Madame Gloanec to hang in the dining room of her hotel, but she rejected the offer without having seen the picture, stating that she was not interested in Gauguin's painting. Gauguin then affixed the signature, presenting his work as that of a debutante, namely Madeleine Bernard, and Madame Gloanec graciously accepted it. The still life depicts a table that had presumably been decorated with globe flowers, a single large sunflower, fruits and a Breton tart on the occasion of innkeeper's Saint's day on August 15th. By virtue of its composition and coloration this painting occupies a special position among the still lifes done in Brittany. The radiant colours and the unconventional frame of view contribute to the distinctive effect of the painting, whose flat, two-dimensional conception reveals clear similarities to *Landscape with Cow*, a work done at the same time. Here as well, Gauguin drew inspiration from both Japanese woodcuts and the still lifes of Edgar Degas, a painter he greatly admired. This type of composition significantly influenced the art of the Nabi group, whose leading practitioner and theorist was Maurice Denis, and to the later still life painting of Pierre Bonnard and Henri Matisse. The landscapes were regarded by contemporary critics as rough and primitive, as the results of a quest for an original state such as that found in so-called primitive cultures. Gauguin was also given credit for having such an "intimate understanding of nature". In the eyes of one of the leading Paris art critics he was an artist with a primitive soul who had something of the savage in him, an ingenious savage and a savage genius at once.[8] The reputation as a non-conformist was ultimately an expression of the expectations placed in the artist, and these would intensify during his absence from Paris.

Apart from non-European patterns of composition, exotic motifs also began to appear more frequently in Gauguin's work, as is evident, for example, in the sculptures completed in 1890 and 1891, of which his *Vase in the shape of a fish* (Cat. no. 10), done in the spring of 1891, is probably the most unusual. As in his painting, Gauguin experimented in his colourful, glazed ceramics with forms oriented towards exotic models. Thus the shape of the bizarre vase in this work calls to mind a Chinese goldfish. Green and red tones shimmer

beneath the transparent glaze, interspersed with traces of blue, combining with the unusual shape of the object to produce a provocative mixture of simplicity and extravagance.

Much like his landscapes, Gauguin's still lifes from the late 1880s can be divided into two distinct groups. The one is comprised of the works mentioned above, with their exotic coloration and, in some cases, bold compositions. The other group consists of apparently quite conventional *nature morte* rendered in subdued colours. Yet just as the first group includes works of a pioneering character in terms of style, those of the second offer programmatical statements with respect to substance. Two examples may serve to illustrate this. The undated work *Still Life with Print after Delacroix* (Cat. no. 13) has been attributed by Wildenstein to the year 1895, although stylistic considerations suggest that it was probably completed during Gauguin's stay in Paris prior to his first journey to Tahiti. The fruits in the foreground and the light-coloured paper of the woodcut on the wall stand out against a dark-hued background of blue, brown and green. The print (a study for one of the spandrel paintings in the library of the Palais Bourbon in Paris) shows the banishment of Adam and Eve from paradise. Gauguin's admiration for the older painters Delacroix and Courbet is expressed in a variety of ways in his work, although rarely in such direct allusions as those found here. The combination of exotic fruits and the demise of the Garden of Eden is highly symbolic. It describes Gauguin's as yet vague yearning, of which his fear of failure was one ingredient. Stylistically speaking, the painting is more conventional than the later still lifes; it is reminiscent of Cézanne, whose works Gauguin particularly admired. At the 1893 exhibition of his Tahiti painting he displayed his works next to those of Cézanne.

In the still life entitled *Roses and Statuette* (Cat. no. 14, 1890) completed somewhat later, the glass vase with white roses on the irregular surface of the table is the dominant and most important motif. The dark, kneeling sculpture behind it sets a powerful accent. Prior to his departure for Tahiti Gauguin repeatedly combined western and exotic elements in his still lifes and portraits. Having increased his knowledge of foreign cultures since his visits to the Paris World's Fair, he now did sculptures of his own that were suggestive of an ethnological context.[9] His plan to live in Tahiti took concrete shape in the autumn of 1890. In September he wrote to the painter Odilon Redon: "My art, which you [Odilon Redon] love so much, is but a seed – I shall make it grow to fruition in Tahiti, in the condition of a primitive and savage. I need quiet. I am not interested in other people's strivings for fame! It is here that Gauguin has achieved perfection. None of his works will ever be seen again in this corner of the globe."[10]

Not only is this statement symptomatic of Gauguin's attitude towards life during this phase, it also bears witness to the intensity with which he pursued his idea. During these months Gauguin took increasing strength from the thought that the simple fact of his departure from Paris for a strange land might well foster public interest in his work. Gauguin, as became clear to the painters who worked and discussed with him in Le Pouldu, was dissatisfied and embittered over his lack of public recognition. The reason for such a response lay in the situation in which he found himself at the time within the circle of his fellow artists, whose works in many cases resembled one another so closely, due to their intense cooperation, that the individual artists often disappeared beneath the cloak of stylistic uniformity. "Nothing remains as the fruits of all of my efforts but the wailing that is heard all the way from Paris and which discourages me to the extent that I can no longer bring myself to paint; I drag myself to the coast near Le Pouldu while the north wind blows!

Almost mechanically I do some odd studies (if the eye even recognises the few brushstrokes as a study). But my soul is not in it. It stares sadly down into the abysmal depth before it."[11]

Perhaps the most significant work indicative of Gauguin's increasingly strong desire to bring about a change in his art by changing his venue is the small painting entitled *Portrait of Aline Gauguin* (Cat. no. 15, 1890). At first glance it suggests nothing of the moods of depression to which Gauguin frequently succumbed. The captivating effect of the painting derives from the yellow background against which the portrait takes on the quality of an icon. As mentioned above, Aline Gauguin had died in 1867 at the relatively young age of 42 during Gauguin's absence from France. He had spent the first years of his childhood with her and his sister in Lima, and he later reminisced upon "how graceful and beautiful she was when she wore her Peruvian dress with her silver-embroidered mantilla that left only her face exposed and covered only one eye."[12] He possessed a photograph that has been printed frequently in publications referring to this context. The photograph itself had been taken from an original painting that had once been in the family's possession.[13] Gauguin depicts Aline in an almost total frontal view as a girl-like woman with long, dark hair in which a blossom is fastened. A close look at the painting reveals a large number of small colour traces on the surface of the essentially strict composition, producing an iridescent sparkle similar to that seen in gemstones. Gauguin modified the photographic original and deliberately portrayed his mother as a distinctive beauty. The likeness bears unmistakable traces of a process of typing that would reappear two years later in his images of young Tahitian women. The silver-embroidered mantilla is rendered as a simple shawl. Aline's complexion is noticeably darker, and the blossom has become an articulate attribute. Gauguin exposed his non-European roots in this painting as he projected his longing for an exotic world upon a past altered by his nostalgic imagination.

In a last portrait completed before his departure for Tahiti, *Self-Portrait with Idol* (Cat. no. 16, 1891), he depicted himself in a thoughtful attitude, dressed in a simple Breton peasant's coat, with a strange-looking figure of a divinity, its hands raised in a gesture of appeal as if it were under the power of some dark god or demon itself. The artist is portrayed as a wanderer between two worlds. Gauguin was quite emphatic in all of his statements on the subject of Tahiti. In a letter written to his wife Mette, possibly during the winter of 1890, he described his project as an escape from European civilisation to an unspecified region of paradise: "If only the day would come when I can flee into the forests of a lonely island in the South Sea like a savage, to live there in peace and ecstasy for my art alone. Surrounded by a new family, far away from the European struggle for money. There in Tahiti, I will be able to listen in the silence of the lovely tropical nights to the soft murmuring music of the movements of my heart in loving harmony with the mysterious beings in my entourage. Free at last! Without money problems I shall then be able to love, to sing and to die."[14] Although Gauguin employed poetic rhetorics in this and similar announcements in which his self-styled status as a "noble savage" is implicitly expressed, he also avoided a clear articulation of his artistic concept. The journey itself provided the ostensible occasion for a retreat from his familiar surroundings in order to concentrate his powers as an artist. His plan was quite comparable to that of his "escape" from Paris to Brittany. Whether he was entirely certain that he could bring about decisive change in his art as well cannot be determined on the basis of his letters. It appears more likely that what he wanted was to "revise" his entire life's plan.

The decision to go to Tahiti was made against the background of a critical phase of his life which Gauguin himself described as a creative crisis. His idea of fleeing the Paris avant-garde, which was becoming increasingly paralysed by convention, took concrete shape under the influence of two circumstances. One the one hand, Gauguin had to earn money in order to provide for his family; on the other, his ambition to assume leadership among the modern painters of his generation had taken on the character of a sense of mission, although self-doubt continually plagued him. During his stays in Paris he had improved his knowledge about the South Pacific to the extent objectively possible. The World's Fair exhibited countless items of realia, presented in the manner of a colonial exhibition with no attempt to provide a sociological context or delineate precise ethnological or geographic borders – a colourful, entertaining mixture. The links between Gauguin's visits to the World's Fair in 1889, his collection of photographs and his reading of quasi-ethnographic novels and scholarly treatises and his life and art are examined by Dina Sonntag in her essay. The aesthetic preconditions, as his paintings from the period 1887 to 1890 clearly demonstrate, had already been established.

One of the most important material prerequisites was met through an exhibition held in the Paris auction house Hôtel Drouot in February 1891, at which thirty paintings were sold for a total of ten thousand francs. "With the money I have", Gauguin wrote to Emile Bernard, "I can buy myself a native hut like the ones I saw at the Colonial Exhibition."[15] The decision was final: he would go to Tahiti, "to forget the miseries of the past and die unnoticed, with the freedom to paint," as he wrote to an artist friend in Denmark, to whom he also described his expectations: "The Tahitians, on the other hand, these happy inhabitants of a forgotten paradise in Oceania, know nothing of life but its joys. To them, living means singing and loving … There I shall devote myself to great endeavours in art, far-removed from all artists' envy."[16] The adjective "forgotten" is symptomatic of an attitude of self-irony, for even before his departure Gauguin's journey was the subject of journalistic eulogies in Paris newspapers, and a banquet attended by Stéphane Mallarmé and other noteworthy figures was held in his honour at the Café Voltaire in March.[17] After receiving official approval from the authorities on March 26th to "study the customs and geography of Tahiti", he proceeded to Marseille without further delay. His freighter reached the Suez Canal in the first week of April and stopped at the port of Aden. On April 16th Gauguin landed for a brief stopover on the island of Mahé in the Seychelles, after which the ship sailed on to the Australian ports Adelaide, Melbourne and Sydney. He landed in Noumea, New Caledonia on May 12th, where he stayed for nine days before departing for Tahiti on a military transport vessel. Paul Gauguin reached his destination on June 9th, 1891, as the ship made fast in the little harbour of the Tahitian capital Papeete.

Tahiti: destination and departure

During the slightly more than 18 months during which Gauguin was able to work in Tahiti he completed more than one hundred paintings, about twenty sculptures and an undetermined number of drawings and water-colours. In other words, he must have finished between four and seven paintings per month, a pace he had never achieved previously. To this we must add writings, notes and sketches done in preparation for completion of the

manuscript of his magnum opus *Noa Noa*. A sixth of his entire painting oeuvre was completed between 1891 and 1893.

Gauguin first took up residence in the capital city of Papeete.[18] He was given a friendly welcome by the governor of the island, whom the French authorities had advised of his impending arrival. During the months of June and July he could be seen wearing a white linen suit in the company of Europeans at the officers' club. First portrait commissions were acquired through his contacts with the French colonists, but Gauguin found the monotonous life of the European citydwellers repulsive. Overwhelmed by the many new impressions he was initially unable to render in paintings, he succumbed to a brief spell of depression. "You ask", he wrote to his friend Daniel de Monfreid on November 7th, "what I am doing – that is hard to say, since I am unable to judge the value of my work. Sometimes I think it is quite good, and at the same time I am dismayed by the sight of it. Up to now I have done nothing special; I am content to search within myself, not in nature, and to learn a little drawing."[19] His sketchbook was soon filled with nature studies and portraits. Neither the bland colonial architecture of Papeete nor portraits of its French inhabitants appear among them. With the exception of a few completed portraits, he turned his attention almost immediately to the native culture, the Tahitian natives of the island and its agrarian landscape – in much the same way as he had done in Brittany only a few months before. A revealing example of his approach is provided by the unfinished picture entitled *Tahitians Resting*, presumably done in 1891 (Cat. no. 18), that was probably conceived as a study in original size for another painting that was never carried out. One sees here the pencil drawing in which Gauguin set out the basic features of the composition, followed by the outlining of the figures in blue chalk. The segment on the left is already coloured. The picture shows Tahitians in casual conversation towards the end of the noontime rest period. The large sheet, now mounted on canvas, is the only known composition study in canvas format. Some of its apparent weaknesses can be attributed to the fact that this was one of Gauguin's first attempts to come to grips with his new surroundings. This may also be the reason why he never executed the whole composition as a painting.

At first, Gauguin was interested primarily in the people. Without understanding their language, he saw them as personifications of the strange culture that had originally attracted him to Tahiti. During the first few months of his stay he did numerous studies of heads, mainly of young men and women who belonged to the "native" population of the island.[20] In September he undertook a first exploratory excursion with a horse and carriage into the province of Mataïea, located about sixty kilometres from Papeete, where he actually found what he had dreamed of in Paris – huts on the beach of the Pacific Ocean. He was accompanied by a young Tahitian woman named Titi, but she was accustomed to city life and left Gauguin after only a few weeks. While travelling through the eastern part of the country he met the family of Teha'amana, a 13-year-old girl who was offered to him as a *vahine,* or bride, on the usual condition that the girl would be permitted to return to her family after an eight-day "probation period" if she so chose. Teha'amana stayed and became Gauguin's *vahine,* with whom he shared bed and board, as we learn from his letters.[21] In his notes he refers to the young woman as a teacher of Tahitian morals and religious customs. More is to be said on this subject at another point.

Gauguin did not begin to paint until several weeks later. At first he made drawings and sketches, which he called "documents", a modern expression used by photographers at the

time. Gauguin had not brought a camera with him, but he bought prints in Papeete and expanded the collection he had carried from Europe. "I have a complete little world of friends on photographs and drawings with me, and they talk with me every day," he had written to Redon in 1890.[22] He possessed an extensive collection of ethnological photos, which were auctioned in Papeete after his death in 1903, including portraits and architectural pictures as well as details of interest from the standpoint of art history and from various different cultures. Many of the motifs in these photographs were incorporated into his compositions. Gauguin mentions them in "Avant et après".[23] Specific photographic originals can be identified for about a dozen of the paintings completed between 1890 and 1893, and his portrait drawings deserve particular attention for this reason alone.

The two double-sided drawings in Chicago, *Head of a Tahitian with profile of another head / Two figures, study for a Tahitian landscape* (Cat. no. 22) and *Heads of two Tahitian women / Portrait of Teha'amana* (Cat. no. 20), were done in charcoal and are to be assigned to the group of works designated as "documents". The drawings look less like portrait studies for paintings than preliminary sketches for sculptures. Contours and a few physiognomic features are applied in heavy, dark lines, some of which have been erased or smeared. The stocky physique, the round form of the head with its broad jawbone and prominent nose wings and the long hair create a seemingly consistent image of the Tahitian natives. Through his repetition of exotic features Gauguin established a kind of archetype for his future work. In doing so, he focused upon a different culture – that of Africa – in which masks have religious significance. A comparison of these type-based drawings with his *Portrait of Aline Gauguin* (Cat. no. 15) reveals shared characteristics that amount to a form of pictorial rhetoric. The tightly closed lips and the oblique gaze of the narrow, almond-shaped eyes lend the "models" an aura of aloofness and mystery. These stylised heads stand in remarkable contrast to the sketchbook drawing of the *Tahitian Girl* (Cat. no. 21, circa 1892). The few appealing features are rendered with greater spontaneity and little stylisation, and thus the drawing clearly shows that Gauguin's immediate impressions of persons were modified through an aesthetic process before they re-emerged later in his later paintings.

Among the most touching of the portraits done on canvas is that of the little *Atiti*, (Cat. no. 19, 1891/92). Aristide Suhas, son of the English bacteriologist and his wife, who lived near Gauguin in Mateïea, died of an infection on March 5th, 1892. A friendship had developed between the boy and the painter soon after Gauguin's arrival,[24] and Gauguin was deeply saddened by the irreversible illness and death of Atiti, whom he depicted as a little prince on his deathbed. The portrait is one of the few works of those years in which the painter's personal involvement with his subject is evident.

The lion's share of Gauguin's gradually accelerating artistic production was devoted to landscapes, however. *The Little Valley* (Cat. no. 17), which is undated but was probably completed shortly after his arrival, is characterised by a unique, almost austere appeal. The colours are applied thinly, allowing the light ground coat to shine through and giving the picture an aura of late Impressionism. The composition is very similar to that of the Le Pouldu paintings, and the painting technique resembles that of the works done in Arles. Tahiti's topography is dominated by high, cone-shaped mountains which rise abruptly from the fertile plains. Gauguin's first landscapes contain precisely observed figural details, such as a peasant viewed from the rear or a cart in the background, which lend the works an anecdotal quality. They also reveal Gauguin's curiosity and eagerness to become acquainted

with the country and its people as quickly and as thoroughly as possible, especially in view of the fact that he could not be certain how long his stay on the island would last.

One gains the impression that Gauguin approached his surroundings with a certain degree of caution, perhaps even shyness, an observation that is confirmed by correspondence. It was not until November that he wrote to Sérusier, telling him that he had now begun working in earnest and had sketched many things he hoped to paint following his return to France. Sérusier answered immediately, and his letter contains the following interesting remarks: "It is very kind of you to keep me up to date on your intellectual progress. Perhaps I do have a certain small part in it; but you must see that I am convinced that artists achieve only what they already carry inside themselves. The seed can grow only in fertile soil. If you are making progress it only means that you are predestined to do so."[25] This passage is interesting for two reasons. On the one hand, it expresses admiration from a geographical distance for Gauguin's courageous undertaking; on the other, it suggests confidence in his ability to accomplish something new and unheard-of in Tahiti. If we recall the events that immediately preceded his journey – the uproar in the press, the banquet and the theatre performance in his honour, in which the intellectual elite of Paris took part – then Gauguin's self-imposed existence as a native appears a quite logical consequence, an obligation, in fact, which he could not shirk. He was now forced to play a part which actually involved two positions not fully compatible with one another. A personal, as yet open-ended wish clashed with a projection of the high expectations of a demanding public. At this point, it may be said at the risk of exaggeration, Gauguin was damned to success, and as external circumstances forced him to extend his stay for more than just a few months he must have felt forced to assume the unexpected role of a captive.

Time was of the essence. Gauguin had arrived in Tahiti with very little money and could not be certain, due to the great distance over which the mails travelled, when the next payments would arrive or whether they would come at all. The duration of his stay was indefinite. He began to explore his surroundings in pictures with increasing speed. A look at *The Big Tree* (Cat. no. 23, 1891), completed somewhat later, suggests just how quickly that process unfolded.[26] The clearly separated foreground and central field of focus combine with the darker background and the sky to suggest the stripelike compositions of the Breton landscapes. Trees and shrubs are distinguished on the basis of their botanical characteristics, although there is no evidence of scientific interest in the vegetation. Instead, Gauguin integrates the flora into a precisely conceived, balanced overall composition that contains elements rendered in an Impressionist technique. The figures are small in scale and, in contrast to those in the previous example, are shown in simple standing or sitting poses. They appear strangely isolated and occupied with themselves, as if oblivious of the observer's presence. The absence of interaction is characteristic of Gauguin's depiction of figures throughout. The two paintings entitled *Black Pigs* (Cat. no. 24) and *Haere mai venez!* (Cat. no. 25), both also dated 1891, indicate that Gauguin was initially interested in the living circumstances of the natives as well. All of his details, including people, huts, horses and the small black pigs, had already been recorded in his sketchbook. Like most of his works, the paintings were executed in the studio and represent a compilation of various different sketches. The composition of these landscapes shows similarities to that of his *Tropical Landscape* from Martinique (Cat. no. 1), as Gauguin suggests spatial depth here as well by placing a single motif in the foreground. The so-called *repoussoir* motif becomes an omnipresent

constant in the Tahiti paintings; like a core, it encapsulates the monumental compositions consisting of one or two figures. Even some of these early paintings show evidence of an unspecified narrative context comprised of a combination of motifs, which will be examined more closely below. In *The White Horse (The Rendezvous)* (Cat. no. 26, 1891), a horizontal format like *The Little Valley* and *Haere mai venez!*, a substantive relationship develops between the intersected figure of the horseman leading a white horse by the reins and a female figure partially concealed by the dense vegetation, as if a discreet rendezvous were about to take place at a secret place permeated by a sweet fragrance. This type of allusion, which could easily have been drawn from a fairy-tale scenario and contains unmistakable erotic undertones, is characteristic of many of Gauguin's works. They project his yearning for a union of man and woman unconstrained by convention and for a life beyond the restrictive grasp of civilisation. They are like fragments of legends whose meaning is not accessible to the viewer at the rational level. Highly revealing is the discovery of an original model for the motif of the athletic man who leads the horse by the reins, a figure from a detail of a relief on the Trajan Column in Rome, of which Gauguin possessed several photographs.[27] The practice of incorporating an unrelated pictorial motif into a new context is by no means unusual in art, particularly for an artist intensely concerned with techniques of Symbolist imagery. At the beginning of his sojourn in Tahiti Gauguin was once again engaged in a phase of experimentation that took him in various directions and reveals itself both in his combinations of motifs and in differing approaches to painting technique.

At about year's end Gauguin completed several pictures which differ in significant stylistic ways from the preceding paintings. The compositions are flatter, their contours more pronounced and the repertoire of forms and colours reduced. Gauguin only seemed to be applying primitive principles of painting in *Beneath the Pandanus Tree* (Cat. no. 27, 1891) and *Tahitian Bathers* (Cat. no. 28). The drastic simplification gives these paintings an almost repelling aura, yet this constrained primitivism represents a stepping stone towards the two- and three-figure compositions that Gauguin would complete the following year. In these pictures as well Gauguin made use of photographs of reliefs from totally different cultures – ancient Roman, medieval Breton and Asian – although he did not copy them directly. His sketchbook contains figures rendered in stylised poses undoubtedly based upon models from his own environment. This mixture of original model and nature contributes significantly to the appearance of the paintings. They almost unavoidably reveal a derivation from an ancient, albeit indeterminate model. A comparison of the two stylistically different variants of late Impressionist and primitivistic landscapes clearly shows that Gauguin had arrived in Tahiti without a definitive aesthetic concept. Each of the distinct groups bears the marks of experimentation, although such features are much more readily apparent in the primitivistic paintings. It is quite obvious that he was attempting to realise his idea of the South Sea artist as an untamed savage by trying out a variety of aesthetic approaches.

The letters written by Gauguin in early 1892, to Paul Sérusier in March and to his wife Mette in April,[28] in which he intoned hymns of praise to the lost religion of the island inhabitants, indicated the onset of a fundamental change. He had returned to Papeete after his stay on the coast. There he met the solicitor Auguste Goupil (1847–1921), a resident of Tahiti since 1867 and a wealthy plantation owner. Goupil gave Gauguin a book entitled *Voyages aux îles du Grand Océan*, a work published in 1837 and therefore by no means new. Its author Jacques-Antoine Moerenhout, who had lived in Tahiti as a consul of the United

Cat. no. 17
The Little Valley
1891/92
Oil on canvas, 42 x 67 cm,
W 488
Private collection, Courtesy
Galerie Beyeler, Basle

Cat. no. 18
Tahitians Resting
circa 1891
Oil, charcoal and coloured
chalks on paper, mounted on
canvas, 85.2 x 102 cm, W 516
Tate Gallery, London, Inv. no.
No3167

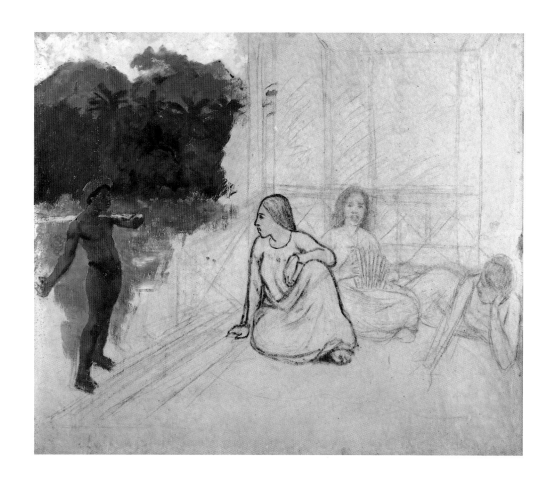

Cat. no. 19
Atiti
1891/92
Oil on canvas, 30 x 21 cm,
W 425
Rijksmuseum Kröller-Müller,
Otterlo, Inv. no. 1221-51

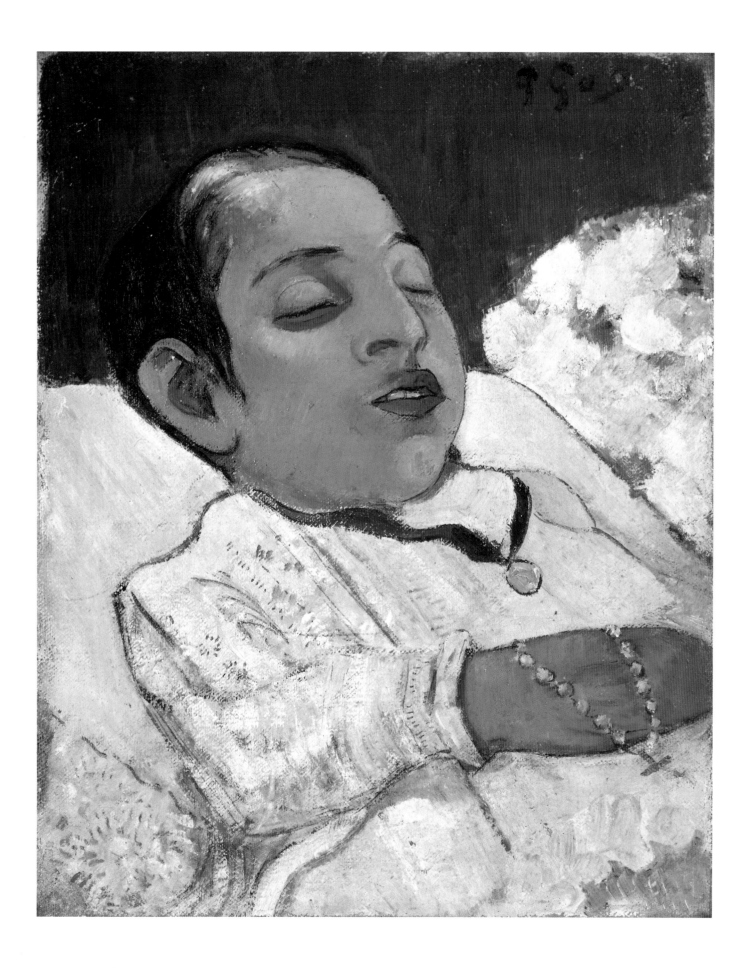

31

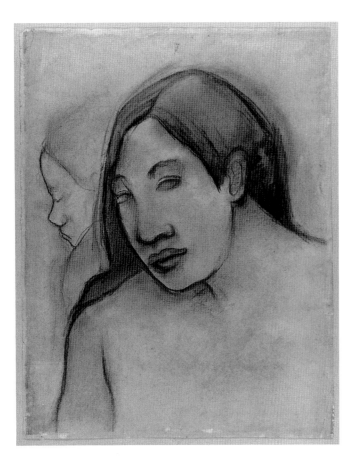

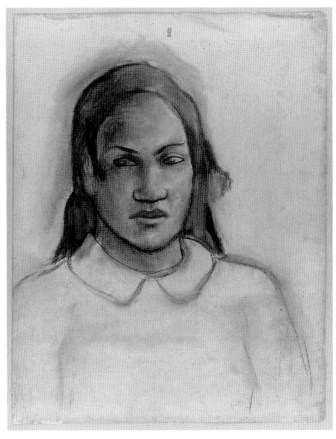

Cat. no. 21
front: Tahitian girl; reverse:
Woman sitting and Study for a
head
circa 1892
Pencil on yellowed sketch-
book sheet, 16.5 x 11 cm
Staatsgalerie Stuttgart,
Graphische Sammlung,
Inv. no. C73/2328

Cat. no. 20
front: Heads of two Tahitian
women en face and in profile;
reverse: Portrait of Teha'amana
1891/92
Double-sided drawing,
Charcoal, partially wiped and
washed, 41.4 x 32.6 cm
The Art Institute of Chicago,
David Adler Collection, Gift of
David Adler and His Friends
1956.1215

Cat. no. 22
front: Head of a Tahitian
with profile of another head;
reverse: Two figures
1891/92
Double-sided drawing, char-
coal, chalk and water-colour,
35.2 x 36.9 cm
The Art Institute of Chicago,
Gift of Mrs. Emily Crane
Chadbourne, Inv. no.
1922.4797 verso

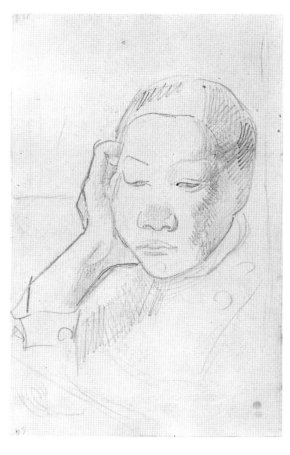

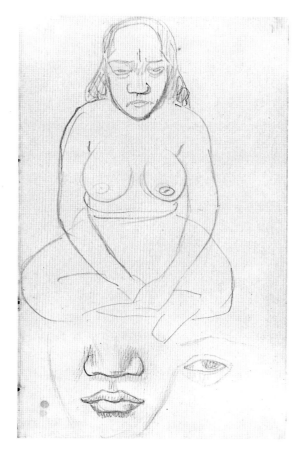

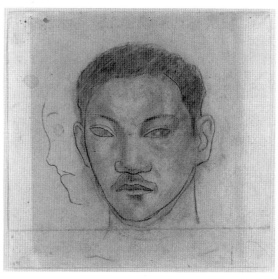

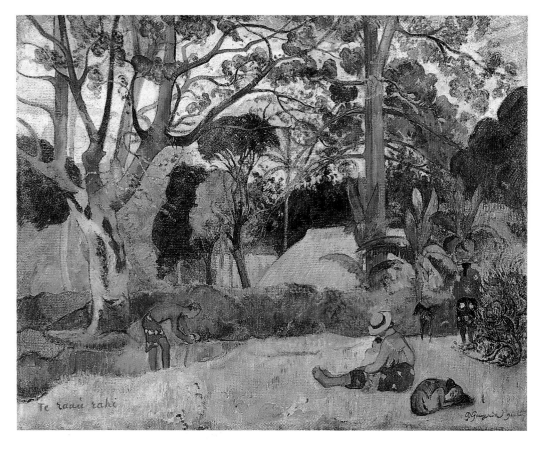

Cat. no. 23
Te raau rahi
The Big Tree
1891
Oil on canvas, 73 x 91.5 cm,
W 438
The Art Institute of Chicago,
Gift of Kate L. Brewster,
Inv. no. 1949.513

Cat. no. 24
Black Pigs
1891
Oil on canvas, 91 x 72 cm,
W 446
Szépmüvészeti Múzeum,
Budapest,
Inv. no. 355.B.

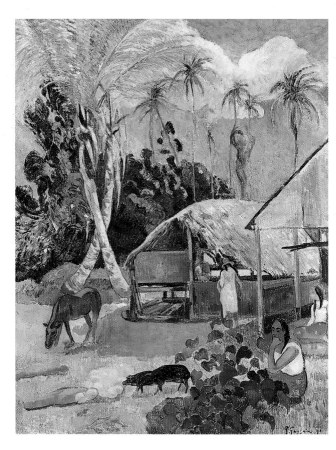

Cat. no. 25
Haere mai venez!
Come Here!
1891
Oil on canvas, 74 x 92 cm,
W 447
The Solomon R. Guggenheim
Museum, New York, Thann-
hauser Collection, Gift of
Justin K. Thannhauser, 1978

Cat. no. 26
Le Cheval blanc
(Le Rendez-vous)
The White Horse
(The Rendezvous)
1891
Oil on canvas, 73 x 91 cm,
W 443
The Solomon R. Guggenheim
Museum, New York, Thann-
hauser Collection, Gift of
Justin K. Thannhauser, 1978

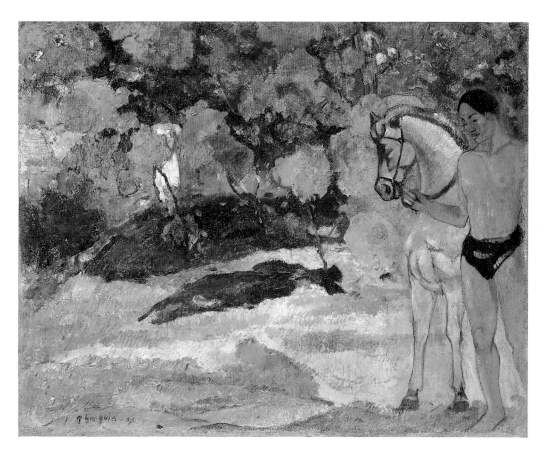

States, travelled to numerous islands and recorded his impressions, particularly with regard to the various religious customs and mores of the natives. Gauguin used the book as a compendium, copying entire passages that dealt with Maohi religious customs and divinities. He compiled a manuscript which he entitled *Ancien culte mahorie* after his return. It was not until then that he acquired a view of the unknown world slumbering beneath the colourful, exotic surface. He immersed himself in a culture about which his native friends could give him only fragmentary information, as it had disappeared so rapidly within no more than two generations. By the 1890s, virtually nothing remained of the Tahiti Moerenhout had described. It would be useless to speculate about what would have happened if Gauguin had travelled to the Marquesas rather than to Tahiti, as he had originally planned. Much of the original culture was still preserved in the Marquesas, yet things changed rapidly, and by the time Gauguin arrived in 1901 Maohi culture had disappeared there as well.

Gauguin's attitude towards the new realities of his life changed considerably during the first few months of 1892. This process, without parallel in his biography, can be traced back to its earliest stage in his works. Gauguin abandoned the depiction of reality, and the anecdotal aspect that had played such an important role in the works done during the first months of his stay began to disappear from his landscapes. The linking of Impressionist technique with primitivistic forms can best be examined by looking at a series of small-format paintings, of which all share the tendency towards simplification and monumentalisation of nature. Narrative aspects disappear in the wake of an increasing focus on a few selected motifs. The manner in which Gauguin depicts them in paintings such as *The Moment of Truth* (Cat. nos. 29 and 30, 1892), *Women at the Riverside* (Cat. no. 31) or *At the Big Mountain* (Cat. no. 32, 1892) is a clear indication of an approach from new perspectives. The landscape is full of highly symbolic motifs; the single tree, the mountain and the river are all part of a greater whole that incorporates a spiritual dimension – a religion of gods in nature that Gauguin was exploring bit by bit, albeit with Moerenhout's book as his guide at all times. The figures in *Women at the Riverside* no longer appear as isolated, stiff dolls but instead are so thoroughly integrated into the colours of surrounding nature that they could be mistaken for parts of the vegetation. Clearly outlined forms appear to communicate through colour with their surroundings. Colour takes on an increasingly atmospheric quality, as the primary colours give way to more subtly nuanced tones. Although orange, pink and violet become more important than the complementary contrasting hues of green and red, blue and yellow, even the softer oppositions of the secondary colours contribute to a new intensity. The unique character of the painting *At the Big Mountain* derives from the almost eerie mood Gauguin achieves through the contrast of his rich oranges and yellows with the deep blue of the sky and the huge mountain cut off by the edges of the picture. The small figures, especially the rider seen galloping off, contribute to the dramatic tension in a natural landscape that is charged as if with electrical energy. This landscape symbolism calls to mind his *Landscape with Cow* (Cat. no. 9), a work done in Le Pouldu. Gauguin sensed that he was nearing his aesthetic objective. In June 1892 he wrote about the changes in his work in letters to friends and to his wife Mette. He was, he claimed, beginning to assume truly "oceanic character",[29] and he assured Mette that "what I am doing here has never been achieved by anyone before me and is totally unknown in France. I hope that this news makes the public favourably disposed towards me." A first shipment of paintings arrived in Paris.

The "oceanic character" is represented not only by *At the Big Mountain* but also by works such as *Morning* (Cat. no. 33, 1892), a genre painting presumably done between September and October 1892. Gauguin depicts villagers who have come to the river to wash in the morning. This painting is one of the coloristic masterpieces of his first stay in Tahiti. The proportionately large areas of blue contrast with the orange and pink sections separated by the deep, almost black blue of the coursing water. Permeated with powerful accents of light red and green, the picture evokes the effect of a colourful carpet. If we call to mind the first, Impressionist-influenced Tahiti paintings, we recognise similarities in the structures of the compositions; new, however, is the rich coloration and the cloisonist-style technique that lends *Morning* an almost musical rhythmic quality.

A comment on the work titles is appropriate at this point. It was about this time that Gauguin began to replace his original French titles (*The Little Valley*, for example, originally entitled *Le Vallon*) with Tahitian designations (*Morning* bears the inscription "TEPOIPOI" on the lower left). As time passed, titles increasingly took on a quality of independence with respect to pictorial content, as if Gauguin intended to give the paintings a poetic dimension.

It was during this phase that Gauguin began work on a narrative that may be described as something between a travel journal and a fictional story. He entitled it *Noa Noa*, which means "fragrant" or "fragrant land". This text, upon which a great many interpretations of his paintings have been based, should be read critically from a historical point of view. In *Noa Noa* Gauguin describes his life among the Tahitian natives, to which he claims to have adapted himself so thoroughly that he had not only adopted their clothing, housing and eating habits and entered into a relationship with a young Tahitian girl but also allowed himself to be initiated into their religious customs as well. Clearly, autobiographical reality and literary fiction are mixed together in *Noa Noa*. By appearing as a first-person narrator, Gauguin lends some passages of the text a quality of authenticity, as if he were recording the realities of his own life in a diary. A discussion of the origins of the Gauguin legend must necessarily include an examination of the reasons why this text in particular was, and continues to be, cited as a source. *Noa Noa* is closely related to the process of change his creative work was undergoing at that particular time. The "painter among savages" had quickly metamorphosed into the "painting savage". His accumulated, albeit unsystematic knowledge of Tahitian culture, of Tahitian gods and rituals, which on the basis of the fragmentary preserved tradition seem quite mysterious, even sinister, was incorporated to an increasing extent into his art. A look at the painting entitled *There Lies the Temple* (Cat. no. 34, 1892) clearly reveals the field of conflict between reality and fiction. The composition is developed from the foreground, where abundant vegetation rendered in green, pink-violet and orange sets the tone; behind it runs a fence, its form inspired by Asian models, which creates a barrier uninterrupted by openings anywhere. In the centre of focus stands a rising hill of radiant yellow that dominates the overall coloration of the painting. The title motif appears in front of a mountain chain at the right-hand edge of the picture, a monumental stone temple figure, at the foot of which rising smoke suggests the presence of an unseen sacrificial fire. There were no temples left standing in Tahiti, no stone images of gods before which fires were kindled and no (Chinese) fences marking the boundaries of sacred areas. Gauguin could not have seen any such things on the island. How, then, does one explain the cryptic "Parahi te marae", "There lies the temple"?

Gauguin's source was Moerenhout's book. Its author describes the worship of the moon goddess Hina in the form of a ten-metre-high stone statue located on distant Easter Island. Gauguin's painting was not an authentic, ethnologically accurate report for the benefit of (future European) viewers of his work. Indeed, he was guilty of deliberate falsification in transferring, apparently arbitrarily, sacred site, statue and ritual to an environment that was now his own and at the same time represented the world with which outsiders associated him. In a letter to his wife Mette he explained the Tahitian title "Parahi te marae": "There lies the marae; temple, a place reserved for the cult of the gods, and for human sacrifice."[30] He was engaging in play with the inadequate knowledge of his viewers, who would believe whatever Gauguin told them, whether in pictures or words, because he, as an artist, was not required to produce a fully conclusive, scientifically justifiable comprehensive view of the subject.[31] It cannot be said that Gauguin falsified reality for lack of knowledge. The facts were available, and thus his result did not merely happen to be "wrong". Gauguin was content to show the "cult" as something mysterious and unapproachable that took place in sacred areas which the "uninitiated" were not permitted to enter. One might regard this as a kind of dual exoticism in which ostentatious exotic colour and the religious puzzle the viewer is incapable of solving serve as catalysts, each heightening the effect of the other. In magnifying the distance between the artwork and the viewer, Gauguin appropriated for himself the aura of the initiated that was reserved for the priestly caste. In essence, he was simply making use of a literary technique already suggested in the title of his tale. "Noa Noa", as already established, means "fragrant" in the Tahitian language. The sense of smell activated by the presence of a fragrance is not as precise as that of hearing or vision. Thus the work of art becomes a synthesis of literary and pictorial fiction. As such, it communicates an almost totally new, invented synthetic myth in its own right – a paradise in a far-too-distant land governed by the rituals of an alien culture.

With reference to this context we may approach a number of works dealing with religious practices, divinities and the effects of belief in the gods. *Te fare hymenee* (Cat. no. 35, 1892) relates to the following passage from *Noa Noa*:

"People frequently gather in a hut to talk and sing. First comes a prayer, recited conscientiously by an elder and repeated by everyone present. Then the people sing or tell amusing stories. The content of these stories is very intricate, hardly understandable; it is the fine details, naively stitched into fabric, that amuse them so. Only rarely do they concern themselves with the discussion of serious questions or wise proposals."[32] Gauguin is not describing an activity but a particular state of things. Even these events, which appear suspended in time as in a snapshot, were not based upon real happenings, since such singing houses were not common in Tahiti. Once again, Gauguin is experimenting with colour. The spatial qualities of the composition, which are lost in the reproduction, derive from the subtle colour graduations of the parallel bands. The colour masterpiece *Te fare hymenee* was thus an invention, a pictorial fiction that can be explained only from the standpoint of its relationship to the literary fiction. Another work that also depicts a ritual activity may serve as a helpful comparison. *Upaupa*, completed in 1891 (see page 49), was a somewhat earlier piece with which Gauguin was obviously not satisfied. The fire of joy, at which one of the supposedly traditional Tahitian dance rituals is enacted, had already become a rare event by that time. The painting is dominated by the huge fire at which the natives are seen moving about in ecstasy to the dull beats of the drums, as if transmuted into a state of archaic savagery.

Gauguin had chosen a theme borrowed from a traditional appeal to minor divinities that has been passed down in the following form: "Oh you who animate the slow dance and the song, inspire the dancing and singing leaders. The drums beat so loudly that one sees the white birds fly away. Make the legs agile, enliven the steps of the girls, pour out your intoxicating spell over us … only in your intoxication, Atua No Te Upaupa, can we live in happiness."[33]

Gauguin had learned of the ritual practices and Tahitian divinities already thematicised in *There Lies the Temple* (Cat. no. 34) from his reading of Moerenhout and the stories told by the natives. A number of his sculptural works deal with themes relating to Hina and Te Fatu, the divinities Gauguin regarded as the most important in Tahitian mythology.[34] In *Noa Noa* he provided a summary of Tahitian theogony in which he emphasised the significance of the three gods Ta'aora, Hina and Te Fatu. Ta'aora represents masculinity, intelligence and the mind, light and the sun. Hina embodies femininity, motherhood and the moon. He had little to say about Te Fatu, referring to him only as the god and personification of the earth. Hina appears more frequently in his work than any of the other gods, despite the fact that she played only a subordinate role in Maohi mythology.[35] His *Cylinder with the goddess Hina* (Cat. no. 36), carved from the hard, dark, reddish wood of the tamanu tree and partially painted and gold-plated, is probably the most ambitious sculpture completed during his stay in Tahiti. It shows a standing figure, its arms extended apart, flanked by a kneeling figure with its hand raised in a gesture of appeal. A second standing figure is posed on the other side, its head inclined as if listening. It is difficult to identify the two flanking figures. They could both be servants, or the kneeling figure could represent Te Fatu.[36]

Although influences of Maohi art are evident, the masklike, frontal view of Hina is not typical of Tahitian art. Here, Gauguin made use of models from Indian culture from his extensive collection of photographs, which included a picture of a relief at the temple of Boribudur.[37] He was obviously not intent upon achieving an ethnologically correct interpretation through his placement of Hina at the centre of his mythological program. And the explanation is a simple one: Gods are very seldom depicted in pictorial works or worshipped as images. Ingrid Heermann discusses this matter in greater detail in her essay. Hina is also the central figure in the wooden sculpture entitled *Hina and Te Fatu*, 1892 (Cat. no. 37), crafted in the manner of the so-called *tiki* worn in the hair as tube-shaped items of jewellery carved from bone. These *tiki*, which appear in a wide variety of figures and ornaments, were not customary in Tahiti but in the Marquesas. The sculpture made of somewhat lighter tamanu wood shows two figures joined to form a communicating group. Charles Stuckey cites a drawing that provides a clue to the origin of the motifs depicting the two gods on the front of the work.[38] It leads back to the manuscript of *Ancien culte mahorie*, in which Gauguin retells the legend "Parau Hina tefatou" (How Hina turns to Te Fatu). "Hina said to Fatu: ‚Bring the dead person back to life.' Te Fatu (the god of the earth) answered Hina (the goddess of the moon): ‚No, I shall not bring him back to life. The earth will die, the plants will die; they will die just like the human beings they nourish; the dust from which they come will pass away. The earth will die; the earth will come to an end; it will pass away, pass away for all time.' And Hina answered: ‚Then do as you please. As for me, I shall bring the moon back to life. And everything that belongs to Hina shall live on. Everything that belongs to Fatu will pass away, and man must die.'"[39] Gauguin attempted to capture the fascination of the myth of death and rebirth in sculpture, although he did not translate the myth itself but rather the legendary dialogue. In this way he avoided the necessity of recapit-

ulating concrete symbols and narrative details related to the foreign culture. He was satis-
fied with the allusion to the exotic world of the gods and the existential themes taken up in
their mythology. While the interpretation of the meeting of the two figures on the front
presents no great problem, the similarly designed rear portion of the sculpture is more
resistant to explanation. It has been seen as depicting Hina and Ta'aora on each side of a
plant symbolising their common descendant. According to this interpretation, the sculp-
ture represents two seemingly opposing dialogues – the one about death and the other con-
cerning perpetual life.[40]

Gauguin had done clay sculptures even before his journey to Tahiti, and he took up the
technique once again after his return, making use of Tahitian motifs. Although the highly
unusual *Rectangular vase with Tahitian gods* (Cat. no. 38) bears a close relationship to the two
wooden sculptures discussed above, it was completed in Paris following Gauguin's return to
Europe. The relief-covered vase made of especially fine-grained terra-cotta exists in three
virtually identical versions. Gauguin presumably shaped them around a wooden core. The
lines were added with a pointed instrument after baking, and the dark areas on the raised
portions of the relatively flat relief are products of the glazing process. The front side shows
the figure identified above as Hina, her arms extended apart, but now shaped in much
rougher fashion and with a wilder expression. The rear bears a depiction of a couple, pos-
sibly analogous to Hina and Te Fatu. In Gauguin's art the quiet gods of the Maohi become
evil, grimacing demons who strike fear into the hearts of humans.

Words of the Devil (Cat. no. 39, 1892) is a painting that deals with fear of demons. The
nude woman who turns towards the viewer with a gesture of astonishment or fright does not
appear to perceive the demon behind her. Gauguin depicts him as a figure kneeling along-
side intense red blossoms that mark out a spatial boundary in the painting. Suspended
above him in the dark tangle of leaves are "hutu" blossoms rendered in cold white. The
magical contrasts, the deep colours and the strange theme of the painting have produced a
plethora of interpretations virtually unrivalled by any other work. The spectrum ranges
from its identification as a key to an understanding of religion to its position as the pictorial
equivalent of psychoanalytical theories regarding puberty and sexuality.[41] The formal prox-
imity of the figure to depictions of Eve, the large tree in the background and the evil (or
diabolical) demon in front of it suggest the projection of the Christian scenario of Original
Sin onto a South Sea setting, an association that is clearly supported in the large *Pastel study*
(Cat. no. 40) for the central figure of the painting. Gauguin must have been aware that
images of demons were not ordinarily found in Tahitian society, and his own demon calls to
mind African rather than Polynesian models. The figure with the frozen stare, called "te
varua ino", which appeared in several paintings in similar substantive constellations, was an
invention of Gauguin's intended to give visual form to the concept of fright in response to
an undefinable sinister force.[42] The roots of his invention can be traced to a mythical tale
from the island of Tupai, in which a female *tupapao* (a phantom) abuses men in their sleep.
Gauguin reversed and distorted the basic pattern by injecting European ideas into the mix.
The combination of uncanny, ultimately indeterminate "superstition" and the equally nega-
tive theme of "Eve and the tree of knowledge" (to which the presumably male demon would
be appropriate) has entirely realistic aspects. The distortion was evidently meant for the
Paris public. In 1893 Gauguin's confidant and editor Charles Morice wrote the following
remarks about the effect evoked by a similar painting entitled *Faire peur*: "Someone tells a

frightening story, and the legend comes alive in the naive imagination of one of the female listeners. It consumes reality in a terrifying manner in the horrified, wide-open eyes of the lady listening in intense anticipation – and the gentle Tahitian night is suddenly populated with watchful creatures, large and strange, ancient gods fallen from grace or long since dead."[43] As the critical reception of these paintings is examined below, it is appropriate to limit the discussion here to a review of Gauguin's development as an artist towards the end of his first stay in Tahiti. We cannot overlook the fact that his paintings reveal certain archetypal patterns expressed in the repetitions of individual motifs. The crouching figure just identified as a demon reappears in a painting originally titled *Parau parau*, which may be translated as W*hispered Words* (Cat. no. 41, 1892), or somewhat less mysteriously as "conversation". This painting, just as ambitious in terms of colour as *Morning* (Cat. no. 33), also has unique formal qualities of its own. The isolated standing figure holding her hand in a protective gesture over the ripe fruit is excluded from the circle of figures portrayed in genre fashion, as if she were on her way to offer a sacrifice to the gods and was for that reason the subject of "whispered words". The possibilities for interpretation posed by these paintings are rather more associative than concrete. The remarkably awkward posture of the standing woman is incorporated into the composition as a stage prop. She appears again in a stained glass window completed by Gauguin in 1892 as a decorative addition to the house of his landlord in Mataïea.[44] She is also depicted as one of the adoring worshippers in the *Ia orana Maria*[45] and appears again in modified form in a large gouache entitled *Te faruru* (Cat. no. 43, 1892). The woman shown in the company of an angel in the gouache has her hands folded in a gesture of Christian prayer. Thus Gauguin attached two very different meanings, seen from the European point of view, to the motif. The obvious, purely formal relationships that link these works cannot be attributed merely to a lack of imagination. They are an aspect of his intention to invest his Tahitian work with formal conclusiveness without providing a systematic canon of meanings to go along with it.

Tehamana has Many Ancestors (Cat. no. 44, 1892), probably completed just a few months before Gauguin's return to Europe, is one of his most impressive paintings of a woman. The woman depicted here looks much like a princess from a far-off kingdom – majestic, mysterious and attractive at the same time, the epitome of archaic strength and dignity. Tehamana, as she is identified in the title, wears a dress of the kind worn at the mission stations. She holds a palm frond in her hand like a sceptre. Her hair is adorned with flowers. A band of mysterious printed characters appears in the background, along with a wooden sculpture in a dancing pose. The real Teha'amana was Gauguin's mistress, his *vahine*, as she was referred to in Tahitian. We know from photographs that Teha'amana looked quite different. Her face was not evenly shaped, her hair was not straight and she certainly did not have the stature of a princess. Behind the figure of Tehamana in the painting is a frieze bearing carved figures carrying out dancing motions. The figure on the left appears repeatedly in Gauguin's sculptural works (see Cat. no. 36). She is based upon a model that is not Tahitian but Marquesan. Nor are the written characters appropriate to Tahitian culture, as they originated instead from wooden plaques discovered on Easter island in 1864. The characters have not been deciphered to this day. Gauguin employed them as an ornamental frieze. The picture bears the enigmatic title *Tehamana has Many Ancestors*, and it is, in fact, a pastiche of motifs from different cultures. One could dismiss the whole composition as a random decorative arrangement, but it must be remembered that, although Gauguin painted

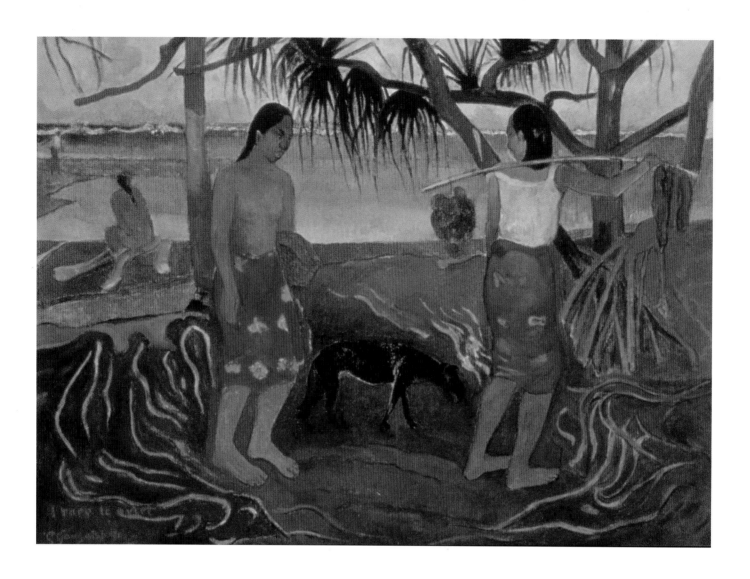

Cat. no. 27
I raro te oviri
Beneath the Pandanus Tree
1891
Oil on canvas, 68 x 90 cm,
W 431
Dallas Museum of Art, Foundation for the Arts Collection,
Gift of Adèle R. Levy Fund,
Inc., 1963.58 FA

Cat. no. 28
Tahitian Bathers
1891/92
Oil on canvas, 110 x 89 cm,
W 462
The Metropolitan Museum
of Art, New York, Robert
Lehman Collection, Inv. no.
1975.1.179

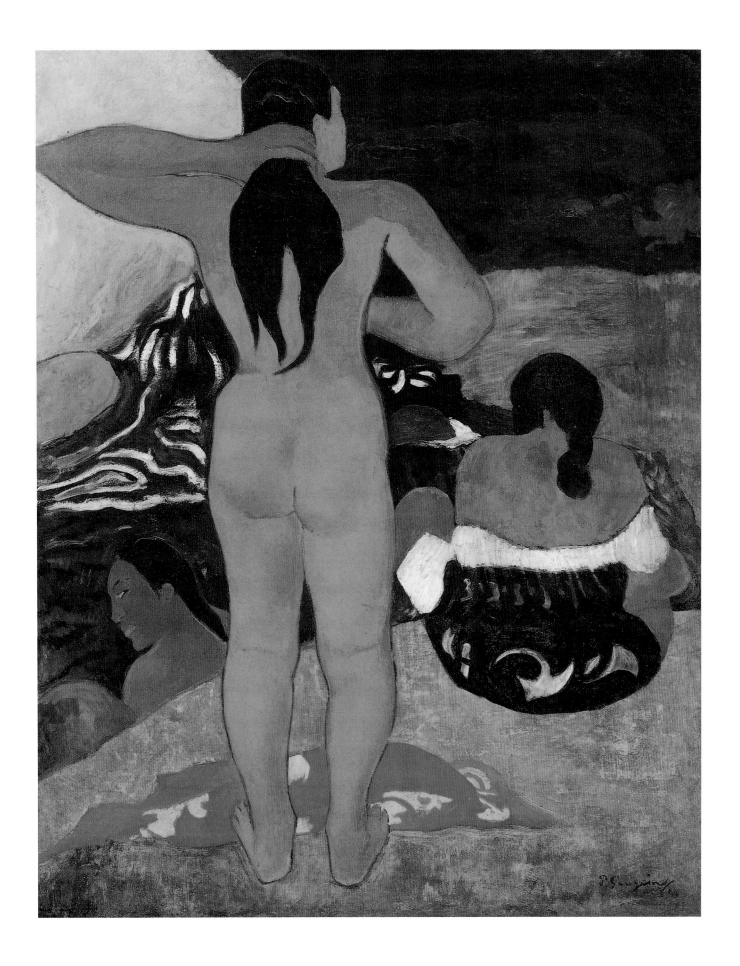

43

 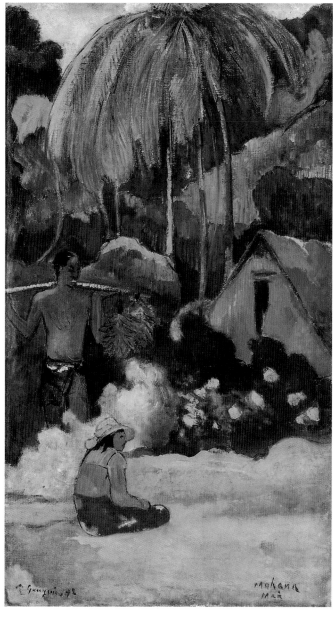

Cat. no. 29
Mahana maa I
The Moment of Truth I
1892
Oil on canvas, 53 x 30 cm,
W 490
Cincinnati Art Museum,
Bequest of John W. Warrington

Cat. no. 30
Mahana maa II
The Moment of Truth II
1892
Oil on canvas, 45 x 31 cm,
W 491
The Finnish National Gallery
Ateneum, Helsinki

Cat. no. 31
Women at the Riverside
1892
Oil on canvas, 43 x 31 cm,
W 482
Rijksmuseum Vincent van
Gogh, Vincent van Gogh
Foundation, Amsterdam,
Inv. no. 222

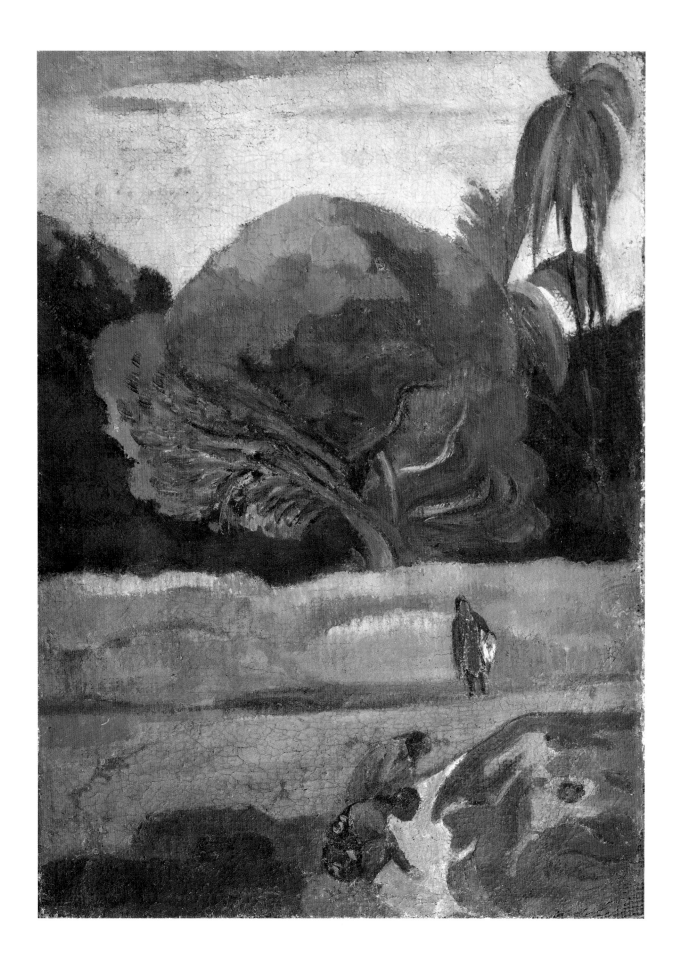

Cat. no. 32
Fatata te mouà
At the Big Mountain
1892
Oil on canvas, 68 x 92 cm,
W 481
State Hermitage, St. Peters-
burg, Inv. no. 8977

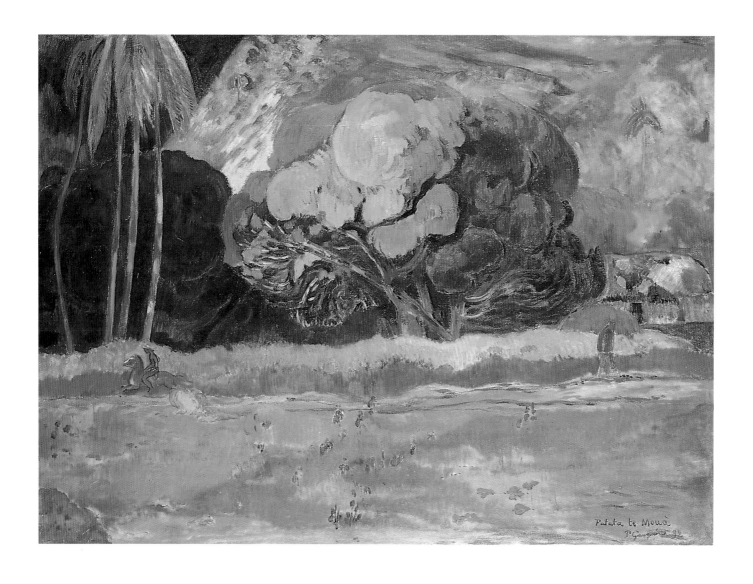

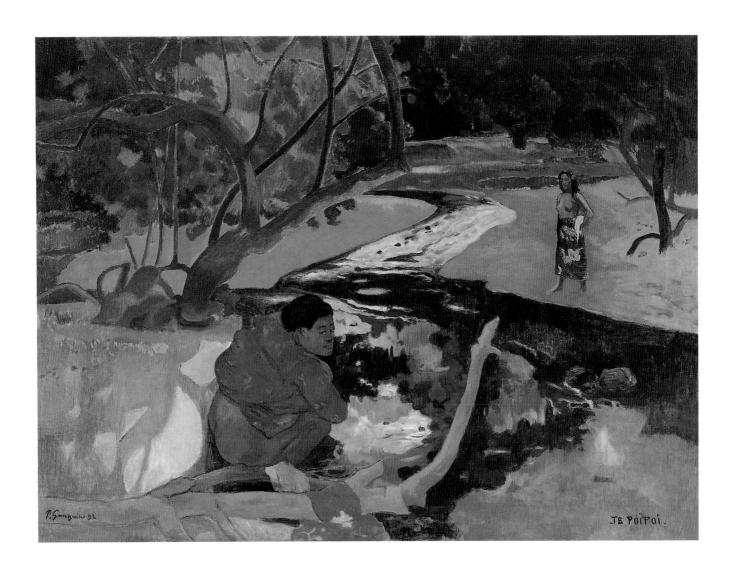

Cat. no. 33
Te poi poi
Morning
1892
Oil on canvas, 68 x 92 cm,
W 485
Collection of Joan Whitney
Payson

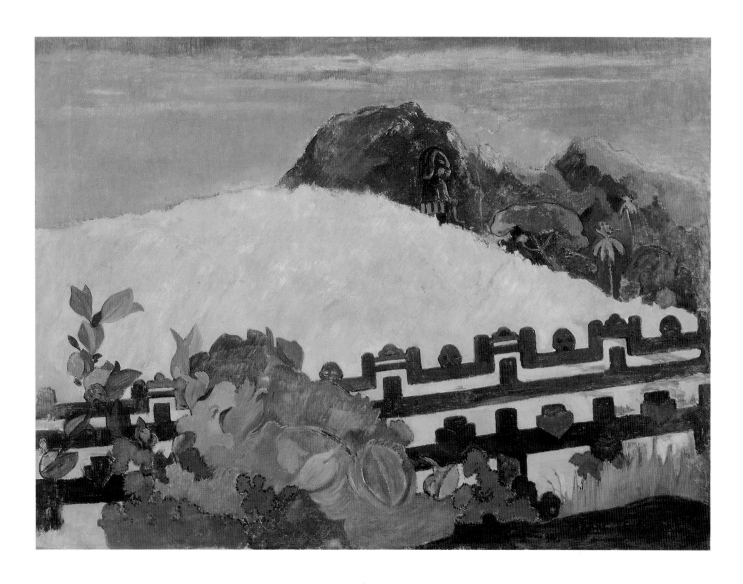

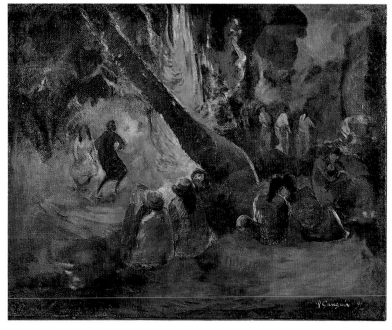

Cat. no. 34
Parahi te marae
There Lies the Temple
1892
Oil on canvas, 68 x 91 cm,
W 483
Philadelphia Museum of Art,
Gift of Mrs. Rodolphe Meyer
de Schauensee, Inv. no.
1980-001-001

Not in catalogue
Upaupa
Fire Dance
1891
Oil on canvas, 73 x 92 cm,
W 433
The Israel Museum, Jerusalem

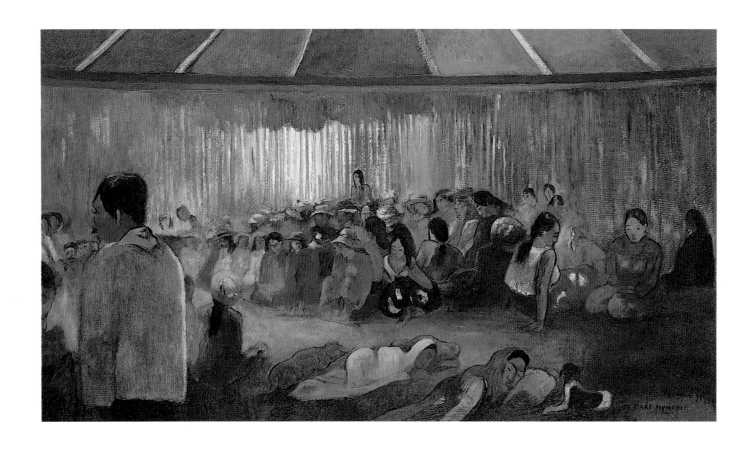

Cat. no. 35
Te fare hymenee
The House of Song
1892
Oil on canvas, 50 x 90 cm,
W 477
Private collection

Cat. no. 36
Cylinder with the goddess Hina
circa 1892
Tamanu wood, painted and
gold-plated, 37.1 x 23.4 x
10.8 cm, G 93, FM 250
Hirshhorn Museum and
Sculpture Garden, Smith-
sonian Institution, Washing-
ton; Museum purchase with
funds provided under the
Smithsonian Institution's
Acquisitions Program, 1981

Cat. no. 37
Hina and Te Fatu
circa 1892
Tamanu wood, 32.7 x 14.2 cm,
G 96, FM 200
Toronto, Collection of the Art
Gallery of Ontario, Gift from
the Volunteer Committee
Fund, 1980

Cat. no. 38
**Rectangular vase with
Tahitian gods**
circa 1894
Terra-cotta, 33.7 x 13.5 cm,
G 115
Kunstindustrimuseet, Copen-
hagen, Inv. no. B 45/1932

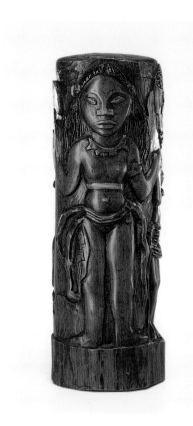
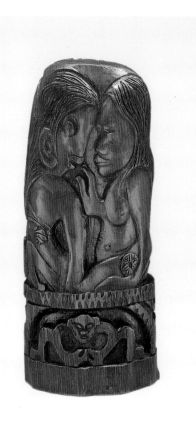
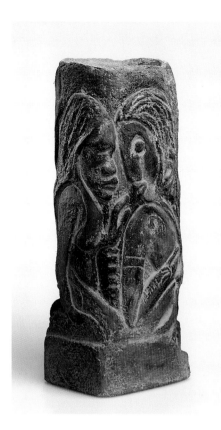

Pages 52–53:
Cat. no. 39
Parau na te varua ino
Words of the Devil
1892
Oil on canvas, 91.7 x 68.5 cm,
W 458
National Gallery of Art,
Washington, Gift of the
W. Averell Harriman Founda-
tion in Memory of Marie N.
Harriman, Inv. no. 1972.9.12

Cat. no. 40
Study for "Parau na te
varua ino"
Words of the Devil
1892
Pastel on paper,
76.5 x 34.5 cm
Öffentliche Kunstsammlung
Basel, Kupferstichkabinett,
Inv. no. 1928.17

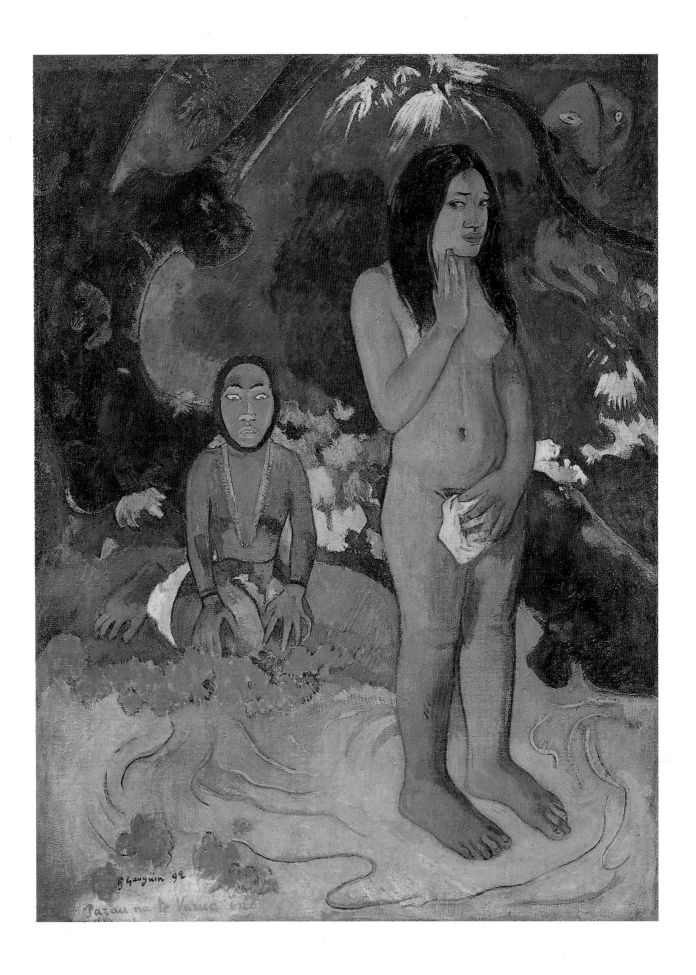

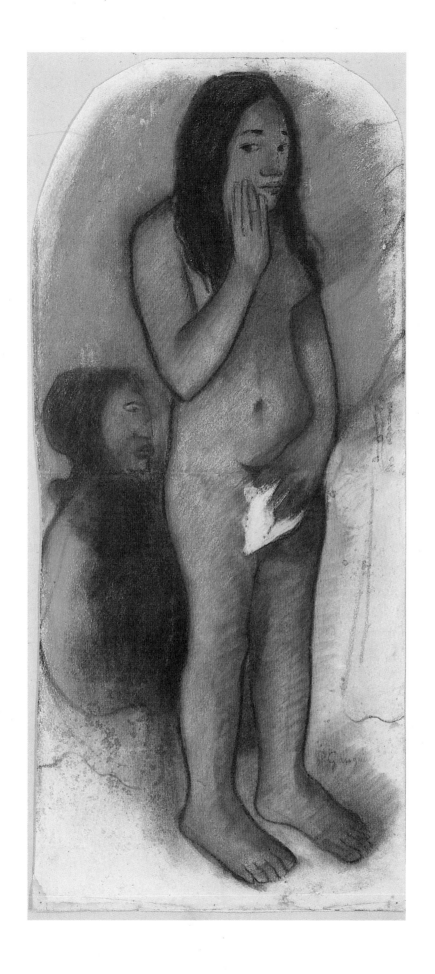

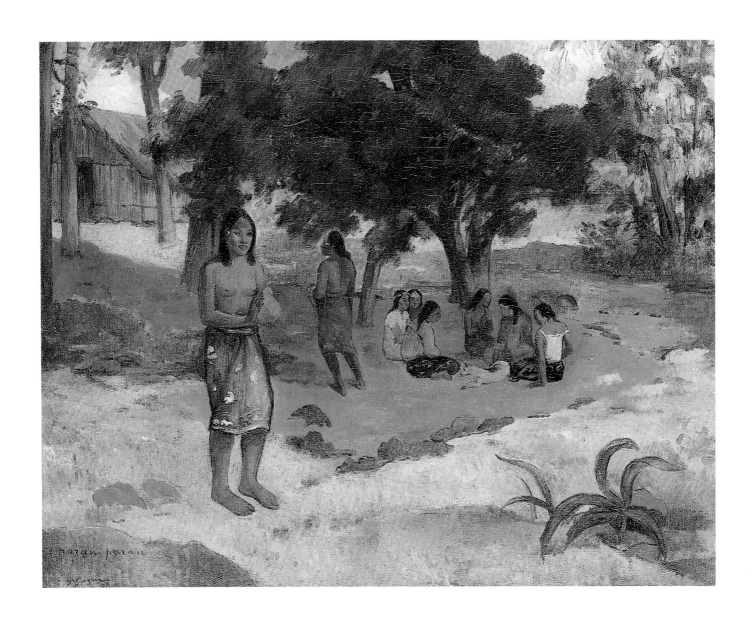

Cat. no. 41
Parau parau (II)
Whispered Words (II)
1892
Oil on canvas, 76 x 96 cm,
W 472
New Haven, Yale University
Art Gallery, John Hay Whitney,
B.A. 1926, Hon. M.A. 1956,
Collection

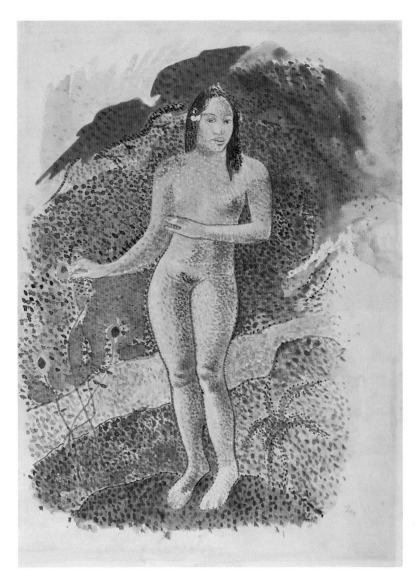
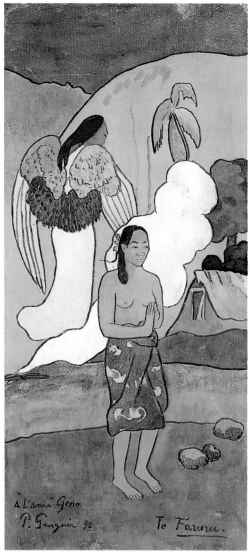

Cat. no. 42
Nave nave fenua, l'Eve
tahitienne
Beautiful Land, Tahitian Eve
1892
Water-colour, 40 x 32 cm
Musée de Peinture et de
Sculpture, Grenoble

Cat. no. 43
Te faruru
The Encounter
1892
Oil and gouache on paper,
44 x 21 cm
Museum of Fine Arts, Spring-
field, The James Philip Gray
Collection

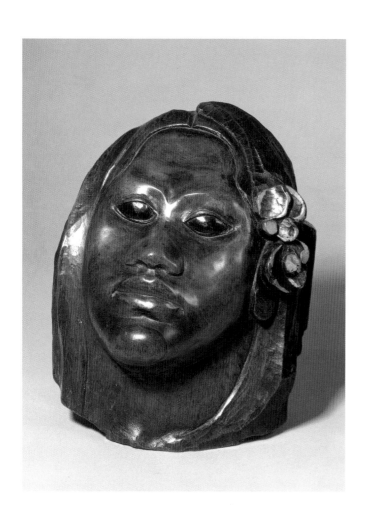

Cat. no. 45
**Head of a Tahitian Woman
(Portrait of Tehura)**
1892
Pua wood, 25 x 20 cm, G 98
Musée d'Orsay, Paris, Don de
Mme Huc de Monfreid, 1968,
Inv. no. OA 9528

Cat. no. 44
Merahi metua no Tehamana
Tehamana has Many
Ancestors
1893
Oil on canvas, 76.3 x 54.3 cm,
W 497
The Art Institute of Chicago,
Bequest of Mr. and Mrs.
Charles Deering McCormick

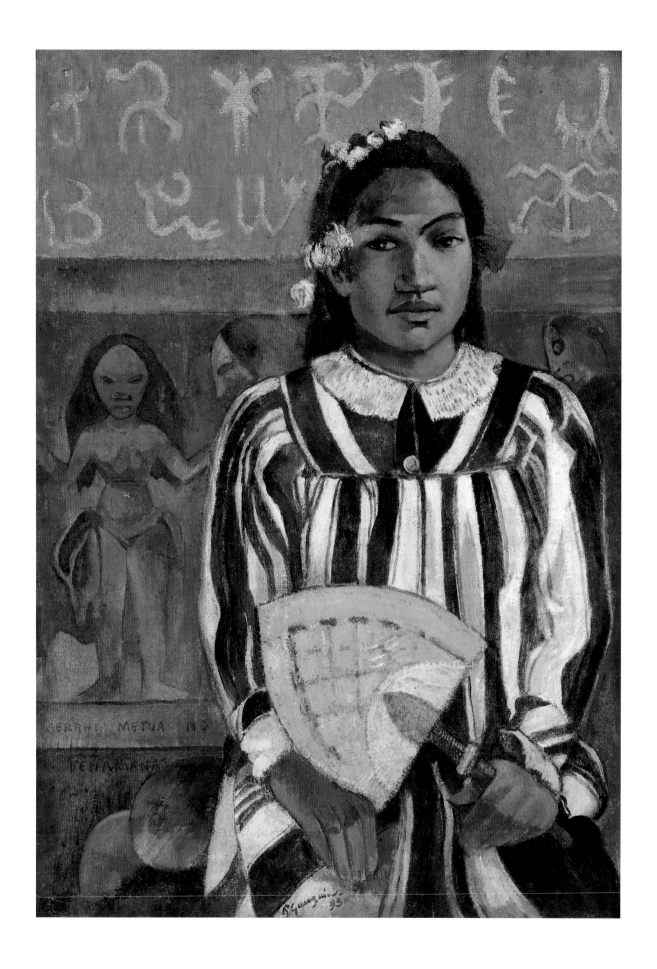

the picture *in* Tahiti it was not intended *for* Tahiti. Expressed more precisely, it did not "work" as art until it was presented to the broad public in Paris. There the substantive contradictions disappeared; they were overshadowed by the coherence of the overall composition and the beautiful colours that gave the painting its majestic aura.[46]

This "tendency to contextualise" is not evident in the earliest of Gauguin's Tahitian works and did not take on clear outlines until near the end of his stay. Ignorant of the actual sociological facts, Gauguin started out with mistaken notions, which he eventually corrected and incorporated into the aesthetic concept that took shape over the course of his sojourn.[47] His method can be described more precisely. The last paintings discussed above originated in a two-part alienation process. Gauguin made use of various different sources, some contemporary and a greater number of historical character (such as Moerenhout's book, which, it might be added, had already assumed literary status in its own right). It is possible to identify a level between the sources and the actual execution of the work of art that is best understood with reference to *Noa Noa*. As a work of literature, *Noa Noa* served as Gauguin's most important mediator. His paintings occupy a point in the spectrum between historical accuracy and free invention, although his art grew increasingly distant from reality as time passed. Because he was, as an artist, a creator of both literature and visual art, he exercised control over a creative process that one may refer to simply as alienation.

Another example may be useful by way of illustration. *Head of a Tahitian Woman (Portrait of Tehura)* (Cat. no. 45, 1892) is the title of a sculpture carved of dark wood depicting the head of a beautiful, exotic woman. To the smoothly polished surface Gauguin applied dark-green paint for the eyes, black for the hair and lips; the flower is gold-plated. The rear of the sculpture bears a representation of a nude woman in relief. The title is ambiguous. Is the work a portrait of Teha'amana or a stylised likeness of his literary heroine Tehura? Teha'amana was tall and looks quite corpulent in photographs. She had long, noticeably curly, unkempt-looking hair. Yet Gauguin's sculpture depicts an exotic beauty. Biographical information is available regarding another woman named Tehura, who posed for him as a model in 1891, and thus was hardly an invention.[48] Gauguin describes the Tehura of *Noa Noa* as beautiful, mysterious and knowing, and his *Head of a Tahitian Woman* (stylistically closer to being a European work than a truly South Sea sculpture) is similarly idealised.

Thus there is another level to be considered with respect to public expectations and the critical reception of Gauguin's work. Gauguin set himself the goal of undertaking "grand aesthetic endeavours" by living the life of a native in a primal civilisation. And nothing else was to be expected of a man whose origin had been described as an affinity with the exotic as early as 1891.[49] Although he had no impact upon the Paris art market during the two years of his absence, art critics had not lost sight of him for a moment. In his letters to Daniel de Monfreid he frequently discussed the necessity of winning over certain critics. The columnist for the *Mercure de France* was one of the few critics Gauguin felt he could rely upon, but with Albert Aurier's sudden death in 1892 one of the few sympathetic members of his profession passed away. Gauguin appeared to be on the verge of desperation, for he needed the press to publicise his paintings. Aurier's successor, Camille Mauclair, also belonged to the literary circle associated with Mallarmé but viewed avant-garde painters such as Pissarro, Cézanne or Toulouse-Lautrec with scepticism. He looked upon the travelling European in his island paradise with a curious but sceptical eye as well. The critic Charles Merki wrote the following comments in *Mercure de France* in a piece entitled "An

apology for painting": "This great carnival of painting, which has absolutely nothing to say for itself, takes a different shape in the case of Monsieur Gauguin. Monsieur Gauguin represents the art of Ideaism – or Symbolism, whatever one chooses to call it. Although his paint is not half an inch thick, his roughness is perhaps even more disturbing. It is said that Monsieur Gauguin imitates the art of the stained-glass window. That is a completely acceptable opinion, and it does no one any harm. A myriad of gingerbread men cavort in hyperbolic landscapes characterised by a savagery for which no perceptible phenomenon provides an excuse. Poses pregnant with meaning, plates of spinach, poorly drawn but full of great ideas, little Maxi's doodles on his notebook cover. Monsieur is presently at work painting negresses. One fine morning we shall meet him again holding a newly-filled bag of surprises, and then we shall speak of him."[50] The article illuminates the field of tension in which Gauguin was working in Tahiti. Some observers believed that he was studying the lifestyles and psychology of the natives in Tahiti, in the manner of an ethnologist,[51] others made derogatory comments about his inappropriate life as a "savage". What they could not know was that his "bag of surprises" was already nearly full to the brim. If we regard Gauguin's journey to Tahiti as an artistic project, we must also recognise the importance of a second venue – Paris.

Paris: The legend is born

During his entire stay in Tahiti Gauguin maintained contacts with Paris through extensive correspondence. When his wife Mette once again expressed her concern in March of 1892 that his journey was keeping him away from Paris and his public he responded: "You say it is wrong of me to stay away from the centre of the art world [meaning Paris] for such a long time. But no, it is the right thing for me to do. I have known for some time what I must do and why I must do it. My art world is in my head and nowhere else. I am strong because I am never drawn away from my path by others and because I do what is inside me."[52] He informed Mette in June of 1892 that he had painted more than forty pictures which he intended to send to her. He planned to wait and see how the Paris public responded to them. While still in Tahiti he wrote to Daniel de Monfreid on December 8th, 1892 on the subject of the scheduled presentation in Paris: "I have made a selection for the exhibition that should do justice to every taste – figures, landscape, nudity. I hope that it arrives in good condition."[53] And in April or May of 1893 he sent off another letter: "Many thanks for the paints. I still have some left and will not need anything more. I haven't worked for two months. I do nothing but observe and think and make sketches. Over a period of two years, of which only a few months were lost, I turned out thirty-six more or less good paintings and a few ultra-wild carvings. That is enough for one person."[54] The period from August 1892 to March 1893 witnessed the completion of a number of paintings viewed as among the most impressive works produced during his stay in Tahiti. Two main groups can be distinguished: those whose central motif consists of two women, shown sitting, and those in which the composition is dominated by a single standing figure. The first of these groups is represented by the *Words of the Devil* and *Tehamana has Many Ancestors* already mentioned above, the second by the following paintings: *What News?*, *When Will You Marry?* and *Women on the Beach.*

Gauguin sold *Women on the Beach*, (Cat. no. 46, 1891), to Charles Arnaud, who was serving in the French Foreign Legion on the island, primarily to finance his journey home. The painting was to be resold in France at the highest price obtainable. The composition is reproduced in the painting *What News?* (Cat. no. 47, 1892), sent by Gauguin to Copenhagen in 1893 to be exhibited. Both paintings are characterised by a striking immediacy, an effect achieved through the clarity of Gauguin's composition and the intersection of the figures by the edges of the paintings, a technique that adds a sense of the monumental to the intimacy of the scenes. Gauguin was enraged when he learned that *What News?* had been sold immediately upon its arrival there, since he needed it for the retrospective in Paris planned for after his return. *What News?* is not a counterpart to *Women on the Beach* but actually a replica of the earlier painting. One might see the workings of an economy of means in the repetition, if it were not for the fact that it represented the artist's aesthetic program. The paintings share the same "simplicity" – the frontal presentation of the central figure, to which a profile is added in some cases as a second motif. The element of portraiture is diminished, and the faces appear typed. The figures do not touch one another in any emotionally determinable sense but merely intersect or overlap as compositional elements. Circular segments play an important part in the pictorial structure, while acute angles are avoided. The colours are consistently radiant, light and luminous, without creating the effect of colourfulness, as contrasts involving secondary colours such as orange, pink, yellow, ochre, brown, rust-red, carmine red and turquoise dominate the whole. The colour fields are clearly delineated and form ornamental patterns. Virtually emblematic symbols of a seemingly paradisical existence emerge. Unlike the earlier paintings completed in 1891, none of the women depicted is engaged in any kind of activity. Apparently sufficient unto themselves, they sit on the ground as if waiting for some signal from without, and the title implies that the viewer could call out to them.

The most important of the figure paintings is Gauguin's *When Will You Marry?*, 1892 (Cat. no. 48), which covers a larger canvas than the previously mentioned pictures and was executed in vertical format. Two women dominate the scene. The one closer to the foreground, dressed in traditional garb, appears to be listening and looking out beyond the viewer. The figure to the rear, of which two-thirds are concealed by the other, is shown in a more classical pose and appears to observe the other woman. Gesturing with her right hand, she seems to call attention to something beyond the confines of the pictorial space.

The figures are remarkably different. The woman in the foreground crouches gracefully, while the other appears as an archaic version of the same type.[55] The spectrum of possible interpretations of this painting is especially broad, and it can come as no surprise that none of the solutions proposed is entirely convincing. Which of the two asks the question, what answer is to be expected, whether the women are intended as a dual personification of love (devotion and deliberate calculation) or whether the woman in the rear is revealing the secrets of love (with a gesture reminiscent of Buddha teaching) to the one in the foreground – an answer could be selected from this range of options, yet none of the interpretations is clearly the only possible and correct solution to the puzzle. Not even the gardenia at the ear, known as a *tiare* in Tahitian, is an allusion to anything specific, as this particular type of adornment was quite common. As already demonstrated at several points in the discussion, the titles affixed by Gauguin to his artworks are not keys to comprehension. They are references meant to evoke a pattern of association that does not conform completely to the

visible image and deliberately leaves interpretation in a state of suspension. Gauguin achieved this effect primarily through his use of formal resources, which he perfected in his figure paintings. The most significant characteristic of this specific painting is its mood, a harmonious synthesis of form and colour. *When Will You Marry?* is one of the few pictures from the first journey to Tahiti that achieves a positive effect from the outset. We know that Gauguin put a great deal of thought and effort into this composition, as a number of studies and draft sketches show. In contrast to the painting, the water-colour study for *When Will You Marry?* (Cat. no. 51) is a composition in horizontal format in which the two figures are drawn to the same scale and combined to form a motif that fills the entire painting surface. The composition of the painting evokes a greater sense of tension, as the woman in the foreground appears larger and dominant from the point of view of colour. The study for *Why Are You Jealous?* (Cat. no. 50) reveals a comparable technique; the figures are outlined in thin, continuous lines, and the entire composition is filled with colour. Of particular interest is the larger, squared study for *When Will You Marry?* (Cat. no. 49), which calls to mind the large, unfinished painting entitled *Tahitians Resting* (Cat. no. 18) and is recognisable as one of the rare direct preliminary studies by virtue of the visible squaring. It is likely that Gauguin often produced such rarely preserved original-sized drafts on paper for paintings he regarded as especially important.

These very well-known paintings of Gauguin's, which appear to form a part of a series, were actually not completed one after the other. They are variations without a fixed conceptual scheme, as a look at the readily interchangeable titles clearly indicates. The questions "What news?", "Where are you going?", "When will you marry?" and "Why are you jealous?" are both rhetorical and evocative, and all imply the presence of a (male?) viewer.[56] They could be posed by either side, by the exotic models or by viewers lured into their world, and yet they remain forever unanswered. In a simple but subtle way the titles conjure up fundamental themes of human existence: love, sexuality, jealousy, guilt, life and death, and are inexorably linked to the paradisical beauty in the painting, where all contradictions appear to be resolved. Paintings and titles suggest the perfect harmony that sublimates all unanswered and unanswerable questions.

Also worthy of note as masterpieces of the year 1892 are several paintings featuring multiple figures and substantial landscape segments, including *Where Are You Going?* (Cat. no. 52, 1892) and *Tehamana has Many Ancestors* (Cat. no. 44, 1892). *Where Are You Going?* is the subject of a misleading but highly informative interpretation which leads us to a point that is essential to an understanding of the critical reception of Gauguin's art. The painting shows a three-quarter view of a stately woman, nude from the waist up, holding an animal – perhaps a puppy – in front of her left hip. Two women are seen crouching on a tree-lined strip of grass. They appear to be intently observing and listening to something that is happening in the scene. The central field of focus is defined by a straw-thatched hut with its door standing barely ajar, behind which abundant vegetation is visible beneath a cloud-strewn blue sky. It is a painting built around a selected few memorable motifs. The interpretation begins with the unusual pose of the woman with the puppy, which she appears to be holding absent-mindedly. After his return to France Gauguin completed a clay sculpture with a remarkable resemblance to this motif, which he entitled *Oviri*. The figure is a wild-looking woman with strikingly rough, almost apelike features bearing a certain resemblance to a death's-head. She has long hair that hangs in a broad swath to her ankles and a remark-

ably powerful upper body. The unusual, bent-kneed posture gives her the appearance of being about to leap. "Oviri" was the epitome of savageness for Gauguin, and he imagined her as an archaic female figure with androgynous features, although it is interesting to note that he never commented on the details of her mythological origin and significance. The interpretation was provided by Charles Morice, who described her in a manner comprehensible to European viewers as "la Diane sauvage" in his book on Gauguin,[57] characterising her as a combination of Hina and an unidentifiable goddess of death. Although there was such a "goddess of the wild" in the Maohi religion, she played only a subordinate role and did not appear in personified form. The image associated with Gauguin's representation was an invention, or perhaps more precisely a European-influenced projection. Its actual source was *Noa Noa*, Gauguin's own literary fiction,[58] in which Oviri appears without explanation and shrouded in mystery. A comparison of Gauguin's Oviri with the other gods represented in his oeuvre reveals an affinity to Hina, although Oviri is assigned negative qualities, whereas Hina is a positive figure. Thus the young woman in *Where Are You Going?* can be seen as the monumental image of a messenger of death, in whose presence the two young women understandably show fear. Precisely because she was ultimately his own invention, Gauguin regarded her as an essential symbol of his art.[59] It was not his intent to expound upon an existing canon of interpretation in his work or to instruct his viewers. His conception of a new form of art encompassed enigma and even incomprehensibility. In the light of these facts one might reasonably ask whether a return to Paris with paintings like *Tehamana has Many Ancestors* or *Where Are You Going?* was not indeed a particularly risky undertaking.

Gauguin set foot on French soil again on August 30th, 1893. Upon arrival he proceeded to Paris, where he spent the following 22 months, virtually without interruption. At first glance this period appears to have been rather barren in terms of artistic production, for compared to his creative phase in Tahiti Gauguin completed only very few, albeit noteworthy paintings in Paris. He was concerned with other matters. He needed to publicise his paintings in Paris by making preparations for exhibitions, and his most important objective was to sell a large number of works as soon as possible, in order to repay his debts. His paintings, his sculptures and his writings from Tahiti were to be the basis and the beginning of a new phase of his career as an artist. The most important and extensive exhibition of his Tahiti paintings was scheduled for presentation at the Galerie Durand-Ruel in Paris. Before discussing this exhibition, however, it is appropriate to return for a moment to a significant aspect of his work – his literary activity in Tahiti. Gauguin – and this was not recognised until quite late – must be understood as both a painter and an author (and as an art writer and journalist).[60] Apart from his essay *Ancien culte mahorie*, which was based very closely upon the chapters "Religion" and "Culte" excerpted from Moerenhout's book, *Noa Noa* is without doubt the major literary work of his first sojourn in Tahiti.

The discussion of the historical origin of *Noa Noa* would be incomplete without reference, once again, to an individual who exercised a significant influence on the poet and visual artist Gauguin during these years – Charles Morice (1860–1919), a student of Mallarmé's whom Gauguin did not meet until 1890, that is, immediately prior to his departure for Tahiti. Twelve years younger than Gauguin and a complete admirer of his art, Morice served as the painter's Paris executor during his stay in Tahiti, a circumstance that occasionally generated tensions between the two men, particularly when payments

expected in Papeete did not arrive. Their relationship returned to normalcy soon after Gauguin's return. As a writer and reviewer, Morice served as a kind of multiplier for Gauguin's artistic concerns. The idea of calling the attention of the reading public to the sensational South Sea pictures through *Noa Noa* could not have been realised without Morice's help.[61] The original plan called for publication of *Noa Noa* immediately following Gauguin's return and in conjunction with a series of exhibitions in Paris and Copenhagen. "I am preparing a book about Tahiti", wrote Gauguin to Mette in October, "that will be very useful in helping people to understand my painting. How much work that all is! But I shall soon know whether or not it was a crazy idea to go to Tahiti."[62] Gauguin gave the manuscript for *Noa Noa* to Morice, who was to edit it for publication, in October or November 1893, but it was not until 1895 that the text could be considered ready to publish, and by that time Gauguin was already making preparations for his second journey to the South Pacific. Its initial publication in the journal *La Revue Blanche* in 1897 contained the changes Morice had made in the original manuscript.[63] In many places the writer replaced Gauguin's terse prose with more poetic passages, giving it a narrative character not fully achieved in the original – an editorial intervention that would have a significant effect on the history of Gauguin criticism. Even the very first manuscript of *Noa Noa* contained many oversimplifications with regard to matters of mythology, such as the world of Tahitian gods, which Gauguin reduced to a very few prominent divinities. Morice edited the text with the intent to give it a literary form not unlike that of contemporary exotic novels and did not hesitate to rewrite existing passages or add new ones, including the section in which Gauguin is initiated by the softly whispering Tehura into the world of Tahitian gods.[64] In the socalled Louvre Manuscript (the version of *Noa Noa* prepared by Gauguin and Morice) no secret is made of the true source: "Who created heaven and earth? Moerenhout and Tehamana gave me the answer... !".

It is worth emphasising again that *Noa Noa* was later mistakenly viewed as an objective travel account and frequently used as the sole source for interpretations of the Tahiti paintings. Gauguin's intention was for the text and the illustrations he had drawn, watercoloured or inserted himself to serve as a kind of manifesto placed on an equal footing with the paintings themselves. A comparison with the letters in which Gauguin described his circumstances in great detail has already shown how far removed *Noa Noa* was from the realities of Gauguin's daily life.[65] It should also be noted that literary travel accounts based upon diaries were not at all uncommon at the time. The publication of the diary of Eugène Delacroix, written during his travels in Africa during the 1830s,[66] caused quite an uproar during the same years. And there was a precedent for the hoped-for success of *Noa Noa* – the novel *Rarahu* by Pierre Loti, already cited above, which had popularised the island world of the South Sea. The biggest obstacle to publication was the manuscript itself. Gauguin's quite legible hand-written version was interspersed with so many water-colours, drawings and photographs that an authentic edition could not be produced with the means of reproduction available at the time. Thus Gauguin began in March of 1894 to make woodcuts that could be incorporated into a printed edition. He did ten aesthetically significant and technically innovative woodcuts for *Noa Noa*, which are discussed here by Christopher Conrad in the context of Gauguin's print oeuvre.

While Gauguin was still in Tahiti, Daniel de Monfreid and Charles Morice began making preparations for the artist's big appearance in Paris. The artistic fruits of his journey, the

new, unusual and indeed sensational paintings and writings, were to be presented to the public and to critical scrutiny immediately and, if possible, as a coherent whole. Within the first six months after his return Gauguin participated in half a dozen exhibitions. Of these, two solo exhibitions of his Tahiti paintings are particularly noteworthy, one at the Galerie Durand-Ruel in November, entitled "Exposition d'œuvres récentes de Paul Gauguin" and another organised by Gauguin himself in his studio a year later. Aside from the show at the Galerie Durand-Ruel, Gauguin was also present at two exhibitions hosted by the Galerie Le Barc de Boutteville and at the newly-opened Galerie of Ambroise Vollard, where he showed early works beginning in December. An exhibition of works by artists of the group known as "La Libre Esthétique" was opened in Brussels in February 1894, and Gauguin participated with five of his Tahiti paintings. Let us begin with the Durand-Ruel exhibition, however. The art dealer Paul Durand-Ruel had established contacts with all of the noteworthy contemporary painters. During Gauguin's stay in Tahiti his gallery had presented retrospective exhibitions of Camille Pissarro, Claude Monet and Auguste Renoir which had attracted considerable attention in the press. Durand-Ruel was undoubtedly one of the best addresses, and it was no secret that the gallery's popularity meant money in the bank for an artist. Not least important was the fact that many museums, most notably the Gallery of the Palais de Luxembourg, purchased works for their collections from Durand-Ruel. In order to ensure that he would have enough paintings, Gauguin wrote to his wife Mette, asking her to send him the South Sea pieces in her possession in Copenhagen.[67] He prepared 55 canvases, some of which had not been stretched and fitted, and had them framed with simple, white-painted slats. The largest section of the exhibition, some 41 paintings in all, comprised works from Tahiti. Three of the other works had been done in Brittany. Selling prices ranged from 1000 to 4000 francs.[68] Gauguin knew that he would have to show a considerable number of the Tahiti pictures in order to lend weight to his appearance and to communicate an overpowering impression of his new art from an exotic world.[69] The retrospective was opened on November 11th, 1893, a mere twelve weeks after his arrival in Marseille. Gauguin's paintings had arrived. The brilliant savage was back.

"I have made a selection for the exhibition that should do justice to every taste – figures, landscape, nudity." He had written this sentence, already cited above, to de Monfreid. In view of the large number of works completed in Tahiti a favourable prognosis appeared justified for the project. Nevertheless, neither Gauguin nor his critic friends could be certain that the exhibition would be as successful as they hoped. One problem was the matter of getting the strange themes and titles across to the viewers, as Gauguin's original plan to have an edition of *Noa Noa* appear in conjunction with the exhibition could not be realised in such a short time. Thus the catalogue for the Durand-Ruel exhibition took on even greater importance. Gauguin needed a literary context in which to embed his paintings for a public exhibition. This task, which he could not perform himself, was carried out by a trusted ally: Charles Morice wrote the foreword for the catalogue. "From the luminous coasts of Tahiti, from the midst of this population of fishing folk, which in the undeniable opulence of a nature at once ancient and very youthful dreams only terrifying myths – a fact it stoically accepts – myths from time immemorial, myths of perpetual renewal, from there Gauguin set forth for the interior of the island. He reached the river of the Aroal, the mountain that touches the heavens, and he saw the beautiful, lusty moon rising, saw it kiss the summit of the raw earth that lay in the darkness of eventide."[70] Morice used poetic rhet-

oric in describing fictitious impressions of paradisical island geography, smoothly interwoven with mysterious myths, to his readers. Morice was not even lying when he described it in a single breath as ancient and youthful at once. One finds here the same archetypal patterns evident in Gauguin's paintings, in which mountain, river and sky were imbued with an indeterminate, exotic, symbolic power as fundamental motifs. At the same time, the phrase "lusty moon" evokes an audible erotic undertone that is also evident in the figure paintings.

Soon, a heated discussion of Gauguin's Tahiti paintings had begun. The level at which it was pursued testifies to the remarkable, perhaps even unique character of French art criticism. The first impression appeared to confirm what was already known in Paris about the distant colony, especially as the paintings expressed themselves primarily through their exotic themes and colours. In an article for the journal *La Revue Blanche* in December 1893, Thadée Natanson wrote: "With their radiant light and their more or less simplified forms, many of the landscapes testify eloquently to the luminous and voluptuous appeal of the fairy-tale world of this land that resembles a dream with the colours of its sunrises and sunsets; all of this, these houses and gardens, is expressed in the rich magnificence of this vegetation, these rivers and streams. Flowers, springs, pebbles and branches are rendered with delicate, graceful detail, without disturbing the impressive diversity of the ensemble."[71]

François Thiébault-Sisson, a writer for the journal *Le Temps* and one of the more sceptical reviewers, reacted quite differently: "If he could only bring himself to paint from nature, instead of deforming it, what grand paintings he could paint! Think of the magnificent pictures he painted while he was still content to look at his models without ulterior motives and depict in complete simplicity what he saw. Why must we find such formless things alongside wonderfully drawn and shaped figures such as his young women at the seaside and his tasteful portrait of a woman. Why has the artist so forgotten himself that he can see in both the Tahitian woman of today and the Tahitian woman of prehistoric times only an ape of the female sex?"[72]

Despite their differing standpoints, both quotations reflect an essential feature of the critical reception of Gauguin's South Sea art in general: a selective view. The ambiguous iconography and the lack of traditional patterns of interpretation that would explain its meaning engendered an emotional response based upon pre-determined aesthetic categories. With rhetorical adeptness, Morice played upon the prejudices of the viewer: "... what Gauguin did was looked upon as a bit scandalous, as a huge mistake. Gauguin was not looking for spiritual renewal in "new themes" ... he is annoyed by our habits, our prejudices, our conventions in art and in everything else, and he is annoyed by our conception of mimesis,[73] which puts painting, in particular, in chains. He wishes to find his own poetry and his own expression. ... And that is why his quest has taken him so far away: to allow him to forget us and to find the true purpose and meaning of his art. ... Truly, these paintings (how can one fail to be happy there?) are like rites from the religion of joy!"[74] This pathetic formulation was perhaps the editor's most cunning and consequential effort. To elevate the artist Gauguin to the rank of a founder and representative of a "religion of joy" was to raise his paintings to the status of evidence, to present them as the colourful reflection of an emotional exuberance that extended from blind abandon to ecstatic intoxication. Gauguin was portrayed as a man predestined, a painter who had sought and achieved a complete synthesis of wish and reality. "The call of Tahiti was heard by the painter in Gauguin and by the poet, by the poet and by the sculptor. He found his way back to the land of his dreams. But

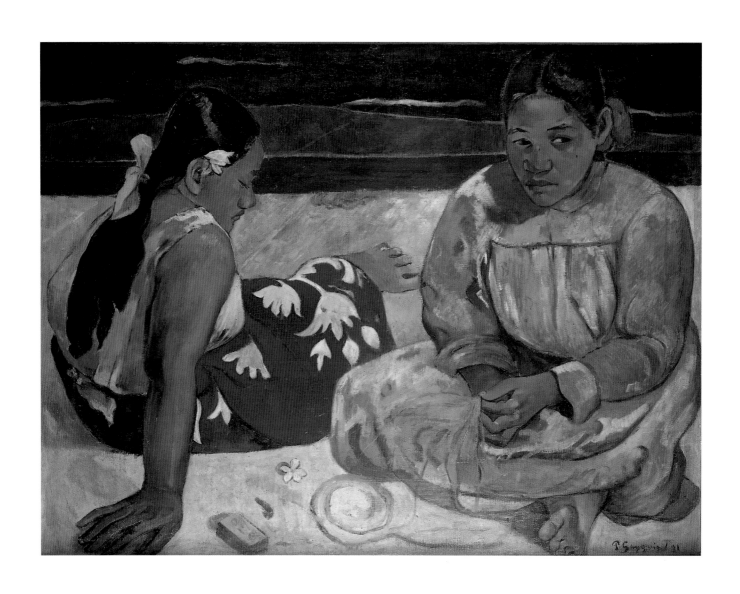

Cat. no. 46
Women on the Beach
1891
Oil on canvas, 69 x 91 cm,
W 434
Musée d'Orsay, Paris, Legs du
comte Guy de Cholet, 1923,
Inv. no. RF 2765

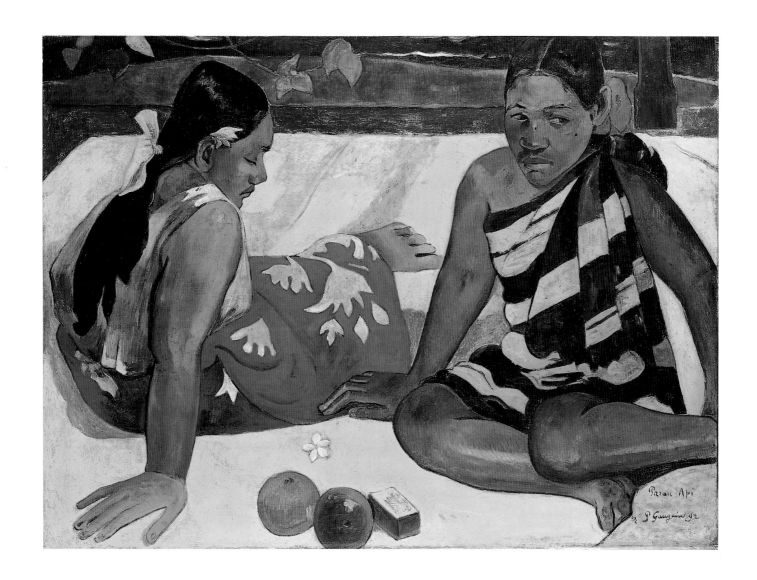

Cat. no. 47
Parau api
What News?
1892
Oil on canvas, 67 x 91 cm,
W 466
Staatliche Kunstsammlungen
Dresden, Gemäldegalerie
Neue Meister, Inv. no. 2610

Cat. no. 48
Nafea faa ipoipo
When Will You Marry?
1892
Oil on canvas, 105 x 77.5 cm,
W 454
Rudolf Staechelin'sche
Familienstiftung, Basle

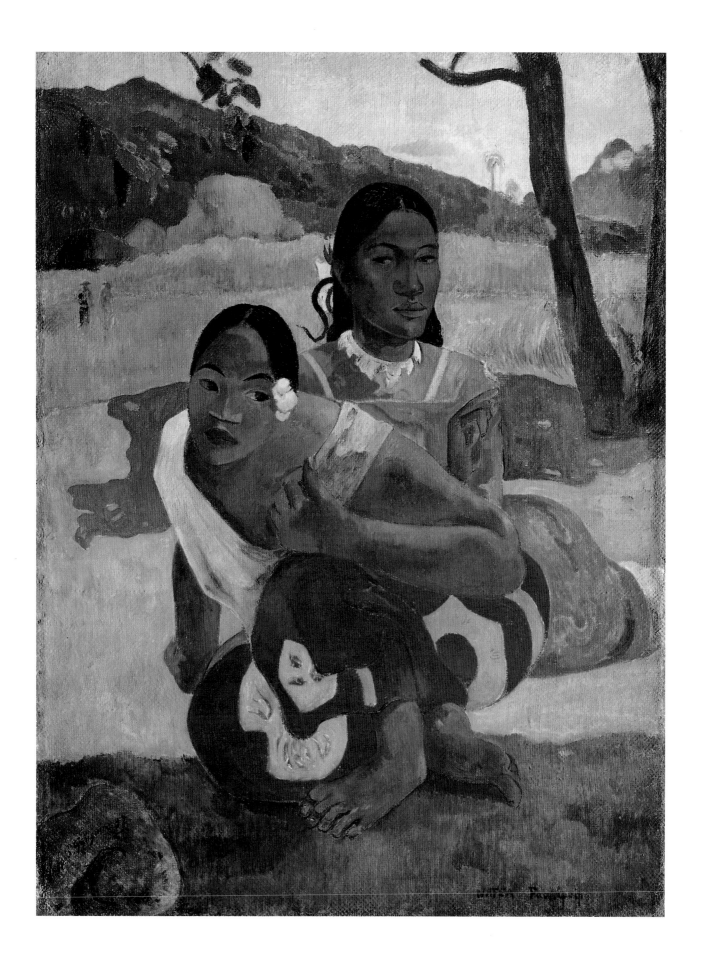

Cat. no. 50
Study for "Aha oe feii"
Why Are You Jealous?
1894
Monotype in water-colours,
partially raised with brush in
water-colours, brown ink and
white chalk, 19.5 x 24.2 cm
Edward McCormick Blair,
Inv. no. RX 16171/2r

Cat. no. 51
Study for "Nafea faa ipoipo"
When Will You Marry?
Water-colour and pen in black
over pencil, 13 x 15.9 cm
Private collection

Cat. no. 49
front: Crouching Tahitian
Woman, study for "Nafea
faa ipoipo"
When Will You Marry?
1892
Double-sided drawing, pastel
chalk and charcoal, partially
wiped, squared, 55.5 x 48 cm
The Art Institute of Chicago,
Gift of Tiffany and Margaret
Blake, Inv. no. 1944.578

Cat. no. 52
E haere oe i hia
Where Are You Going?
1892
Oil on canvas, 96 x 69 cm,
W 478
Staatsgalerie Stuttgart,
Inv. no. 3065

73

Cat. no. 53
Self-Portrait with Palette
circa 1894
Oil on canvas, 92 x 73 cm,
W 410
Private collection

75

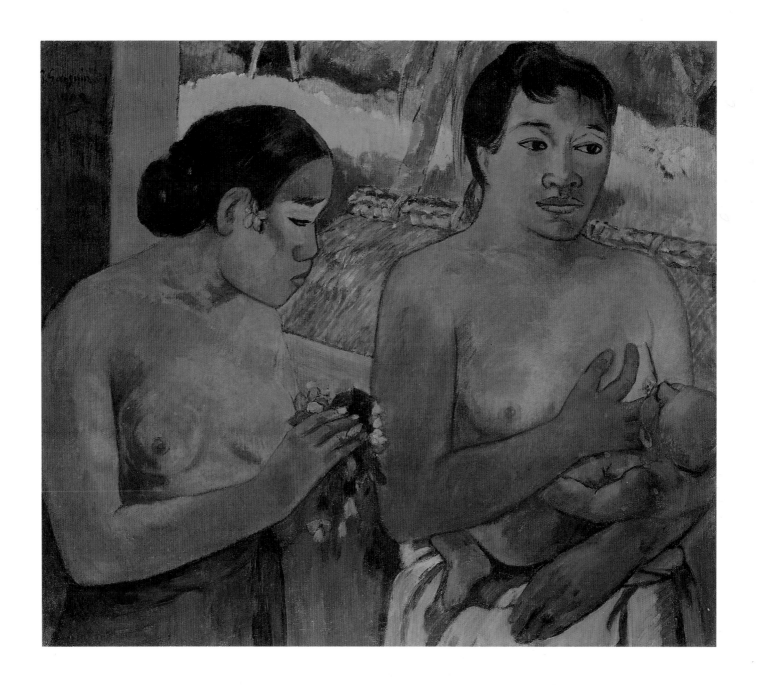

Cat. no. 54
The Sacrifice
1902
Oil on canvas, 68 x 78 cm,
W 624
Stiftung Sammlung Emil G.
Bührle, Zurich

Cat. no. 55
Two Tahitian Women
1899
Oil on canvas, 94 x 73 cm,
W 583
The Metropolitan Museum of
Art, New York, Gift of William
Church Osborn, 1949

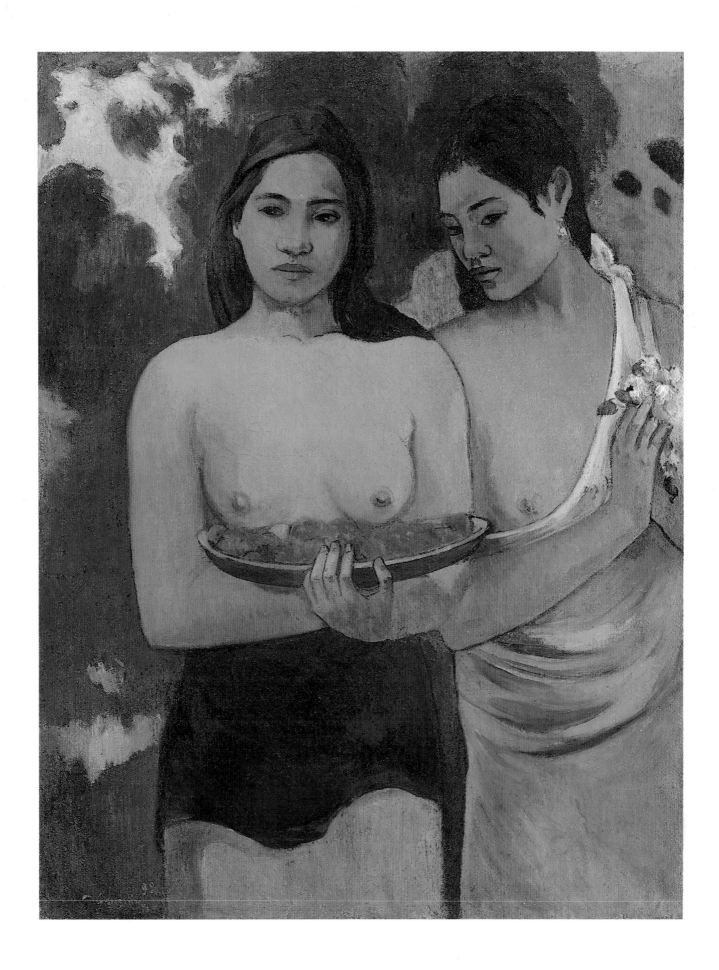

he did not arrive there with a naked soul! ... Yet his works would be a poor signpost to the islands, were their soul and his not related. Do you believe you would see Hina and Tefatou just as he did? He shows you a race, a religion, whose roots lie far away and which are developed to the point at which they lead to the infancy of Christianity – a race, a religion, a world – and an oeuvre! Where else will you find anything like it? Where else will you find the places where your view of things and his converge?"[75] Thus it soon became clear what the selective eye of the public would choose from among the large number of works. Those in which the illusion of exotic paradise shined brightest found favour, while "peintre sauvage" was rejected. The modernity of his art, the aspect Gauguin had expressly designated as his highest goal, was in danger of being discredited in consequence of this selective recognition. Morice attempted to present the artist as a misunderstood figure exposed without defence to the arrogant prejudices of the Paris public. In *Mercure de France* he published a reply to Thiébault-Sisson in December 1893: "The painter and the poet have unveiled their idea of the infinite Try, if you will, to rediscover in objective nature the landscape in which Gauguin saw only his thoughts! And then go to Tahiti, you photographers, with your sensitive plates: one may presume that the sun will not reveal to you what it has shown this painter ..."[76] The comparison with photography, which was both modern and very popular, is revealing in two ways. It betrays knowledge of the real conditions that prevailed on the island, including the consequences of colonialism, which had nearly wiped out the original culture. And it enhanced Gauguin's position as an artist capable of creating something that was more perfect than reality. Indeed it was this comparison that first revealed the paradise represented by Gauguin's art to the eyes of viewers. At the same time that paradise showed itself to be an aesthetic construction, in the building of which Gauguin was as actively involved as his critics. The art critics were, in a sense, the designers of the artist-legend; the artist had created the masterpieces without which their design would have remained a hollow framework.

The debate cooled in early 1894. In May, Julien Lerclercq wrote in the *Mercure de France*: "Those who reject Gauguin cite three arguments against him: his ignorance, his extravagance and his barbarity."

"His ignorance ... It may be that he is ignorant, he, who *does what he can and knows what he wants,* and who employs only those elements in his work that he has carefully chosen from among many others!"

"His extravagance ... All one need do is look at his works in Brussels alongside those of the painters of 'La Libre Esthétique', and one can retract that mistaken judgement. It is no more extravagant than the work of Poussain, and it is just as well conceived, just as earnest and radiates similarly luminous colours."

"His barbarity? ... No, I prefer to describe his Tahitian landscapes as peaceful, joyful and graceful."[77] As this last appraisal demonstrates, the expectations entertained by critics with respect to Gauguin's undertaking conformed for the most part with the artistic outcome. Gauguin was very satisfied with the journalistic response to the exhibition of his Tahiti paintings at the Galerie Durand-Ruel: "The most important thing is that my exhibition has been an immense artistic success and that it provoked equal degrees of both passion and jealousy. The press has treated me like no one else before and, to be quite objective, devoted expressions of eulogy to me. I am now considered by many the most important contemporary painter."[78]

Although the Durand-Ruel exhibition was not a financial success (only eleven paintings were sold), it brought him the most important public relations success of his career. Intent upon prolonging and promoting the debate about his art, he began preparations for a studio exhibition scheduled for December 1894. It was a course of action that attracted great attention, since it was ordinarily the galleries that brought in the public. Gauguin wrote an article of his own, in which he encouraged the Paris public to visit his studio. He had rented spacious rooms at 11 Rue Vercingétorix and furnished them at considerable expense. A portion of the well-lighted studio was painted in olive-green and luminous chrome-yellow. There he displayed the unsold works left over from the Durand-Ruel exhibition, complemented by additional South Sea paintings, the collection of ethnological art put together by his uncle Zizi and paintings by artist friends, including Cézanne and van Gogh, from his own collection.[79]

The art dealer Ambroise Vollard later recalled his first impressions: "Based upon the decrepit appearance of the house in which the artist's studio was located, one would have thought it was no more than a barn. But upon entering it one had the illusion of being inside a palace. This wonder was accomplished by the paintings with which he had covered his walls."[80] The studio was furnished with exotic, old furniture and brightly coloured carpets, and Gauguin received guests as in a commercial gallery. Beginning in January 1893, friends regularly attended a *jour fixe* on Thursday evenings, at which he read passages from *Noa Noa* and presented lectures on his art and his journey to Tahiti. With the resumption of his own visits to the *jour fixe* organised by Mallarmé on Tuesday evenings, he accomplished a re-entry into what was probably the most sophisticated intellectual circle in the city. In 1894 Delaroche wrote the following remarks regarding the studio exhibition in the journal *L'Ermitage*: "Gauguin appears to have gained a better grasp than any other of the importance of suggestive pictorial design. His method is characterised in particular by a simplification of line, by a synthesising of sense impressions. Each of his paintings is a general idea, yet he does not take the external realities of forms so seriously that one could mistake it for a mere likeness. There is no work of art anywhere that more clearly reveals the relationship – as Baudelaire expressed it so precisely – between the soul and the landscape. When Gauguin wishes to show us jealousy, he does so with a bonfire of pinks and violets, as if all nature were a willing and silent accomplice."[81] The term "suggestive pictorial design" provides a capsule description of the specific effect of Gauguin's South Sea art that has remained virulently valid to this day. Gauguin was clearly aware that he needed to exploit the attention being given to his art in the interest of his own individual position among the many artists of Paris as well. "Seeing the tall, broad-shouldered figure with the arrogant expression on his face, a fur cap on his head, his coat thrown over his shoulders and followed by a small, half-Javanese woman in brightly coloured garments, one might have mistaken Gauguin for an oriental prince," as Ambroise Vollard recalled his encounter with the artist during those months.[82] Gauguin painted a *Self-Portrait with Palette* (Cat. no. 53) in Paris that contrasts strongly with Vollard's description. Remarkably, the painter did not present himself in his new role as a celebrity, as if his spectacular reappearance had had no effect on Gauguin, the person.

It is clear even at first glance that the painting has nothing in common with the exotic display of colour that had characterised his most recent works, although the colours of his Tahiti pictures appear as a reflection on his palette. The woollen coat and the fur cap emphasise the cold winter temperature of the studio, which had no heating. Gauguin suf-

fered spells of depression because, as he wrote to Mette, he "could no longer go about unclothed and had to stay in heated rooms",[83] and because the effects of his strenuous journey on his health now expressed themselves in a condition of severe physical weakness. Of particular interest is the signature: "A Ch. Morice de son ami P.Go." Gauguin affixed specific dedications to only a very few works, and his dedication of a self-portrait with painting utensils to his friend is evidence of his exceptional esteem. Morice had done Gauguin an invaluable service. His sensitive, supportive and sometimes polemical texts, by virtue of both the beauty of their prose and the author's adept placement of them in journals and catalogues, were probably the most important part of his campaign to further Gauguin's intentions. It is significant that Gauguin did not present himself as the painter-prince of an exotic territory but portrayed himself instead, as in the period before his journey, in a simple pose, his sceptical gaze turned towards the viewer. Gauguin revealed to Morice a side of his personality that he increasingly sought to conceal from the public. On the street, in cafés and in his studio he played the role of the self-assured, arrogant eccentric. This public identity, half self-determined, half imposed by the outside world, is subjected in the self-portrait for his friend to a process of splitting that aptly characterises Gauguin's own inner condition. He now regarded himself as a "wanderer between worlds".

Paul Gauguin had reason to be satisfied. The journey, ultimately an organisational and financial fiasco, had turned after the fact into an artistic success, the duration and effects of which could not yet have been foreseen in 1893. In the eyes of the public Gauguin had accomplished everything he had intended and found what he had been seeking: the hut on the beach, the beautiful native woman at his side, an original, unspoiled nature – the wilderness that had given him refuge for a while and then set him free. The evidence was available to anyone who cared to read his works. With a certain degree of hindsight, Morice recalled the 1893 exhibition: "In the spacious gallery, where the walls were aflame with the visions of his paintings, he stood observing the people, listening to them. Soon he was certain: none of them understood him. That was the final break between him and Paris. All of his great plans had failed, and what was perhaps the hardest blow for this proud man: he was compelled to admit that he had crafted his plans poorly. Had he not seen himself as the prophet who, misunderstood by the philistines who had failed to realise that they should bow before him, takes his leave to find a new perspective, only to return again greater than ever before?"[84] This sentimental recollection, written after Gauguin's death, reveals an aspect of the artist-legend that appears towards the end of these remarks but actually represents the introduction to the next chapter. Gauguin had not, as originally announced, remained forever in the South Pacific but had returned, and his return had proven to be an important ingredient in his artistic concept, a concept that had taken on increasingly clear contours during his stay in Tahiti. The focus of his activities had shifted following his return, although it must be remembered that he completed the greater portion of his prints in Paris, including the woodcuts for *Noa Noa*, which were the centrepiece of his graphic oeuvre. Yet as a painter he was nowhere as productive as he had been in Tahiti. Gauguin's dissatisfaction with his material situation, which success had not improved, combined with his disappointment in face of the realisation that his paintings were not selling, in spite of the recognition he had gained. He assessed the restraint exhibited by potential purchasers as ignorance, angrily posing the question: "Don't these people understand anything at all. Is it too brilliant for these excessively intelligent, over-refined Parisians?"[85] He complained

to Durand-Ruel in January 1895 that he could not work with the same intensity in Paris and was therefore planning to go to the South Pacific again for some years to perfect his art. Somewhat later he wrote to Paul Sérusier, stating that he had resolved not to return to Europe again. Gauguin left Paris in July 1895 after having lived there for 21 months. He landed in Tahiti on September 9th. He lived out the remainder of his life in Tahiti and on the island of Hiva Oa in the Marquesas, where he died on May 8th, 1903.

The sense of finality with which Gauguin departed from France in 1895 accounts for the primary difference between his second journey and his first sojourn in Tahiti from 1891 to 1893. His first "escape" had been a part of his artistic concept, which in turn had also (despite his somewhat melodramatic announcements that he would never come back again) involved his return to Paris. To be precise, then, only the first stay in Tahiti can truly be viewed as a journey. The second period beginning in 1895, on the other hand, is not to be understood as a journey but as a phase of his life preceded by a dramatic caesura. His post-1895 paintings can be distinguished from the works done between 1891 and 1893 on the basis of their underlying mood of melancholy and the evidence of Gauguin's return to a symbolic pictorial language. One of his last paintings, *The Sacrifice* (Cat. no. 54, 1902), shows two women in an upper interior room of a simple house. The woman on the right is nursing an infant; the woman on the left holds flowers in her folded hands, posing in an attitude of humility. The attempt to identify the authentic setting and the occasion for the painting leads only to puzzling revelations.[86] With the exception of Gauguin's studio and the local church, no such upper rooms existed where Gauguin lived. The room in the scene may be intended to represent his studio, where the sacrifice is offered. Yet the ritual itself cannot be traced to any existing original religious procedure. It does not matter whether Gauguin actually saw the scene with his own eyes or imagined it entirely, for he was no longer concerned with depicting exotic reality. The work itself is as uncommunicative as the two women it portrays. It has no pictorial language in the traditional sense. Even in earlier paintings one senses that Gauguin had gradually eliminated communication from his art. The titles pose questions left unanswered by the pictures: Where?, Why?, Who are you?. The works themselves are metaphors for unanswered, unanswerable questions. *Two Tahitian Women* (Cat. no. 55, 1899), provides perhaps the most impressive evidence of the distance Gauguin eventually achieved from the landscapes of 1891 and the lasting influence the figure paintings of 1892 were to have upon his art. An eerie silence spreads over these melancholy later paintings. The woman closer to the foreground brings a sacrifice of blossoms or fruits in a bowl. The second woman, also unclothed, appears to whisper to her and to listen at the same time (her left ear is emphasised by the presence of a gold-coloured earring), although no hint is given as to the substance of this barely perceptible exchange. As was the case in the 1892 paintings, Gauguin apparently intended to negate all of the preconceived criteria for interpretation in order to achieve an autonomy of content. He accomplished, in these paintings, the objective of a process of development as an artist that was outwardly characterised by breaks and discrepancies yet ultimately reveals a remarkable inner consistency. The journey to Tahiti, including its background and its consequences, stands out as the most decisive event in Paul Gauguin's life. It is inseparably linked to the history of the growth of an exemplary artist-legend and is the reason for the unabating popularity of this great artist.

1 Gauguin 1984, No. 139 and p. 472, footnote 239.

2 See the essay by Christopher Conrad.

3 In a letter to Emile Bernard in April or May 1890; Malingue 1949, CII.

4 Rewald 1956, p. 290. In the course of my research I clearly realised what a huge contribution John Rewald has made to an objective assessment of Paul Gauguin in his books.

5 See W 366.

6 Rewald 1956, p. 296, shows a photograph of the guest room. Gauguin was accompanied by Meyer de Haan and Sérusier.

7 Dina Sonntag discusses the Symbolist-style figural paintings of this period in her essay.

8 The remark is attributed to G.-Albert Aurier; see Bismarck 1992, p. 157. The dissertation by Beatrice von Bismarck is presently the most comprehensive study available of the reception of Gauguin's work among French art critics.

9 The sculpture shown in the painting is the *Statuette of a Woman from Martinique*, circa 1889, wax, height 20 cm; Gray 1963, No. 61.

10 In a letter to Odilon Redon im September 1890; Bacou 1960, p. 193.

11 Malingue 1949, XCII.

12 Gauguin describes his mother in his book of reminiscences "Avant et après" (1923, p. 138).

13 This information was kindly provided by Victor Merlhès. This previously discovered fact explains the poor quality of the original, which was reproduced many times.

14 Malingue 1960, pp. 103 f.

15 Malingue 1949, CV.

16 Cited from Field 1977, p. 10.

17 Rewald 1956, p. 485.

18 The precise date of arrival is uncertain and is variously given as somewhere between June 4th and June 9th, 1891; see also Nicholas Wadley, Gauguin 1985, p. 65, footnote 2.

19 Gauguin 1920, pp. 1–2.

20 See the essay by Ingrid Heermann for a discussion of the actual social circumstances.

21 In the Tahitian language, "Teha'amana" means "giver of strength"; see Danielsson 1965, p. 119. Gauguin uses the spelling "Tehamana" in his titles. The name has been changed to "Tehura" in the Louvre Manuscript of *Noa Noa*.

22 Gauguin 1960, p. II.

23 Field thoroughly researched and described this method in 1977. Most of the more recent investigations into the interrelationship between photography and painting in Gauguin's work refer to his study.

24 Ginies 1941.

25 Paul Sérusier, *ABC de la Peinture. Correspondance*, Paris, 1950, pp. 53–54; cited from Rewald 1956, p. 497.

26 Field 1977, p. 311, No. 6.

27 Field 1977, pp. 40ff. refers to the pictorial source of the man with the horse.

28 Field 1977, pp. 74–75.

29 Malingue 1949, CXXIX.

30 Cited from Thomson 1993, p. 179.

31 See the painting entitled *Matamua - Autrefois* (Time Passes On), W 467, Thyssen-Bornemisza Collection, Madrid.

32 Cited from Prather/Stuckey 1994, p. 180. The very useful book by Marla Prather and Charles Stuckey, cited here a number of times, contains a compendium of sources, including written statements by Gauguin as well as (even more informative) remarks about him and critical pieces concerning his art.

33 Cited from Berger 1978, p. 13.

34 Gray 1963, pp. 56ff.

35 Field 1977, p. 284, No. 12.

36 Charles Stuckey compares this so-called Hirshhorn Cylinder with the sculpture entitled *Hina and Te Fatu*, which is discussed below; see exhib. cat. Chicago/Washington 1988, Cat. nos. 139 and 140.

37 Gray 1963, p. 220; Amishai-Maisels 1985, p. 374.

38 In exhib. cat. Chicago/Washington 1988, p. 254, No. 140.

39 Cited from Gauguin 1951, p. 13. A similar dialogue also takes place in *Noa Noa* (Louvre MS, 88). With respect to the actual source see Gauguin 1985, p. 76, footnote 48.

40 Teilhet-Fisk 1983, pp. 80–81.

41 Charles Stuckey has presented approaches to and results of interpretation in his catalogue essay for the 1988 retrospective exhibition; see exhib. cat. Chicago/Washington 1988, Cat. no. 147.

42 The figure also appears in the woodcut illustration *Te po* (Cat. no. 78) done by Gauguin for *Noa Noa*; see the essay by Christopher Conrad.

43 Cited from Stuckey, in exhib. cat. Chicago/Washington 1988, p. 267.

44 See exhib. cat. Chicago/Washington 1988, No. 134, pp. 241–242.

45 Wildenstein 428; see exhib. cat. Chicago/Washington 1988, No. 135.

46 Gauguin later wrote in his notes regarding Tehamana: "This Tahitian Eve is not just any little Rarahu listening to a pretty ballad by Pierre Loti …", an allusion to *Le Mariage de Loti*, a book that was popular for quite some time; see Eisenman 1997, p. 71.

47 Paradigmatic is the painting *Te fare hymenee* (The House of Song), which Field (1977, p. 84) therefore dates during the period between December 1891 and January 1892.

48 See Stuckey 1988, p. 212.

49 Bismarck 1992, p. 172.

50 Merki 1893; cited from Prather/Stuckey 1994, p. 204.

51 This view is defended by Beatrice von Bismarck in her dissertation and supported on the basis of numerous source texts by contemporary art critics; see Bismarck 1995, p. 172.

52 Malingue 1949, CXXVIII.

53 Gauguin 1920, p. 11.

54 Gauguin 1920, p. 21.

55 Field provides a résumé of the interpretation of the figure to the rear as an "alter ego", Field 1977, p. 135 and footnote 68. It is not particularly convincing.

56 Field 1977, p. 132, refers to this group as "question-pictures".

57 See Inboden 1978, pp. 87–90.

58 Danielsson 1964 pp. 115ff.

59 He wanted to have the sculpture placed as decoration on his grave; a self-portrait relief is entitled *Oviri*; Inboden 1978, p. 88.

60 Gudrun Inboden has discussed this matter in detail in her 1978 dissertation.

61 See Gauguin 1985, pp. 100ff.: Nicholas Wadley, "The collaboration with Morice" (on the writing and editing of *Noa Noa*). After 1910 Morice attempted to establish that his share of the effort had been greater than Gauguin's. *Noa Noa* 1891/1893 (revised 1897) first appeared in excerpts in *La Revue Blanche* (Vol. XIV, No. 105, October 15ᵗʰ, 1897, pp. 81–103; No. 106, November 1ˢᵗ, 1897, pp. 166–190).

62 Thomson 1993, p. 185.

63 André Balland, in the commentary for his edition of *Noa Noa*, indicates the changes made in Gauguin's manuscript for the version edited by Morice; see Gauguin 1966, pp. 108ff.

64 Nicholas Wadley in Gauguin 1985, p. 111.

65 Danielsson 1975, p. 142.

66 Gauguin must have become familiar with the original much before this time, as he did a drawing based upon one of Delacroix's African women in 1884; see Wildenstein 27.

67 Malingue 1949, CXXXVIII.

68 The library of the Metropolitan Museum possesses a copy of the catalogue containing hand-written price notations.

69 Richard Brettell in exhib. cat. Chicago/Washington 1988, p. 301.

70 Charles Morice, "Expositions d'Œuvres récentes de Paul Gauguin, préface". November 1893; cited from Prather/Stuckey 1994, p. 206.

71 Thadée Natanson, "New Works by Paul Gauguin", in *La Revue Blanche*, December 1893; cited from Prather/Stuckey 1994, p. 225.

72 Thiébault-Sisson 1893; cited from Prather/Stuckey 1994, p. 218.

73 The word "mimesis" refers to the imitation of nature in art.

74 Charles Morice, "Expositions d'Œuvres récentes de Paul Gauguin, préface", November 1893; cited from Prather/Stuckey 1994, p. 208.

75 Ibid. p. 217.

76 Charles Morice in connection with the Durand-Ruel exhibition, in *Mercure de France*, December 1893; cited from Prather/Stuckey 1994, p. 221.

77 Julien Leclercq, "On Painting", in *Mercure de France*, May 1894; cited from Prather/Stuckey 1994, p. 227. The artists' group "La Libre Esthétique" in Brussels was an offshoot of the society known as "Les XX"; see exhib. cat. Liège 1994. Danielsson 1975, p. 152, referred to Leclerq in connection with the 1894 studio exhibition as "Gauguin's shadow".

78 Malingue 1949, CXLV.

79 Vollard 1937; cited from the German edition, Zurich, 1957, p.196.

80 Vollard 1937; cited from the German edition, Zurich 1957, p.169.

81 Achille Delaroche, "On Paul Gauguin's Painting", in *L'Ermitage*, 1894. Cited from Prather/Stuckey 1994, p. 228.

82 Vollard 1937; cited from the German edition, Zurich, 1957, p. 168.

83 Thomson 1993, p. 187.

84 Charles Morice, "Paul Gauguin: On the Tahiti Exhibition" (1919); cited from Prather/Stuckey 1994, p. 205.

85 Cited from Gauguin 1978, p. 137.

86 Richard Brettell in exhib. cat. Chicago/Washington 1988, pp. 478–479, Cat. no. 267.

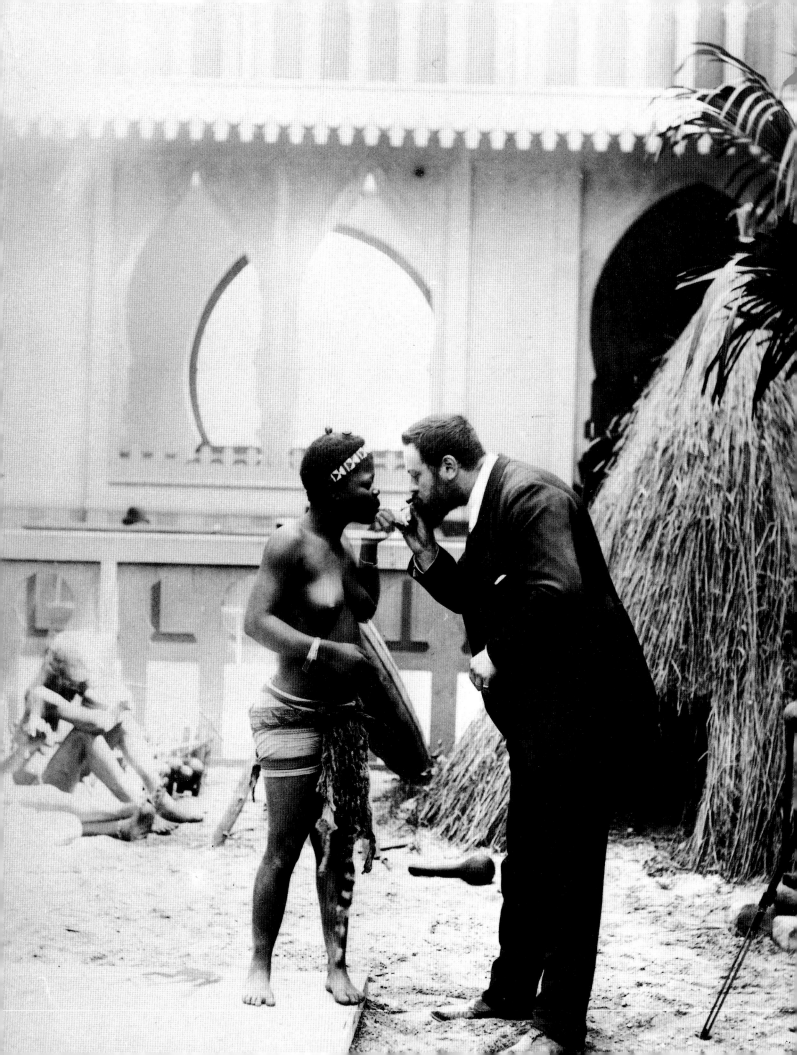

PRELUDE TO TAHITI:
GAUGUIN IN PARIS, BRITTANY AND MARTINIQUE

Dina Sonntag

> "Goupil in Paris is showing an exhibition of my paintings
> alone, which are causing quite a stir. But they are not
> selling well. When that will change, I cannot say.
> But of one thing I am sure: Today I am one of
> the painters who astonish the world the most."[1]

On the evening of April 4th, 1891 a group of painters and writers from the French capital gathered at the Gare de Lyon to bid farewell to their friend and colleague Paul Gauguin. Visibly moved, as one of the party recalled, Gauguin boarded the train bound for Marseille.[2] His emotional response was thoroughly understandable in view of the occasion. Not only was he embarking on a journey of adventure that would take him halfway around the globe to his destination on the Pacific isle of Tahiti, his farewell was to be a permanent one. His decision to turn his back upon France and the entire western world was the first step towards fulfilment of a lifelong dream. Gauguin's aim was to trade in the achievements of civilisation offered by modern life against an existence beyond the pale of western culture. He was driven by the longing for what he believed to be a long-lost primal originality that, in his view, was embodied in the concepts of the savage and the primitive.

Gauguin had given a great deal of thought to this move and prepared it thoroughly. In order to raise funds for his journey he organised a public auction of his works in February. Ironically, the paintings completed on the island of Martinique and in Brittany during the preceding five years did not attract their long-awaited purchasers until his plans to emigrate had become public knowledge. The results of the auction were astoundingly positive in view of the fruits of his previous efforts to make a living with his art. Nor were Gauguin's plans to leave the country ignored in the Paris artists' circles with which he was associated. A banquet in his honour was held on March 23rd, 1981: "Verses, toasts and the warmest reception in my honour", noted Gauguin in reference to the event attended by 45 painters and writers, for which the poet Stéphane Mallarmé served as master of ceremonies.[3]

By leaving Paris Gauguin hoped to put an end to a long series of failed attempts to gain recognition as a painter and secure a decent living from the sale of his pictures. He had taken virtually every opportunity to express his contempt for the circumstances of life in what was then the most modern metropolis in the world, as he constantly gave voice to his yearning for peace and solitude beyond the boundaries of that world. Such was Gauguin's response to the prevailing cultural ambivalence of his time, a condition in which a materialistic society driven by an optimistic belief in progress nevertheless indulged itself in nostalgic historicism in the arts. In an effort to achieve a reversal of this relationship, Gauguin sought a renewal in painting through a return to a state of originality and primitive life. This quest, which had taken on increasing urgency for Gauguin since the mid-1880s, engendered in him a state of restless mobility to which his frequent stays in Brittany and his journeys to Martinique, Tahiti and eventually to the Marquesas bear witness.

A look at Gauguin's travels in retrospect shows that the city of Paris was both a determinative opposite pole and the true hub of his existence. The city was the centre and the motor of his creative life. An invaluable source of inspiration, Paris provided him a forum for intellectual interaction with artists of the avant-garde and placed an immense treasure house of museums and exhibitions within his reach. Yet the new ideas he encountered there as an intellectual ally of literary Symbolism could only be brought to full creative bloom in entirely different surroundings. And it is clear that his move to Tahiti in 1891 was motivated less by an attraction to the specific destination, which remained uncertain for some time. The real driving impulse was his hope of finding – somewhere in this world – a paradise that would provide sufficient nourishment for his creative inspiration. This essay is devoted to an examination of the prehistory of Gauguin's journey to Tahiti. The aim is to gain insight into Gauguin's ideas about art as expressed in his written statements in letters and short theoretical treatises and to relate these to the development of his own oeuvre on the basis of evidence provided by selected paintings.

A bourgeois existence

Although born in Paris, Paul Gauguin did not live there for an extended period of time until he had reached adulthood. The Gauguin family moved to Peru in 1849, when Paul was but one year old. Father Gauguin having died during the voyage, Paul, his mother Aline and his sister Marie were taken in by relatives in Lima. Gauguin would later recall the years there as the happiest of his life. Aline Gauguin returned with her family to Orléans when the children had reached school age. After completing his schooling, Gauguin spent several years as a seaman, at first in the merchant marine and later in the navy, during which time he sailed the oceans of the globe and collected impressions of faraway regions of the world. Six years later – his mother had died in 1867 – Gauguin returned to Paris to live with his guardian Gustave Arosa (1818–1883). In many ways, Arosa exercised a determining influence on the course of the young man's future. He was instrumental in obtaining him a position at the Paris stock exchange, thus ensuring that Gauguin maintained ties to the world as a middle-class wage-earner. It was in Arosa's home that Gauguin met Mette Gad, the Danish woman he married in 1873. And it was his guardian as well who opened the young man's eyes to art. A financier, Arosa was also a passionate collector of porcelain, faiences and photographs, which had been in commercial distribution since 1867. Aided by a fine sense of value, he had also built a collection of paintings comprising works by Delacroix, Corot, Courbet, Daumier and others. Receptive to the newest tendencies in painting, he had collected paintings by Camille Pissarro – a member of the circle of Impressionists still so rudely scorned by the public in those years – since the early 1870s.[4]

It was Arosa who introduced Gauguin to the Impressionists. Fascinated, the young man studied the new light painting of Monet, Cézanne, Degas and others. Letters written by friends and acquaintances indicate that Gauguin was already drawing with great eagerness at this time. Soon afterwards, Camille Pissarro initiated him to Impressionism and its approach to the study of objects in natural light. Gauguin adopted Pissarro's technique of rendering objects with short brushstrokes as well as his preference for light colours. It was

not long before Gauguin joined the Impressionist circle and began to acquire their works himself. He had also begun exhibiting his own work alongside theirs at the fourth exhibition of Impressionist art in 1879.

Having lost his job in the wake of the stock market crash in 1882, Gauguin boldly decided to earn his living henceforth as an artist. The example set by his Impressionist colleagues, who had achieved some initial success with their paintings during the early 1880s, certainly encouraged him in that undertaking, although that alone was not a decisive factor in his decision. Indirectly, this step revealed for the first time not only Gauguin's inner conviction of having been "called" to a vocation as an artist but also his resolve to pursue that calling in spite of whatever external circumstances might place themselves in his way. He would later express this view in his letters, and it would become equally evident in many of his self-portraits, in which he took up the iconography of the self-sacrificing Christ pursuing a preordained destiny.

The break with his bourgeois existence was soon followed by the abandonment of his family. Gauguin was the father of five children. It was not long before the family found itself faced with insurmountable financial problems. The Gauguins first moved to Rouen, where the painter's friend Pissarro had already taken up residence. There they could live much more cheaply than in Paris. Yet the threat of financial ruin grew larger, and the family moved once again to Copenhagen, where Gauguin attempted in vain to establish himself in business on the side. He returned to Paris alone in 1885, and from that point on husband and wife went their separate ways.

Paris bohemia

Following his arrival in Paris in 1871 Gauguin had been drawn into the sphere of the artist avant-garde, which consisted of a circle of painters who had rejected the rules of academic painting and dedicated themselves to a new kind of naturalism. Unable at first to gain access for their paintings to the official exhibition scene, represented in the annual salon presented in the French capital, the Impressionists took matters into their own hands. In May 1874, a group of artists including Claude Monet, Auguste Renoir, Alfred Sisley, Edgar Degas, Berthe Morisot and Camille Pissarro presented their works in a privately organised group exhibition, an event that earned them the scorn of public and critics alike and witnessed the birth of the term "Impressionists".

The public rejection of the art of the Impressionists can be attributed to a number of different breaks with tradition. Their paintings were products of a purely naturalistic mode of vision; they resisted all forms of idealised representation. The Impressionists no longer drew from historical material for their pictorial subjects, concentrating instead upon unsophisticated motifs representative of modern life as it unfolded before their eyes in the French metropolis. They opposed the monumental formats and dark pictorial spaces of studio painting with light-coloured, luminous open-air painting. These painters relied entirely upon their impressions of an object and thus emphasised the superiority of their own perception to all other aspects of expression in the painting. Employing a technique of energetic, rapid brushstrokes and spots of colour applied with great spontaneity, they captured scenes from their surroundings in the manner of photographic "snapshots". The

1 Paul Gauguin, *The Seine at the Iéna Bridge*, 1875, oil on canvas, 65 x 92 cm, Musée d'Orsay, Paris.

mood of a moment, evoked by qualities of light, was of greater importance to these painters than the precise development of details in service of an objective representation of things. For the Impressionists, the quickly captured impression of scenes and events was the highest truth expressible in a painting. A very early example of Gauguin's Impressionist-style painting is the Paris cityscape bathed in cold winter light, *The Seine at the Iéna Bridge*, 1875 (Ill. 1). The painting was completed before Gauguin began taking lessons under Camille Pissarro.

Turning away from Impressionism

Gauguin's paintings from the very early 1880s show signs of a shift of interest that would draw him away from pure painting studies of the object and its perceptible manifestation. While he retained the technique of short brushstrokes he had learned from Pissarro, he no longer emphasised the transitory aspect of the captured moment. New in Gauguin's painting was a tendency to imbue his motif with emotional expressive power.

The painting entitled *Child Sleeping*, completed in 1884 (Ill. 2), depicts his son Clovis, whose long, blonde hair gives him a girlish appearance. The boy's head and upper body rest upon a table as he sleeps, his right hand has released a toy from its grasp, and the left lies against a large pitcher with a closed cover. The composition is confined to a narrow detail comprised of two zones, its lower portion formed by the table top, while the upper segment is filled with a section of patterned wallpaper with a blue background. The expressive strength of the painting originates in the tension generated by the confrontation of the child's head with the massive covered pitcher. The unknown contents of the pitcher

correspond to the state of the small boy's consciousness, separated in sleep from the outside world. In this atmosphere, the fleetingly rendered patterns of the wallpaper assume the fantastical features of dreamlike ghostly figures inhabiting the room. The suggestion of enigma, no longer restricted to a representation of the visible, is translated masterfully by Gauguin into painting in this early example of his art.

A letter written to Emile Schuffenecker at about the same time offers further evidence of Gauguin's gradual inner shift away from Impressionism. Writing from Copenhagen in early 1885, Gauguin revealed to his friend the thoughts that occupied his mind after he had lain down to sleep of an evening. They revolved primarily around the question of the relationship between the artist and nature. Gauguin clearly rejected the naturalist concept embodied in the authentic representation of perceived reality. Of crucial importance, in his view, was the fact that internal responses and perceptions of the outside world came together in the human brain. Gauguin distinguished between the role played by the visible world for the artist and that which he referred to as "sensation", the power of inner response, whose roots lie in the realm of intuition and thus are part of an internal reality. In this way Gauguin articulated his unmistakable deviation from the path of Impressionism, which was concerned exclusively with visualisation of the perceived world. Thus the issue of the expressive power of pictorial resources such as line and colour took on an entirely new meaning, since, as Gauguin remarked, "Why shouldn't lines and colours reveal to us the more or less grandiose character of the artist as well?".[5] Viewed in this way, nature retained its significance as an object of observation. But in an endeavour to achieve a new painting of ideas, the study of nature was but a first step towards a kind of painting that incorporated the power of human sensation. The quest for forms of expression appropriate to the world of the mind and the emotions was a matter of concern for the Symbolist movement in literature that was emerging at this time. It is not known, however, whether Gauguin had already established contacts with the Symbolists during these years.

The example of Paul Cézanne, of whose works Gauguin owned several, appears to have served him as a model. Both Gauguin and Cézanne, who was two years older than he, had developed their talents as self-taught artists within the Impressionist circle. They also

2 Paul Gauguin,
Child Sleeping, 1884,
oil on canvas, 46 x 55.5 cm,
Josefowitz Collection.

3 Paul Gauguin,
Breton Peasant Women, 1886,
oil on canvas, 72 x 91.4 cm,
Neue Pinakothek, Munich.

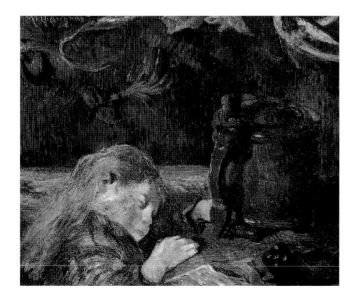

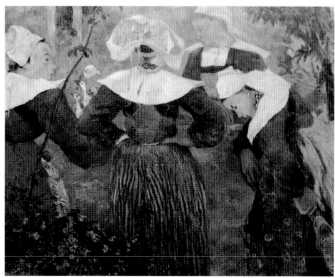

shared closed ties with Camille Pissarro, who as their teacher had familiarised them with the ideas of the Impressionists (Ill. 4). Cézanne's persistent failure to find purchasers for his paintings was one of the factors that prompted his decision to return to his home in southern France in 1881. His move to Aix-en-Provence coincided with his abandonment of the fundamental principles of Impressionism. Cézanne sought to replace the random quality of constantly changing surface manifestations with a more stringent arrangement of elements on the pictorial surface. Not only did Gauguin accept Cézanne's new approach to painting as a guidepost for his own development, he also recommended the older painter as a model to Emile Schuffenecker: "Look at Cézanne, understood by no one, a profoundly mystical nature from the Orient (his face resembles that of an old man from the East); he seeks the mystery and the weighty serenity of a person dreaming in sleep; his colour is earnest and employed like the essence of the oriental; a man of the South, who spends entire days on a mountaintop reading Virgil and observing the heavens, which is why his horizons are so high, his blues so intense and his red so astonishingly vibrant … his materials are determined as much by imagination as by reality."[6]

4 Paul Cézanne (sitting) with Camille Pissarro (standing, right) in Pissarro's garden in Pontoise, 1877.

Gauguin's characterisation of Cézanne's painting alludes to the latter's technique of attempting not to "reproduce" nature in the painting but to "represent" it through the use of colour equivalents. Yet unlike the conceptual painters and the Symbolists of his time, Cézanne never once considered abandoning his fundamental point of departure, which ivolved the depiction of the visible world. Gauguin failed to perceive these differences, as he was much too concerned with his own ideas. He dreamed in his fantasies of a southern Arcadia, far removed from the cold and darkness of the Scandinavian winter in Copenhagen and his own depressing living circumstances there. The move to Denmark had soon provend to be a total failure, as his hopes of gaining a professional foothold remained unfulfilled. He found the art world in the Danish capital provincial, and the relatives of his wife Mette made it all too clear how far he was from meeting their expectations (Ill. 5).

Under these circumstances Cézanne and the South of France took on the quality of an imaginary counterworld. In his vision, free of the conditioning effects of time and place, he melted everything into one. The southern Frenchman appeared oriental to him; France in the waning years of the 19th century was as alive in his mind as the descriptions of the ancient world contained in the poetry of Virgil. In characteristic fashion, Gauguin made use of a literary comparison with the Roman poet. For just as Virgil's epic *Aeniad* interwove historical events with mythical tales, Gauguin now saw the interaction of imaginary content and references to reality determined in painting.

5 Paul and Mette Gauguin in Copenhagen, 1885.

Brittany and Martinique

Following his return to Paris from Copenhagen it had taken Gauguin a year before he finally put together enough money to leave behind the hectic life of the big city for a three-month stay in the country to paint. With the help of a loan provided by a relative, he departed Paris at last in July 1886, destined for Pont-Aven in Brittany. As was the case with respect to every later undertaking of this kind, Gauguin cited financial worries in an attempt to justify his decision to travel to Brittany to his wife. He hoped, as he explained at the time, to live through the summer months there with a minimum of expense. On the basis

of statements of this kind, Douglas Druick and Peter Zegers surmised that ideological motivations did not come to override financial considerations until Gauguin's journey to Tahiti.[7] In view of the complicated relationship between the Gauguins this statement should not be taken too literally, however. As a rule, Gauguin's letters to Mette contained more or less explicit justifications of his inability to provide for his family. In other cases, he took the offensive and attacked her with grumbling, arrogant complaints. Many of his letters were written under the influence of such abrupt vacillations of mood that they began with high-flying expectations of future success only to end in tones of bitter self-pity.

The appeal of Brittany for Gauguin derived from the raw originality of its landscape and the traditional ways of its inhabitants, as this region of France had remained virtually untouched by the effects of progress. He regarded this source of inspiration as a necessary prerequisite for the realisation of his aesthetic goals. Gauguin dreamed of a painterly "synthesis" that would aid him in achieving new symbolic expressive power in his paintings. In a text written in Copenhagen on "The Theories of the Master Mani-Vehbi, Zunbul, Zadi", he had already given specific instructions regarding a kind of painting that was removed from, but in harmony with, nature: "The best thing to do is to paint from memory, so that your work is your own, your feelings, your thoughts, and so that your soul can stand up to a lover's gaze."[8]

Whereas Impressionism was inseparably connected with a perception of the modern metropolis in which the random and the transitory took form in art, increasingly strong criticism was expressed by those on the fringes of the movement around the mid-1880s, eventually culminating in dissension among the painters participating in the eighth and last Impressionist exhibition. In a letter to his son, Camille Pissarro wrote: "Things are coming to an end for the Impressionists ... It is evident that a great change is about to take place in art ... I have met a number of artists and critics who apparently understand that the old Impressionists are outdated."[9] Gauguin was not alone in contending that it was now time to approach things from the standpoint of their essence as fixed and permanent entities.

What Gauguin had said of Cézanne only a year before – that he had found a new attitude towards nature in southern France – he now sought to duplicate for himself in the isolation of Brittany. While still in Copenhagen he had articulated theoretically in his "Notes on synthetic painting" the ideas he now hoped to realise in the form of a new pictorial language. As he explained in his "Notes", the artist needed more than "aesthetic intelligence and aesthetic knowledge". Indeed, Gauguin continued, it was more important to nourish "special feelings towards nature",[10] which he perceived as a key to the world of emotions and thus to the inner nature of the human being, something only a select few enjoyed, however. He believed that nature and mankind interacted through the medium of the world of feelings. With reference to Impressionism he expressed the critical view that "thought is the slave of perception", for "nature stands above the human being".[11]

In Brittany Gauguin selected motifs from his immediate surroundings and was particularly inspired by the dress and local folk art of the rural populace. During this stay there he painted the Munich picture *Breton Peasant Women* (Ill. 3). The very narrow frame of view shows four young women wearing the white bonnets typical of the region, rendered in decoratively rounded forms. The semicircular grouping of the Breton women appears as a self-enclosed, culturally distant world from which the viewer is totally excluded. Their

postures, frozen in motion, serve to heighten the emotional intensity of the scene. The colour surfaces of garments and bonnets are clearly delineated, revealing Gauguin's interest in achieving a decorative effect. The faces are rendered without modelled interior features. Only the light coloration and the brushstroke technique are reminiscent of Impressionism.

Having spent the autumn and winter months of 1886/87 in Paris, Gauguin embarked with Charles Laval, a young painter with whom he had become acquainted in Pont-Aven, for the island of Martinique in the Antilles in April 1887. What had begun as a flight from the city environment of Paris to the rural countryside of Brittany now took on the character of an escape from civilisation itself. In March he wrote to Mette, informing her: "I am going to Panama to live as a savage."[12] He saw the journey as a necessary avenue of escape that would allow him to regain his creative power in the absence of external constraints. After two weeks of hard work as a labourer on the Panama Canal project, necessary because he, like Laval, refused to paint commissioned portraits for money, the two men journeyed on to Martinique. For a brief period Gauguin succumbed to the illusion that he had found paradise on the island of Martinique. He praised his life with Charles Laval in enthusiastic terms in a letter to Mette: "At present we are both living in a Negro hut. Is like paradise – near the isthmus. Beneath us the sea, fringed with coconut palms, and above us all manner of fruit trees – the city: 25 minutes away. Black men and women pass by here throughout the day, with their Creole songs and their endless babbling ... a nature that could hardly be more opulent; a hot climate, yet interspersed with cool days. One needs but little money to be happy here."[13]

While severe attacks of fever put an end to the life of ease on the Antilles isle, they did not prevent Gauguin from working for very long. He completed numerous sketches of island inhabitants, intending, as he expressed it, to explore the essential nature of the natives. His plan was to persuade them to serve as models for more thoroughly developed drawings and paintings later.[14] In the same way he also gathered images of the typical flora of the island, in drawings at first, later incorporating them into the decorative compositions of his paintings. For *Tropical Landscape* (Cat. no. 1), one of his most beautiful paintings from Martinique, Gauguin adapted a highly popular island view, the Bay of Saint-Pierre. Images of the bay had been widely disseminated in the form of postcards and book illustrations.[15] Gauguin, however, painted the shrubs and bushes in his version in such a way that they concealed the silhouette of the town of Saint-Pierre from view. Thus his depiction of the bay evokes the impression of a rural setting untouched by civilisation. At the same time he strove for a two-dimensional consolidation of pictorial elements, employing harmonious colour gradations to achieve an overall decorative effect.

Yet it was not until after his return from Martinique that Gauguin began to explore the question of how to force external reality even farther into the background of his painting. In the summer of 1888 he advised Emile Schuffenecker: "Do not copy nature so closely. Art is an abstraction; lure something from nature by dreaming of it. Think more about the process of creation than the product. That is the only way to reach God and to achieve what our divine master did – creation."[16]

In the years preceding his departure for Tahiti in 1891 Gauguin spent several extended periods in Brittany. He did not confine himself to exploring the surrounding landscape with his eyes but attempted to enter and discover it with his entire being. His intent was to

express in his paintings his internal responses to the surroundings and his intuitive sense of what was characteristic about them – a process that led far beyond the description of reality. The remarks made by Félix Fénéon in 1887 with regard to the Post-Impressionist movement in general applied to Gauguin's intentions as well: "They regard objective reality as no more than a point of departure on a quest for a higher, sublimated reality which they can fill with the effusions of their personalities."[17]

A comparison with the 1889 composition entitled *Flutist on the Cliffs* (Cat. no. 8) clearly shows the extent of Gauguin's progress in the use of aesthetic resources in the years since completion of his *Tropical Landscape*. The painting shows a scene on the rocky coast near the Breton village of Le Pouldu. Gauguin had taken refuge in this coastal town in 1889 in order to escape the increasing hustle-and-bustle of Pont-Aven. The skyless detail of his image of cliffs and water combined with the unnatural coloration and Gauguin's simplified rendering of forms serve to intensify the decorative qualities of the painting. Yet the greatest difference is to be found in the artist's new approach to space. In *Tropical Landscape* the viewer's gaze is drawn as if through a window to an inviting clearing in the foreground, from which it then follows the curving outline of the bay towards a hazy chain of mountains in the distance. For his painting of the flutist, and for his *Landscape with Cow among the Cliffs* (Cat. no. 9), Gauguin drew inspiration from Japanese woodcuts of the kind found in many artists' studios during those years. It has been established that Gauguin hung Japanese prints on the walls of his studio in Le Pouldu and studied them carefully.[18] In addition to their function as models for ornamental design, they exercised a formative influence upon his stylistic handling of problems of space. The rediscovery of the bird's-eye perspec-

6 Paul Gauguin, *Vision after the Sermon or Jacob Wrestling with the Angel*, 1888, oil on canvas, 73 x 92 cm, National Gallery of Scotland, Edinburgh.

tive in the art of Gauguin and many other painters can be traced to Japanese models. In the *Flutist* painting cited above, the angle of view from above is further dramatised by the steep incline of the cliff terrain, which descends suddenly, as if in a free fall, into the bottomless abyss below. The viewer's experience of the extreme absence of spatial orientation is disturbing, as it contrasts strangely with the pleasant atmosphere of the meeting of the flutist and the young Breton girl. As in many of Gauguin's paintings, the depicted subject appears to have attained a suggestive state of unbridgeable distance.

The most radical of the works painted by Gauguin in Brittany originated during the preceding year, however: *Vision after the Sermon or Jacob Wrestling with the Angel* (Ill. 6). Here the biblical theme is shifted to Brittany. Women dressed in typical, traditional Breton costumes appear as spectators at the battle scene. The vitality of the painting derives from the lively contrasts of expansive areas of colour. The women spectators in the foreground wear black garments and white bonnets which stand out strongly against the red of the background and the green of a nearby treetop. All of the forms are radically simplified and outlined with curving contour lines. There is no uniform perspective on the scene, which appears to be approached simultaneously from above and from the side. A sense of space is suggested by a tree trunk that crosses the pictorial surface in a manner reminiscent of Japanese prints. The trunk divides the painted surface into separate zones, each characterised by different dimensional relationships. Gauguin completes the break with reality by incorporating different elements of anti-naturalist origin, which he combines in his representation. Inspiration for this new technique came from the Japanese prints already mentioned, from medieval woodcuts and stained-glass art (cloisonism) and from the work of the Symbolist painter Puvis de Chavannes, which Gauguin greatly admired.[19]

All of the principles of the new synthetic style developed by Emile Bernard and Gauguin during their stay in Pont-Aven are united in this painting: reduced forms, unnatural coloration, emphatic contours and two-dimensional surface orientation. Without the least intent to represent an image of reality, the painting expresses the deeply rooted piety of the farming people. Its dominant theme, the vision of the pious women, is a programmatic articulation of Gauguin's anti-mimetic concept based upon visionary imagination. To his friend Vincent van Gogh he explained: "For me, the landscape and the battle in this painting exist only in the imagination of the people praying after the sermon. And that explains the opposition between the natural-looking people and the unreal and wholly disproportionate battle in the landscape."[20]

Gauguin found himself in Paris again in 1887, and we have evidence of his contacts with literary circles closely allied to the Symbolists during the following months. Jean de Rotonchamp, who was frequently in attendance at these gatherings, provides a memorable description of the participants: "Every Monday at about nine o'clock in the evening a meeting took place at the Café Voltaire on the Place de l'Odéon, to which everyone came who regarded himself as belonging to the movement or simply desired to attend as an interested listener. These lofty, whitewashed rooms often witnessed the appearance of the poet Paul Verlaine, plagued by illness, a heavy scarf wrapped around his neck and leaning on a solid walking stick. Other regular visitors: Charles Morice, the uncrowned king of the younger generation, Jean Mauréas, Albert Aurier, with a pale face and the long, black hair of a Renaissance poet, Julien Leclerq, with his magnificent head of brown curls, as if he had just stepped out of a painting by Jean Bellin [Giovanni Bellini]; others who appeared

included Edouard Dubus, Adolphe Retté and Dauphin Meunier. Several painters came as well, most notably Gauguin and Carrière, and a few sculptors; Rodin made an appearance from time to time."[21]

Jean Moréas, one of the writers who regularly attended these gatherings, wrote a kind of manifesto on Symbolism, a piece that appeared in *Figaro littéraire* in September, in which he commented on the goals of literary Symbolism. His ideas were adapted by Paul Gauguin, Emile Bernard and others from the Pont-Aven group and applied to their painting. In his manifesto Moréas contended that objectivity could be no more than a point of departure for art. "Symbolic poetry", he wrote, "strives to express the idea in a sensitive form that does not serve its own purpose but is subjugated instead to the idea it is intended to express. The idea, on the other hand, once it appears, must not be robbed of its abundant ornament of external analogies, as the essence of Symbolist art derives from the principle that the idea as such should never be expressed directly."[21]

The 1889 Paris World's Fair

The entire city of Paris was involved in the World's Fair of 1889. The World's Fairs held during the latter half of the 19th century were conceived as showcases of technological and cultural progress. Industry, science, commerce and art were united in a chronological panorama in service of national self-presentation. The 1889 World's Fair presented France from two major perspectives, emphasising both its significance as an industrialised country and its importance as a colonial power. The 300-metre Eiffel Tower (Ill. 7) was erected for the occasion as a demonstration of technical and industrial progress. France's status as a leading colonial power, second only to Britain, was underscored in a special section of the show comprising the "Exposition coloniale", which enjoyed sensational public success.

Apart from officially recognised painting, the centennial exhibition of French art at the Palais des Beaux-Arts on the Champ de Mars at the foot of the Eiffel Tower featured only a few painters from the Impressionist movement, including Manet, Monet, Pissarro and – after some wrangling – Cézanne. However, Paul Gauguin and his fellow artists from Pont-Aven did not want to miss the opportunity to take part in an event of such significance. They were given permission by an Italian café proprietor to hang their works on the

7 Panorama at the 1889 World's Fair, view of the Champ de Mars with the newly erected Eiffel Tower from the Trocadéro.

95

 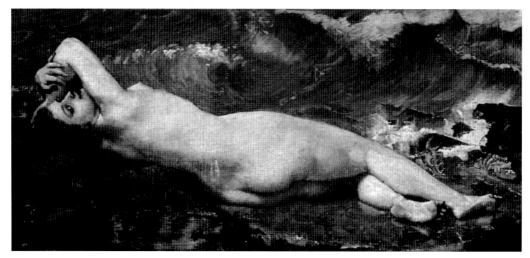

walls of the Café des Arts beneath the arcades of the Palais des Beaux-Arts. Nearly one hundred works were exhibited in the expansive rooms of the "Café Volpini" under the title "Groupe impressionniste et synthétiste". In addition to Paul Gauguin, such artists as Charles Laval, Léon Fauché, Emile Schuffenecker, Louis Anquetin, Daniel, Emile Bernard and Louis Roy were represented. Gauguin showed seventeen of his paintings, works done in Brittany, on the island of Martinique and during his stay in Arles with Vincent van Gogh in 1888. His pictures were hung in white frames on the dark-red tapestried walls.[23]

This was to be the first public presentation of paintings done in the synthetic style. But the undertaking was a failure, both financially – not a single work was sold – and in terms of public and critical response to the show. The works of the Pont-Aven painters deviated too greatly from the idealising historicism practised at the academies and promoted by the state. A comparison of approaches to painting may help to illustrate the gap that separated the two styles. A female nude by Gauguin entitled *In the Waves* (Ill. 8) was shown, a work also shown at our exhibition as a fragment of a pastel (Cat. no. 11). The same theme was treated in a painting by Paul Baudry with the somewhat suggestive title *The Pearl and the Wave* on exhibit at the centennial exhibition, shown here as an engraving based upon the painting (Ill. 9). The unfavourable spatial circumstances also played a part in the failure. Félix Fénéon commented on this problem, remarking: "It is difficult to get close to the paintings because of the beer taps and tables, the bosom of M. Volpini's cashier and an orchestra of young Muscovite women whose violin bows immerse the room in music that bears no relationship whatsoever to these colourful works of art."[24]

Gauguin had strolled through the exhibition rooms at the Palais des Beaux-Arts while the centennial exhibition of French art was still in preparation, recording his impressions in his "Notes sur l'art à l'Exposition universelle". They were printed in two parts in the journal *Le Moderniste illustré* in early July.[25] The notes contained a highly perceptive and critical assessment of the established aesthetic taste of his time. With reference to the architecture of the exhibition pavilion he criticised the combination of modern iron-and-steel construction – hard in quality and austere in effect – with an archaic ornamentation that "covered the iron with butter" and incorporated imitations of bronze statues as well (Ills. 10, 11). He found the materials in complete disharmony with one another, noting that

8 Paul Gauguin, *In the Waves (Ondine)*, 1889, oil on canvas, 92 x 72 cm, Cleveland Museum of Art.

9 Paul Baudry, *The Pearl and the Wave*, 1863, engraving from the oil painting by Paul Baudry in E. Monod, *L'Exposition universelle de 1889*.

10 View of the interior of the hall of machinery on the Champ de Mars.

11 Façade of the main building on the Champ de Mars.

12 Grand hall of the Palais des Beaux-Arts on the Champ de Mars.

form must do justice to the material employed in the creation of every work of art. He expressly excluded the newly erected Eiffel Tower from his criticism. The main thrust of his remarks was directed against the Fine Arts Exhibition (Ill. 12). In his view, the presentation was dominated completely by works loyal to the tradition of academic painting. When viewing them, Gauguin wrote, "we are rather more disgusted than astonished. I do indeed say astonished, for we have known for some time what we should think of such poor quality that has so little success on the open market. This whole vain world exhibits its achievements as it pleases and with an unparalleled impudence. It is true – things are the same everywhere in Europe. Parisian bad taste has conquered the whole of Europe."

Thus Gauguin found his expectations with respect to the World's Fair disappointed at first. Yet the event was ultimately anything but a failure from his personal point of view. He unexpectedly discovered another exhibition that would attract him as a visitor again and again. This section of the show was not located on the Champ de Mars but somewhat farther away, along the Esplanade des Invalides (Ill. 13). It was here that the French colonies and the Ministry of War made their joint presentation. Visitors were treated to a colourful, diverse panorama of homes and religious architectures of foreign peoples from all over the world. The greatest attraction of the Colonial Exhibition was the participation of natives from the French colonies who had been brought to Paris. These people lived in reconstructed villages of huts, selling their own products made by hand under the curious gazes of visitors to the pavilion. The streets of the exhibition were filled with a diverse mixture of ethnic groups – fashionably attired Parisian women with hats and walking sticks promenading alongside dark-skinned natives of tropical lands, their bodies covered in some cases by nothing more than a loincloth (Ill. 14). The colonies had been represented merely as a matter of form at the previous Paris World's Fair in 1878. In 1889, however, they were allocated a key role in a campaign devoted to familiarising the people of France with the many newly acquired colonial territories. And a reciprocal effect was also intended at the same time: natives of the colonies were meant to gain an impression of the power and greatness of France.[26]

Most of the architectures of the Colonial Exhibition were imitations of structures typical of the countries in question, among them the Tonkin Pagoda and the Chinese Palace. In some cases a direct reference to a famous architectural structure was sought. The Cambodian pavilion took the form of the Pagoda of Angkor, where Buddhist religious services were conducted for the amusement of the public. The exterior walls of the building were decorated with wooden and plaster replicas of sculptures and reliefs from the famous temple at Angkor Wat. The temple attracted particular attention, having gained widespread fame amongst the French public through the travel writings of Henri Mouchot, who had toured Indochina from 1858 to 1861. Natives from the colonies were brought to Paris to enliven the architectural setting. Their presence gave the public a sense of real life in a strange, distant culture and was a major factor in the grand success of the Colonial Exhibition, as was made evident in the reports of German visitors, among others:[27] "For one finds here fully authentic reproductions of the palaces, official buildings, homes and shops, etc. from all of the French colonies in original size. No less than 190 individual buildings have been reconstructed here, some of them (including the Chinese Palace) measuring 80 metres or more in length and depth! Thus this separate part of the exhibition in particular represents a main attraction for everyone who knows something about

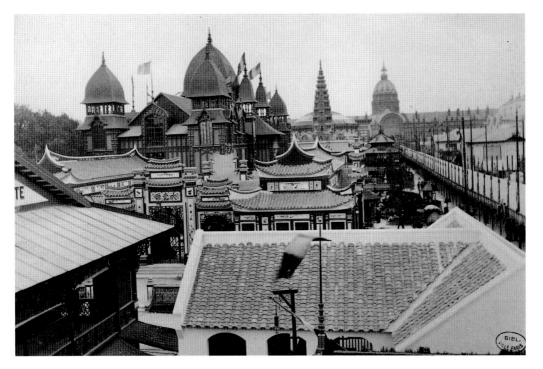

architecture, and not least of all for those from Germany for whom everything related to colonies is presently of such burning interest."[28]

Gauguin did not mention the Colonial Exhibition in his article for *Le Moderniste illustré*, as he obviously discovered it somewhat later. After his initial visit, however, he returned frequently and with great enthusiasm to individual exhibits and events. He was profoundly impressed with the performances of Buffalo Bill, who entertained capacity crowds with his wild-west troop at the World's Fair (Ill. 15). It is no coincidence that he began to wear his hair longer, posing for the camera wearing a broad-brimmed hat (Ill. 16), after having attended several performances of the show. In a note to Emile Bernard following a missed meeting appointment he wrote: "I looked for you in vain at the exhibition – I went to see Buffalo. – You simply must see that. It is very interesting."[29]

The Pagoda of Angkor was also of particular interest to Gauguin (Ill. 17). The side walls were decorated with reproductions of reliefs and Cambodian figures, which he drew on one of his visits.[30] As was also the case at the pavilions of other countries, visitors to the Cambodian pavilion could acquire native products as well as books, albums, maps and individual photographs.[31] We can only presume that Gauguin was among the purchasers of such photos. In any event it is clear that he was in possession of similar reproductions even before the World's Fair began. This is documented in a note written to Emile Bernard, in which he expressed his great enthusiasm for the performances of Javanese dancers of the so-called Kampong (Ill. 18): "Hindu dances can be seen in the Javanese village. All of the art of India is on display there, and the photographs I have from Cambodia literally come alive there. I am going back there on Thursday, as I have a rendezvous with a mulatto girl."[32] The "Village tonkinois", or Kampong, comprised not only the pagoda and the palace but living quarters for the Tonkinese as well. The pavilion had been built by 53 native workers from Indochina and enclosed within a bamboo palisade.[33] The reconstruction of entire villages (Ills. 19, 20) in which natives lived, performed their handicrafts, of-

16 Paul Gauguin circa 1893/94, Larousse Archives, Paris.

Die Pagode von Angkor (Kambodja).

17 The Pagoda of Angkor.

fered their products for sale and presented shows of a cultural nature permitted visitors to entertain the illusion of entering a new, strange world, as if on a world tour, without being forced to deal with the vagaries and dangers of genuine travel.[34] The French press emphasised the realistic conditions under which visitors were given access to foreign cultures and people at the Colonial Exhibition. Why it was possible to regard this manner of display as authentic can only be understood in the light of earlier modes of presentation of non-European cultures. Parisians had grown accustomed to encountering inhabitants of the colonies in the Jardin d'Acclimitation, a combination zoo and botanical garden in the Bois de Bologne, in 1877. Here the natives performed as snake charmers, dancers, singers or participants in rites purely for the sake of public amusement. The grand finale presented by a Ceylonese troop in 1886, for example, featured some seventy human performers, thirteen elephants and fourteen zebras.[35] Compared to this form of public entertainment in the guise of ethnographic sensation, the Colonial Exhibition did indeed establish an entirely new basis for the assimilation of foreign cultures.

Two different modes of transportation were available to visitors, emphasising the contrast between the most recent technological advances in France and the traditional ways of non-European peoples. The first was a railway connecting all of the pavilions of the World's Fair, which ended outside the entrance to the Colonial Exhibition, however. From that point on, some 200 to 300 native Tonkinese provided a ricksha service through the streets of the exhibition (Ill. 21). Gauguin made drawings of these ricksha drivers.[36] Another quite popular feature of the exhibition was intended to heighten the appeal of colonial life for French visitors: the panorama. From inside, visitors experienced the illusion of standing on the bridge of a ship of the French transatlantic steamship company, from which they enjoyed a view of the French coast and the open sea. Thus the concept of a comprehensible world within reach was deliberately applied in an effort to bring the colonies "closer" to the mother country. The effect was not lost on Paul Gauguin, at least, who changed his objectives repeatedly and, as it would appear, without significant reservations, before finally embarking on his journey to Tahiti.

Breaking away

Gauguin spent several extended periods working in Brittany in 1888 and 1889. From an artistic standpoint, these were highly productive years in which he responded to the surrounding landscape in the subjects of his paintings. To a certain extent, the consistent manner in which he applied his concepts of symbolism in painting was clearly the product of intensive intellectual exchange – with Emile Bernard in Brittany, a man twenty years his junior, and in Paris, where he met Vincent van Gogh and gained access to the circle of literary Symbolists. Nevertheless it would appear that it was Gauguin's never-ending money problems that initially prompted him to consider a second journey to Martinique. He longed for peace and solitude, yearned to pursue his painting without distractions of any kind. His retreat from Pont-Aven to the much quieter coastal village of Le Pouldu had been an attempt to draw inner peace from outer serenity. The prospect of leaving his financial worries behind, at least temporarily, motivated his not entirely voluntary decision to travel to Arles to visit Vincent van Gogh in October of 1988. Southern France did not

offer him a landscape capable of captivating his imagination with a wild, raw nature, however. Aside from his work with van Gogh in Arles, Gauguin spent much of his time there planning a second trip to Martinique. Given his achievements in art during his last stay in Brittany he hoped, "that I shall now be able to accomplish some beautiful things there. In fact, if I could put together a sizeable sum of money, I would buy a house there and establish a studio where friends would find life prepared for them, as it would cost them next to nothing. I agree in part with Vincent: the future belongs to painters of the tropics that have not yet been painted, and one will have to offer the stupid buying public something new, in terms of motifs, that is."[37]

Gauguin planned a stay of 18 months, for which he intended to depart in May of the following year, provided he could put together the necessary means by then.[38] After the World's Fair, however, nothing more was said of such a journey. Tonkin was the new destination of choice: "I hope to secure what I am presently trying to obtain – a good spot in Tonking where I can work on my paintings and save some money. The whole Orient, the grand idea that is written in golden letters in all of its art – all that is worth the effort of studying it, and it appears to me that I shall be able to tap new strength again there."[39] China and Tonkin had been represented at the Paris exhibition not only by magnificent architectures like the pagoda of Angkor Wat but by a village of bamboo huts as well. This mixture of a highly sophisticated culture of the past and a modest but original way of life in the present had awakened Gauguin's desire to experience that unknown world. Despite his insistent applications, however, Gauguin was unable to obtain permission from the colonial authorities for his journey.

Gauguin changed his plans several times in 1890. Madagascar initially replaced Tonkin as his destination of choice. Once again it was the experience of the World's Fair that gave

new wings to his dreams. In a letter to Emile Bernard he wrote: "I am definitely going to Madagascar. I shall buy a house of clay brick in the country and enlarge it myself; I shall plant crops and live a simple life. Model and everything I need to do studies. And then I shall establish the studio of the tropics."[40] What he now sought was escape from the civilised world. The images of the World's Fair had etched themselves in Gauguin's memory and given substance to his vision of a life far from the shores of Europe. For Bernard, who was to accompany him to Madagascar, he sketched the outlines of his future life: "With the money I get I can purchase a native hut like those you have seen at the World's Fair. Made of wood and mud, with a straw roof."[41] Somewhat later he compared Madagascar and Tahiti, referring to the best-selling author Pierre Loti, whose autobiographical 1880 novel *Le Mariage de Loti* was set on the idyllic Polynesian isle of Tahiti. At this point he still regretted that Tahiti was so much farther away than Madagascar. In the meantime, he had begun to go about "like a savage with long hair" on the beach at Le Pouldu, reporting to Bernard that he had carved arrows and was practising shooting them "like Buffalo Bill".[42] Ultimately, after all of his vacillations, Gauguin settled on Tahiti. It has been said that the wife of his fellow painter Odilon Redon advised him to decide in favour of Tahiti.[43]

It was not only a period of planning. Gauguin was becoming more and more certain that he would be leaving Europe forever. Once again he assuaged all doubts concerning his decision with bold hopes of finally building a future free of troubles. In colourful terms he expressed his wishes for such a future to his wife Mette, of all people: "If only the day would come when I can flee into the forests of a lonely island in the South Sea like a savage, to live there in peace and ecstasy for my art alone. Surrounded by a new family, far away from the European struggle for money. There in Tahiti I will be able to listen in the silence of the tropical nights to the soft murmuring music of the movements of my heart in loving harmony with the mysterious beings in my entourage. Free at last! Without money problems I shall then be able to love, to sing and to die."[44]

Sometime during this period of preparation for his ultimate departure from Europe Gauguin painted two portraits in which he expressed his attitude with regard to his future as an artist. One of these is his *Self-Portrait with Yellow Christ* (Ill. 22), which can be dated only approximately during the years 1889 to 1890. Seen in the painting behind the head-

19 Native village at the Colonial Exhibition, Bibliothèque Historique de la Ville de Paris.

20 Native village at the Colonial Exhibition.

and-torso figure turned slightly to the side are two works done by the painter only a short time before. On the left is a detail from his painting *Yellow Christ*.[45] On the right is a stoneware vessel as a self-portrait[46] in the background. This was Gauguin's allusion to his often-expressed belief that two different beings were united within him – a civilised European and a savage. If one gives credit to the painting, then it is clear that he had already made his choice between the two: Gauguin is depicted inclining his head towards the grotesque, which represents "Gauguin the savage",[47] as he described the ceramic to Madeleine Bernard in late November 1889.

21 Tonkinese ricksha driver at the World's Fair.

At about the same time, Gauguin must have been at work on the somewhat smaller vertical-format painting entitled *Portrait of Aline Gauguin*, a work now in the collection of the Staatsgalerie Stuttgart (Cat. no. 15). Aline Gauguin had died some twenty years before at the age of 42. Gauguin did not paint his mother as he remembered her; instead, the painting shows her as a young girl. The dark outline of her silhouette stands out against the rich yellow background. The head-and-torso likeness rendered in powerful brushstrokes and the softly modelled facial features possess all of the characteristics of the decorative, surface-oriented style typical of his Breton painting: the handling of clearly outlined, simplified forms reduced to the bare essentials and the use of ornamental curved lines and radiant fields of colour devoid of gradation.

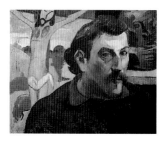

22 Paul Gauguin, *Self-Portrait with Yellow Christ*, 1889/90, oil on canvas, 38 x 46 cm, private collection.

This portrait provides a revealing example of Gauguin's technique of abstracting from nature, since he painted the work from an existing original. The original was not, as has frequently been claimed, a photograph of his mother but was actually a portrait of her done in about 1841 by Jules Laure (Ill. 23). Nevertheless, this mistaken assumption is understandable in light of the poor quality of the reproduction. It is likely that Gauguin based his version on a photograph of the painting rather than the original itself.[48] A comparison between the original image, intended to capture the woman's natural appearance, and Gauguin's painting, in which the artist reshaped his mother's facial features to form the image of an exotic beauty, clearly emphasises Gauguin's view that painting must pursue the objective of lending visible form to an idea in the pictorial image, and thus in a portrait as well. In order to represent the essence of a subject the painter made use of significant forms and colours which in turn contributed, through the processes of exaggeration and reshaping of the natural likeness, to a heightened form of expression. Gauguin had once said of his mother that "although of noble, Spanish character, my mother was passionate in nature. I remember receiving a number of blows from her small hand, which was as soft as rubber. But it was her habit to kiss me tearfully and hold me to her breast afterwards."[49] Gauguin's memories of his mother, recorded years later in his "Avant et après", cannot be judged on the basis of the typifying representation of his portrait of her, however.

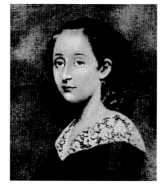

23 Jules Laure, *Aline Gauguin*, circa 1848/49, oil on canvas.

The portrait of Aline Gauguin is as personal a work as his *Self-Portrait with Yellow Christ*. It is neither signed nor dated and was never offered for sale during the artist's lifetime. Both paintings point clearly to his impending departure for Tahiti. Gauguin incorporated more than the features of his ideal of exotic femininity in his portrait of his mother. Gauguin, the civilised European, had exchanged artist identities with Gauguin, the savage. And to this profession of identity he added a corresponding genealogy.

Gauguin's journey to Tahiti can be viewed only to a certain extent as an escape from western society. Long before his departure he was able to announce: "I have a finished painting in my head."[50] Gauguin hoped primarily to find in Tahiti what he had already

sought in Martinique or Brittany. His was a quest for the stimulating atmosphere of a locale in which his art could be a reflection of pure sensation in the presence of unadulterated ("savage") nature. Gauguin hoped, not only for himself but for his art as well, that "I shall be able to cultivate it to primitiveness and savagery down there." In his luggage for Tahiti he packed drawings and photographs, "a whole world of friends who will speak with me every day".[51] His dream was not deterioration into a primal, precultural state but the rediscovery of an original condition long since lost to western culture, in order to achieve a renewal in painting.

1 Paul Gauguin to his wife Mette, cited from Malingue 1960, p. 97 (Le Pouldu, late June 1889).
2 Jan Verkade, "Die Unruhe zu Gott. Erinnerungen eines Malermönchs", Beuron 1955, p. 81.
3 Malingue 1960, p. 124 (Paris, March 24th, 1891).
4 Merlhès 1984, pp. 319f.
5 Merlhès 1984, p. 88 (Copenhagen, January 14th, 1885).
6 Merlhès 1984, ibid.
7 Druick/Zegers 1989, p. 1.
8 Prather/Stuckey 1994, p. 57 (about 1885).
9 Camille Pissarro, Lettres à son fils Lucien, Paris, 1950.
10 Prather/Stuckey 1994, p. 60 (1884–1885).
11 Prather/Stuckey 1994, ibid.
12 Merlhès 1984, p. 147; Malingue 1960, p. 54 (Paris, late March 1887).
13 Prather/Stuckey 1994, p. 77 (to Mette Gauguin, St. Pierre, Martinique, June 20th, 1887).
14 Exhib. cat. Auckland 1995, p. 12.
15 Exhib. cat. Chicago/Washington 1988, p. 78; a reproduction of the photograph of the Bay of Saint-Pierre is found in Merlhès 1984, pp. 460f.
16 Merlhès 1984, p. 210 (Quimperlé, August 14th, 1888).
17 Félix Fénéon, "Le Néo-Impressionnisme", in L'Art Moderne, May 1st, 1887; cited from Rewald 1967, p. 59.
18 Gauguin 1932, p. 21 (Le Pouldu, 1889).
19 Simpson 1995, p. 24.
20 Merlhès 1984, p. 323.
21 Prather/Stuckey 1994, p. 78.
22 Rewald 1967, p. 91.
23 Rewald 1967, p. 172.
24 Félix Fénéon, "Autre groupe impressionniste", in La Cravache, July 6th, 1889; cited from Rewald 1967, p. 182.
25 Le Moderniste illustré, Vol. 1, July 4th, 1889, No. 11, pp. 84/86 and No. 12, July 13th, 1889, pp. 90f.
26 See E. Monod, L'Exposition universelle de 1889. Grand ouvrage illustré historique, encyclopédique, descriptif, Vols. 1–3, Paris, 1890.
27 Political considerations prevented official German participation in the 1889 World's Fair.
28 Franz Woas, "Von der Weltausstellung in Paris", in Deutsche Bauzeitung, 23 (1889), Nos. 49–54, Letters 1–6.
29 Gauguin 1932, p. 19 (Paris, 1889).
30 Exhib. cat. Auckland 1995, p. 15 with illustration.
31 Monod, 1890, footnote 26, Vol. 2, p. 192.
32 Gauguin, 1932, p. 20 (Paris, 1889). However, Douglas Druick and Peter Zegers were able to prove that the photographs from Cambodia mentioned by Gauguin also included reproductions of Javanese art. He presumably acquired them from the estate of Gustave Arosa. See Druick/Zegers 1989, pp. 132f.
33 Monod, 1890, footnote 26, Vol. 2, pp. 158ff.
34 Stefan Koppelkamm is mistaken in speaking of a "zoological exhibition" at which visitors were separated from the natives by a fence. This is clearly demonstrated in numerous illustrations of the World's Fair. See Koppelkamm, "Exotische Architekturen im 18. und 19. Jahrhundert", in Mythos Tahiti. Südsee – Traum und Realität, Berlin, 1987, p. 150.
35 Esielonis 1993, p. 140.
36 Exhib. cat. Auckland 1995, p. 15.
37 Gauguin 1932, p. 15; Merlhès, 1984, p. 274 (to Emile Bernard, November 9th–12th, 1888).
38 Merlhès 1984, p. 305 (Arles, December 20th, 1888).
39 Gauguin 1932, pp. 26f. (Le Pouldu, 1889).

40 Gauguin 1932, p. 39 (Paris, 1890).
41 Gauguin 1932, p. 44 (Le Pouldu, 1890).
42 Gauguin 1932, p. 50 (Le Pouldu, 1890).
43 Malingue 1960, p. 123, footnote. 1 (Paris, February 19th, 1891).
44 Malingue 1960, pp. 103f. (Paris, February 1890).
45 *Yellow Christ*, 1889, 92 x 73 cm, Albright-Knox Art Gallery, Buffalo, New York.
46 *Self-Portrait as Grotesque*, 1889, glazed stoneware, height 28 cm, Musée d'Orsay, Paris.
47 Cited from exhib. cat. Chicago/Washington 1888, op. cit., p. 177.
48 Maurice Malingue was the first to reproduce the painting in his book entitled *Gauguin. Le peintre et son œuvre*, Paris, 1948, p. 19. The portraitist Jules Laure (d. 1861 in Paris) painted two other portraits of Aline and Paul Gauguin circa 1848/49, both of which are now in the possession of the Musée départemental du Prieuré, Saint-Germain-en-Laye; see illustrations in exhib. cat. Chicago/Washington 1988, p. 2.
49 See exhib. cat. Chicago/Washington 1988, p. 185.
50 Prather/Stuckey 1994, p. 132 (to Odilon Redon, September 1890).
51 Prather/Stuckey 1994, *ibid.*

Paul Gauguin, circa 1890.

TECHNIQUE AS STIMULUS FOR THE ARTIST'S IMAGINATION – GAUGUIN'S PRINT OEUVRE

Christofer Conrad

Printmaking technique and innovation in art

In a letter to Theo van Gogh dated November 20th, 1889 Gauguin – reluctantly – provided several clues for an interpretation of his wood relief *Soyez amoureuses et vous serez heureuses* (Be in Love and You Will Be Happy, 1889; Museum of Fine Arts, Boston), a work that had completely baffled the public. At the end of his remarks the artist wrote: "For those who desire a written explanation: Now you have one. But it is totally useless. The background against which this all needs to be seen is the art of sculpture, or more accurately, the art of the relief, its forms and colours, the expressive possibilities inherent in this material. Between the *possible* and the *impossible*."[1] The painstaking exploration of the specific possibilities of a given technique and, more importantly, of the significance of material qualities and aspects of craftsmanship involved in that technique to the artist's aesthetic statement typifies Gauguin's approach to the graphic arts. He regarded lithography, the woodcut and the monotype print as media in which existing pictorial ideas could be reinterpreted from the perspective of the specific print technique used. Thus the panorama of figures Gauguin employed in the woodcuts done in France following his return from Tahiti were adapted almost without exception from the paintings and sculptures he had completed in Polynesia. Nor was it the reconfiguration of this established repertoire alone that enabled him to achieve an original artistic statement; just as important was his experimental exploitation of the inherent capacity of both his own print forms and the printmaking process itself to generate new meaning in a remarkably broad spectrum of equally valid interpretations. A process of interaction involving the material aspects of the work of art and the imagination of its creator played a decisive part in the articulation of the pictorial idea.

The Volpini Suite of 1889

This stimulating effect of printmaking technique upon the artist's imagination characterised Gauguin's earliest work in the graphic arts, the series known as the *Volpini Suite*, a collection of lithographs on zinc done in Paris during the months of January and February 1889 (Cat. nos. 57–67). Almost all of the prints in this series are based upon paintings, drawings or sculptures completed in Pont-Aven, Arles or Martinique. The primary reason for the artist's decision to make these prints was probably the joint exhibition by the artists of the so-called „Groupe impressionniste et synthétiste", scheduled to open at the Café Volpini in Paris in June 1889, at which Gauguin wanted to present works he could not show as paintings in the medium of lithography. Quite apart from this specific occasion Gauguin had already turned his attention to lithography some time before in the hope of exploiting

the medium for the purpose of acquainting a broader segment of the public with his art. He is likely to have been encouraged in that effort by the systematic increase in respect afforded to print graphics within the hierarchy of artistic techniques since the late 1880s, to which the "Société des peintres-graveurs" (Society of Painter-Engravers), established in the winter of 1888/89, and the journal *L'Estampe originale* (The Original Print), first published in 1888, contributed in a significant way. The engraver Félix Bracquemond, who played a leading role in both undertakings, had also provided important impetus to Gauguin's first approach to ceramics. The goal of his efforts and those of his associates was to raise the original print, that is, the true printmaking process in which the artist prepared the print form (the copper plate, lithograph stone or wood block) himself and either carried out or supervised the actual printing procedure, above the status of mass-produced reproduction prints. Each separate print taken from the hand-made print form was to be regarded as a unique work of art in its own right and placed on an equal footing with one-of-a-kind works such as paintings, drawings or sculptures.[2] Gauguin, therefore, had reason to view the lithograph as an opportunity to promote his previously little-known and less recognised art by producing a large number of originals.[3] Gauguin's prints were presented at the Volpini exhibition in a folio which also included *Les Bretonneries,* a series of seven zincographs by his friend and fellow-artist Emile Bernard. Because the album was shown only on request, it is likely that only a small number of visitors to the exhibition were aware of its existence, although it was not entirely ignored in critical circles.[4] One may presume that Bernard, who had begun producing lithographs on zinc as early as 1887, gave the inexperienced Gauguin helpful tips regarding the application of the technique. A comparison of the *Volpini Suite* with the *Bretonneries* clearly suggests, however, that the two artists exploited the potential inherent in the same medium in totally different ways. Bernard largely ignored the possibilities for creating highly differentiated effects with work in chalk, brush and the use of diluted lithographic ink on the grainy surface of the zinc plate. In his *Femmes aux porcs* (Women with Pigs, Ill. 1), for example, the banded framework structure of the lines is dominant, while shadowed areas suggestive of three-dimensional relationships are virtually non-existent. Bernard was obviously intent upon imitating the simple language of lines employed in the early medieval woodcuts he so greatly admired. In addition, this approach also permitted him to prepare for the subsequent application of water-colours to the prints, which further enhanced their character as one-of-a-kind works of art. Although Gauguin himself did not wish to dispense with colour entirely, he did not favour the method of manual colouring – only a few prints from his *Projet d'assiette – Leda* (Design for a China plate – Leda, Cat. no. 57) were coloured with water-colour and gouache and presented as portfolio covers for the *Volpini Suite* – but instead had the printer Edouard Ancourt, who had also printed Bernard's *Bretonneries,* produce an edition on light-yellow paper. The hearty reddish brown print entitled *Misères humaines* (Human Sorrow, Cat. no. 67) was the only one not done in black. Gauguin probably took his stimulus for the use of coloured paper from Japanese colour woodcuts.[5]

The suggestive appeal of the radiant yellow paper, which immediately catches the eye of the viewer, is missing in the second edition of the *Volpini Suite* presented here, most likely printed without the artist's involvement on white Simili-Japan paper after 1900.[6] Clearly evident in this version, however, is a broad range of differentiations achieved using lithograph chalk and brush wash. Modelled on Japanese prints, with which French artists had been familiar since the 1870s, primarily through the work of Bracquemond, Gauguin developed

1 Emile Bernard: *Women with Pigs,* 1889, zincograph with water-colour, Josefowitz Collection.

Cat. no. 57
Projet d'assiette – Leda
(Design for a China plate –
Leda)
1889
Zincograph, second edition
on white Simili-Japan paper,
printed after 1900
22.1 x 20.4 cm, MKJ 1/B
Inscriptions (in reverse):
Underneath composition
"Projet d'As[s]iet[t]e 89",
within composition "Homis
[sic!] soit qui mal y pense"
(the motto of the English
Order of the Garter, which
translates as "Shamed be he
who thinks evil of it") and
signature "PGO."
Staatsgalerie Stuttgart,
Graphische Sammlung

Pages 110 – 111
Cat. no. 60
Baigneuses bretonnes
Bathers in Brittany
1889
Zincograph, second edition
on white Simili-Japan paper,
printed after 1900
24.5 x 20 cm, MKJ 4/B
Inscription: Signed below
borderline in lower left corner
"P Gauguin"
Staatsgalerie Stuttgart,
Graphische Sammlung

Cat. no. 67
Misères humaines
Human Sorrow
1889
Zincograph, second edition
on white Simili-Japan paper,
printed after 1900
29.4 x 23.7 cm, MKJ 11/B
Inscription: Signed in lower
right corner "P. Gauguin 89"
(in reverse)
Staatsgalerie Stuttgart,
Graphische Sammlung

a brilliant interplay of clearly outlined light and dark areas that unfolds within the framework of a very broad paper margin. The exaggerated size of this white framing border gives the prints a quality of intricacy and preciousness. The spatial structure is also modelled upon Japanese originals. Traditional depth is lacking, the spatial planes appear stacked in multiple layers and seem to interpenetrate one another; and the super-elevated point of view characteristic of Japanese colour woodcuts is frequently in evidence. Gauguin allowed himself considerable freedom in dealing with the original motifs – his own paintings – converting horizontal formats to vertical, eliminating figures or adding new ones. He succeeded in intensifying the power of his pictorial statement in virtually all of the prints. The requirements of particular printmaking techniques favour the revision of the painted version, as they compel the artist to abstract and simplify his motifs. Thus in *Baigneuses bretonnes* (Bathers in Brittany, Cat. no. 60), for example, the integration of the human being in nature, the restoration of innocence through the immersion of the naked body in the waves, is illustrated by presenting it in a richly curved, opaque black mask, in which the wave forms of the sea, actually a part of the background, are already evident in the figure seen standing in the foreground. In contrast to the painting from which the print was adapted, in which the boundary between foreground and background is clearly delineated, the interweaving of spatial planes in the print generates a new structure of time. Narrative chronology, suggested in the painting by the presence of a bather already immersed in the water

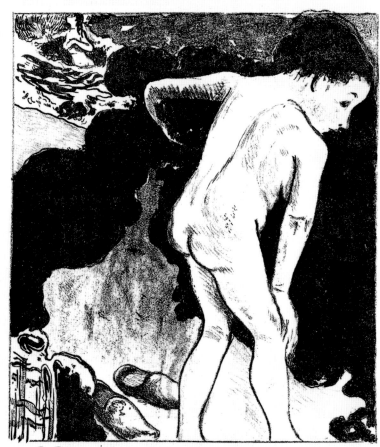

P Gauguin

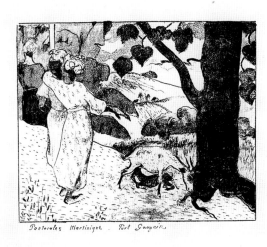

Cat. no. 58
Les Drames de la mer, Bretagne
Dramas of the Sea, Brittany
1889
Zincograph, second edition on
white Simili-Japan paper, printed
after 1900
17.6 x 22.2 cm, MKJ 2/B
Inscriptions: Dated and signed
in lower left corner "89
(in reverse) Paul Gauguin",
underneath composition "Les
Drames de la mer Bretagne"
Staatsgalerie Stuttgart,
Graphische Sammlung

Cat. no. 61
Les Cigales et les fourmis –
Souvenir de la Martinique
Grasshoppers and Ants –
A Memory of Martinique
1889
Zincograph. Second edition
on white Simili-Japan paper,
printed after 1900
21.6 x 26.1 cm, MKJ 5/B
Inscriptions: Lower left corner
beneath borderline "Les
Cigales et les fourmis", above
signature "Paul Gauguin"
Staatsgalerie Stuttgart,
Graphische Sammlung

Cat. no. 59
Les Drames de la mer – Une
descente dans le Maelström
Dramas of the Sea: Descent
into the Maelström
1889
Zincograph, second edition
on white Simili-Japan paper,
printed after 1900
18 x 27.2 cm, MKJ 3/B
Inscriptions: Underneath
composition "Les drames
de la mer" and signature
"P Gauguin"
Staatsgalerie Stuttgart,
Graphische Sammlung

Cat. no. 62
Pastorales Martinique
Martinique Pastorals
1889
Zincograph, second edition
on white Simili-Japan paper,
printed after 1900
18.5 x 22.2 cm, MKJ 6/B
Inscriptions: Beneath lower
borderline "Pastorales
Martinique" and signature
"Paul Gauguin"
Staatsgalerie Stuttgart,
Graphische Sammlung

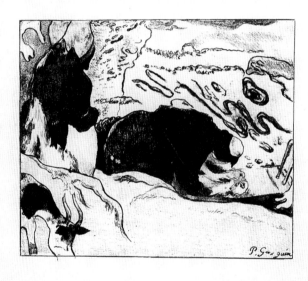

Cat. no. 63
Joies de Bretagne
The Pleasures of Brittany
1889
Zincograph, second edition
on white Simili-Japan paper,
printed after 1900
20.1 x 24.1 cm, MKJ 7/B
Inscriptions: Lower left corner
"Paul Gauguin" and title
"Joiee [sic!] de Bretagne"
Staatsgalerie Stuttgart,
Graphische Sammlung

Cat. no. 65
Les vielles filles à Arles
Old Maids of Arles
1889
Zincograph, second edition
on white Simili-Japan paper,
printed after 1900
19.2 x 20.8 cm, MKJ 9/B
Inscription: Signed in lower
left corner "P. Gauguin"
Staatsgalerie Stuttgart,
Graphische Sammlung

Cat. no. 64
Bretonnes à la barrière
Breton Women Beside a Fence
1889
Zincograph, second edition
on white Simili-Japan paper,
printed after 1900
17 x 21.5 cm, MKJ 8/B
Inscription: Signed in lower
left corner "P Gauguin"
Staatsgalerie Stuttgart,
Graphische Sammlung

Cat. no. 66
Les Laveuses
Women Washing Clothes
1889
Zincograph, second edition
on white Simili-Japan paper,
printed after 1900
21.2 x 26.5 cm, MKJ 10/B
Inscription: Signed in lower
right corner "P. Gauguin"
Staatsgalerie Stuttgart,
Graphische Sammlung

and a woman cautiously entering the waves, is replaced by a sense of simultaneity, evoked by a synthesis of organically animated pictorial elements that assigns all events to a single level of time. The harmony of human being and nature is echoed in the tension-filled balance between light and dark areas and thus takes on concrete form as an abstract harmony quite independent of the anecdotal iconography of the picture. A similar effect of distancing from the anecdotal depiction reminiscent of genre paintings also characterises the print *Bretonnes à la barrière* (Breton Women Beside a Fence, Cat. no. 64), whose motifs were adapted from several different originals. As in the Japanese colour woodcut, the intersection of scenery and figures by the margin on all sides evokes an impression of highly selective detail and the sense of a very momentary view. Here again the abstract interplay of the differently structured segments takes precedence over the representational function of figure and landscape. The regular rhythm of the fence, for example, is contrasted with the pattern in the dress worn by the peasant woman in the foreground, which spreads diffusely into the surrounding space. Although the synthesis of human form and landscape achieved here can be traced to Gauguin's desire to present the life of the Breton peasantry as a concrete expression of his own yearning for primal originality and timelessness, it is impossible to overlook how close this synthesis comes to abstraction in this particular print. The same effect is even more clearly evident in *Les Laveuses* (Women Washing Clothes, Cat. no. 66), where the silhouette figures of the women at work are almost completely integrated into the surrounding riverside landscape. In his programmatic painting *The Stone-Breakers* of 1849 (formerly in Dresden, Staatliche Kunstsammlungen) Gustave Courbet had created a timeless image of the human being engaged in hard physical labour by rendering the figures in anonymity, negating the genre-style view that had previously characterised artists' depictions of the world of work by translating it into a monumental vocabulary of forms. In Gauguin's art, however, the concepts of timelessness and depersonalisation represent man's identification with his environment and with an undeniable higher plan of existence, in the pursuit of which life consumes itself. Thus it comes as no surprise that the figures of the women at work in Gauguin's lithograph are articulated, aesthetically speaking, no differently than the cow grazing in the foreground or the landscape that surrounds them. The symbolically simplified landscape presentation adapted from Japanese models makes it impossible in many cases to assign specific pictorial elements to concrete natural phenomena. Gauguin explored the possibilities for diversification of surface textures through the precisely calculated use of chalk and brush wash in the clothing worn by the woman shown standing as she washes her clothes. Her shawl is developed exclusively by means of brushwork, the fluid condensing into tiny drops on the grainy surface of the zinc plate. Opaque black sections of her skirt contrast with parallel chalk streaks of various density, which in turn are emphasised by the presence of minuscule spots of wash fluid.

Apart from these prints, whose highly abstract formal language derives from the fact that Gauguin was further condensing previously tested pictorial inventions in them, we also find in the *Volpini Suite* compositions characterised by an almost classical sense of balance, in which a world of cheerful lightness and pleasure is addressed. In the prints entitled *Les Cigales et les fourmis – Souvenir de la Martinique* (Grasshoppers and Ants – A Memory of Martinique, Cat. no. 61) and *Pastorales Martinique* (Martinique Pastorals, Cat. no. 62) the artist combines the impressions and experiences of his stay in Martinique in 1887 with inspirations gained during his lengthy visits to the painting collections of the Musée du Louvre.

The group of burden-bearers in the former scene is vaguely reminiscent of the dancing muses in Mantegna's *Parnassus (Venus and Mars)*, whereas the women shown sitting in the foreground may be viewed as an African variation on the motif of Arcadian musicians in Titian's/Giorgione's *Concert champêtre*. Nicolas Poussin's heroic landscapes and Japanese beauty of line are joined in an effective synthesis in the complete harmony of the linear rhythms of nature and the human being. The quality of animation of the two female figures in their light-coloured dresses is diminished by the strict gridwork pattern of the tree trunks behind them, giving the overall composition a rather more static effect. The industrious "grasshoppers" and the idly lounging "ants" – to recall the imagery of Jean de la Fontaine's fable – jointly express the capacity of the islanders to enjoy life in any given situation, and the moral undertone of the title recedes far into the background. A remarkable feature of this print is the abundance of differing textures – the brilliantly shining skin of the women, the patterned dresses, the woven structure of the baskets – which Gauguin achieved primarily with his brushwork. The rich array of textures is even more pronounced in *Pastorales Martinique*, a work in which the artist demonstrates in an impressive manner the wide range of grey nuances he is able to create using lithographic ink diluted to different concentrations. The image of an exotic paradise evoked here by the harmonious quality of the composition, in which figures and landscape attract the viewer's attention in equal measure, anticipates the paintings Gauguin would complete during his first sojourn in Tahiti.

Gauguin's receptiveness to new creative solutions derived from the specific possibilities inherent in the printmaking process is particularly evident in the prints in which the traditional European limits on illusion are negated and new, suggestive approaches to the pictorial surface are explored. In *Joies de Bretagne* (The Pleasures of Brittany, Cat. no. 63) and *Les vieilles filles à Arles* (Old Maids of Arles, Cat. no. 65) – both of which are based upon paintings – the framing line of the margin is intersected by two little dogs or by the curving trunk and foliage of a tree, negating the autonomy of the illusion. Gauguin experimented with the forms of fans in *Les Drames de la mer, Bretagne* (Dramas of the Sea, Brittany, Cat. no. 58), in which a halved fan-shaped form protectively cloaks the two praying women, and *Les Drames de la mer – Une descente dans le Maelström* (Dramas of the Sea – A Descent into the Maelström, Cat. no. 59). In the latter print the fan borrowed from Japanese models[7] – turned at an angle of 180 degrees – is reinterpreted as the interior wall of a turbulent maelstrom into which a fisherman and his boat are pulled, while a ship glides smoothly over the calm water above. The boldly composed print is one of the few works in which Gauguin expressly alludes to a specific literary source. The inspiration in this case was Edgar Allan Poe's tale "Descent into the Maelström", written in 1841, which tells the story of a Norwegian fisherman who, drawn into a deadly whirlpool, has the stringth of mind to save himself.[8] Gauguin does not actually illustrate the text itself but instead draws specific motifs compatible with his own expressive intent from it. Thus the work evokes an image – through suggestion rather than mimesis – of a raging wall of water torn by the clash of multiple forces – Poe describes it as smooth as ebony[9] – through the use of different layers of lithographic ink and a combination of broad and pointed brushes.

The suggestion of a diffuse mood of mystery influenced by the presence of subconscious fears in Gauguin's *Misères humaines* (Human Sorrow, Cat. no. 67), presumably the last print of the *Volpini Suite* to be completed, places the work in close proximity to some of the paintings done during his first stay in Tahiti. Only the figure of the darkly brooding young

girl was extracted from the painting of the same title. All of the remaining elements comprised within the vertical composition are new additions, the standing male figure and the observer seen in the background as well as the curved tree trunk reminiscent of Hiroshige. Integrated into an entirely new context, the girl, who remained totally apart from the events around her in the painting, assumes an active role in a dramatic plot. Her attitude of depression may be regarded as a response to her relationship to the young man who stands beside her; the curious gaze of the figure in the background suggests the surreptitious, forbidden character of the action. These anecdotal associations are qualified at the same time by the high degree of formal stylisation that is particularly evident in the face of the young man, which is partially covered by shadow. The pattern of the shadow, with its resemblance to a distorting facial mask, lends the physiognomy a grotesque quality. This alienation effect alters the figure, which assumes the character of a being from beyond the realm of everyday reality – a precursor of the spell-binding *tupapau* (spirits of the dead) in the Tahiti paintings.

The Noa Noa series and the prints from 1894 to 1895

Aside from his famous portrait of the greatly admired poet Stéphane Mallarmé (Ill. 2), an etching completed by Gauguin in 1890/91 (although Gauguin's first attempt to apply this technique, the print qualifies as a masterpiece of alternation between precise objective definition and suggestive soft-focus), the artist produced no other works of graphic art prior to his departure for Tahiti. It was not until after his return to France, in the winter of 1893–1894, that he began work on a series of ten woodcuts intended as illustrations for his ostensible travel account *Noa Noa*. The specification of ten prints corresponds to Gauguin's original plan to organise the book into ten chapters. It is quite probable that work on the manuscript and on the wooden blocks proceeded more or less hand in hand. In October 1893, before the exhibition of his Tahiti pictures at the Galerie Durand-Ruel was to open, the artist explained in a letter to his wife Mette that he was working feverishly on a book which would be helpful to viewers of his paintings.[10] In April 1894 he wrote to a friend, the poet and critic Charles Morice: "I have just completed my work (woodcut) for *Noa Noa*: I believe it will contribute a great deal to the book's success. Thus the book *must be* [the corresponding words were double-underlined in the manuscript; the author] finished, and as soon as possible."[11] Gauguin obviously had in mind a major work, a visual and literary *gesamtkunstwerk*. Morice was to compile the final text from Gauguin's notes on his life in Tahiti , from the notebook *Ancien culte mahorie*, in which Gauguin had written excerpts from *Voyages aux îles du Grand Océan*, a book published by J. A. Moerenhout in 1837, and from prose passages and poems of his own. In addition to a conventional book-trade edition, the artist apparently planned to produce an exclusive limited edition of thirty copies, illustrated with original woodcuts.[12] The failure of this project in its originally conceived form – Morice first published his edited version of the text in book form without the woodcut illustrations in 1901, after it had already appeared in the journal *La Revue Blanche* in 1897 – is presumably attributable in large measure to Gauguin's characteristically unsystematic nature. It may be assumed that he never developed a concrete concept of either the function or the final form of his book. In any event, the prose fragment[13] and the woodcut illustrations sup-

2 Paul Gauguin: *Portrait of Stéphane Mallarmé*, 1890/91, etching, Bibliothèque Nationale, Paris, Cabinet des Estampes.

port the conclusion that the assistance he expected the book to provide viewers did not consist in detailed interpretations of his paintings, something he had always resisted. The text of *Noa Noa* depicts the artist's life in an original state of nature among the natives, far removed from civilisation, in a loosely connected series of episodes that seldom refer to specific works. As the title – translated as "fragrant" – suggests, the reader is to be immersed completely in this atmosphere of a tropical Arcadia and prepared from the vantage point of that experience to arrive at an adequate understanding of the concrete manifestation of this paradise on earth in painting. The woodcuts, of which virtually none actually illustrates the text, were obviously meant to perform a similar function by fostering the development of associations.

Charles Morice referred to Gauguin's *Noa Noa* series as a "revolution in the art of the woodcut"[14], and rarely has such a euphoric assessment uttered by a well-wishing critic been as appropriate as it was in this case. Indeed, no artist before Gauguin had ever exploited in such a meaningful way the suggestive potential of the material aspects of the print form or the possibility of varying individual prints. Gauguin reworked most of the blocks three or four times, carrying out the last revision of each block in preparation for the formally and chromatically standardised version produced at his request by his friend and colleague Louis Roy in the spring or summer of 1894. Gauguin first processed print blocks composed of multiple layers of boxwood with a gouge to remove larger areas; the next step involved the definition of the outlines of figures and scenery with a graver capable of cutting pronounced contour lines. More delicate lines were drawn with an etching needle, which Gauguin probably also used to cover specific areas with a fine web of hatched lines that allowed for a broad range of modulations within individual fields of colour. His totally unorthodox, eagerly experimental approach to the process of working the print block combined diverse features of a number of different graphic techniques. His preference for long wood – wood cut along the grain – and the technique of working it with a gouge accorded with the classical tradition of European woodcuts since the late Gothic; the use of very hard boxwood, on the other hand, and the practice of processing it with a graver was derived from the wood-engraving technique frequently employed for book illustrations during the 19th century.[15] Gauguin's experimental use of the etching needle, originally employed in copper engraving and etching, was surely a by-product of the work on his Mallarmé portrait. He documented each stage in the processing of the print form by making trial prints on papers of different colours. One of the earliest print versions of *L'Univers est créé* (The Creation of the Universe, Cat. no. 74), printed on pink paper, illustrates the early phase of the creative process; several of the figures and landscape elements found in the final version (see Cat. no. 75) are missing here, and the finished sections are difficult to read, as Gauguin quite clearly lacked experience in the technique of pulling prints by hand. Traces left by the artist's hands and fingernails on the print show that he pressed the paper against the print form by rubbing it with his hands. Over the course of the several steps in the process Gauguin perfected his own technique of producing prints by hand, clearly taking into account both the unpredictable aspects and the possibilities for variation offered by this printmaking method. He produced a large number of prints himself in his Paris studio in the Rue Vercingétorix, employing a technique in which he laid the inked plate together with the paper on his bed, pressing it with his full body weight against the bed to produce the print. One certainly plausible explanation for Gauguin's unique approach to printmaking, which betrayed his

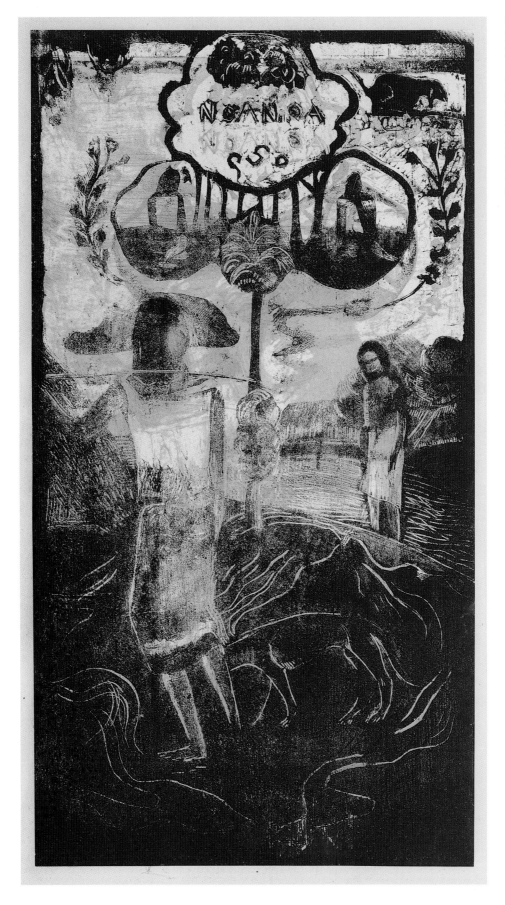

Cat. no. 68
Noa Noa
Fragrance
1893–94
Woodcut, printed by Gauguin
in yellow, black and red
35.8 x 20.4 cm, MKJ 13/III/B
Inscriptions: "NOA NOA",
monogram in top center
"PGO"
Musée National des Arts
d'Afrique et d'Océanie, Paris

Cat. no. 69
Noa Noa
Fragrance
1893–94
Woodcut, printed by Louis
Roy in black, red, orange and
yellow on Japan paper
35.8 x 20.4 cm, MKJ 13/III/D
Inscriptions: "NOA NOA",
monogram in top center
"PGO"
Sammlung E.W.K., Bern

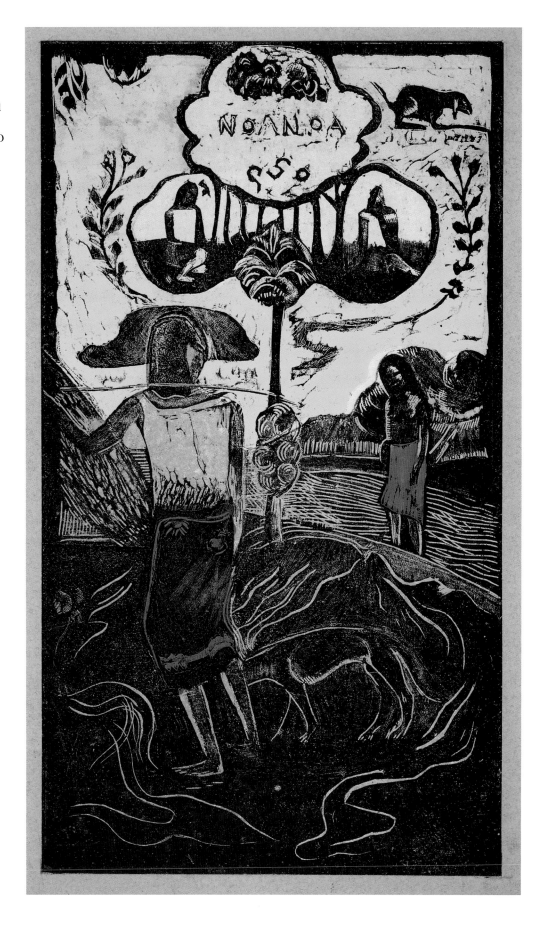

versatility and spontaneous love of improvisation, can be found in the relaxed atmosphere in which the work was done. It was not seldom that Gauguin performed his printmaking tasks in the presence of his Javanese mistress as well as friends or other visitors, to whom the artist was known to make gifts of prints finished in the course of an evening.[16]

As in the case of the *Volpini Suite* of 1889, Gauguin was stimulated in his work on the woodcuts for *Noa Noa* by the printmaking techniques he employed. In response to these impulses he reformulated visual ideas already developed in his previously completed paintings and sculptures. The more painstaking, recalcitrant woodcut technique had an even greater influence on the process of defining form than zinc lithography, however. On the one hand it forced the artist to simplify and to enhance the precision of his original pictorial concept; on the other, the built-in constraints specific to the work process encouraged Gauguin to seek highly abstract solutions in which the original motif gave way to an autonomous harmony of rhythmic surface areas. The sense of coherence that characterises the entire *Noa Noa* series is the product of the reversal of the traditional relationship of positive (white) and negative (black) areas in the woodcut. Gauguin articulated the majority of his figures and landscape elements using thin, white lines which stand out as negative forms against the dominant black ground, giving the prints the appearance of photographic negatives. The dominance of dark background areas in the images has a programmatical function, for Gauguin's illustrations conjured up the mysterious world of Polynesian myths and legends. Hina and Fatu, the gods of the earth and the moon, Ta'aroa, the creator of the universe and, once again, the standing Hina are presented in a frieze-like arrangement in the print entitled *Te atua* (The Gods, Cat. no. 73). *L'Univers est créé* (The Creation of the Universe, Cat. nos. 74, 75) deals with the theme of the rebirth of the human race after the flood, while *Maruru* (Content, Cat. no. 80) and *Mahna no varua ino* (The Day of the Evil Spirit, Cat. no. 76) show the reverence of mortals for the gods in the worship of a monumental idol and in the wild night-time dance ritual. In *Nave nave fenua* (Delightful Land, Cat. no. 70) Gauguin's syncretism is evident in the figure of a Tahitian Eve tempted by a demon in the form of a wingedlizard. The Tahitians' fear of the *tupapau*, the spirits of the dead mentioned in the text of *Noa Noa*, is the subject of the prints *Manao tupapau* (Watched by the Spirit of the Dead, Cat. no. 77) and *Te po* (The Night, Cat. nos. 78, 79). *Te faruru* (Here We Make Love, Cat. no. 71), *Auti te pape* (The Fresh Water is in Motion, Cat. no. 72) and *Noa Noa* (Fragrance, Cat. nos. 68, 69), which was to appear as the frontispiece of the book, deal with the everyday life of the island population. The prints *Maruru, Mahna no varua ino* and *Nave nave fenua* reproduced significant portions of paintings done by Gauguin in Tahiti; while the artist retained his original composition with only a few changes in the first of the above-mentioned woodcuts, the other two prints reveal new approaches to the underlying pictorial ideas. In *Mahna no varua ino*, which is based upon *Upa upa* (The Dance, 1891; The Israel Museum, Jerusalem), the shapes of the witnesses to the fire ritual are visible only as briefly illuminated bodiless silhouettes in the light, which disappear into the blackness of the background immediately. The Arcadian quality of the painted version of *Nave nave fenua* (1892; Ohara Museum of Art, Kurashiki, Japan), in which the figure of the beautiful native woman is shown against the backdrop of abundant, brightly-coloured vegetation, is negated in the woodcut by the dominance of black areas and the primitivistic simplification of forms. The boldly serrated, ornamentally shaped leaves on the trees stand out in threatening clarity against the light background. The blocklike figure of the woman,

Cat. no. 70
Nave nave fenua
Delightful Land
1893–94
Woodcut, printed by Gauguin
in black on vellum
35.5 x 19.9 cm, MKJ 14/II/1
Inscriptions: "NAVE NAVE
FENUA", monogram in lower
left corner "PGO"
Museum of Fine Arts, Boston,
Bequest of W. G. Russel Allen

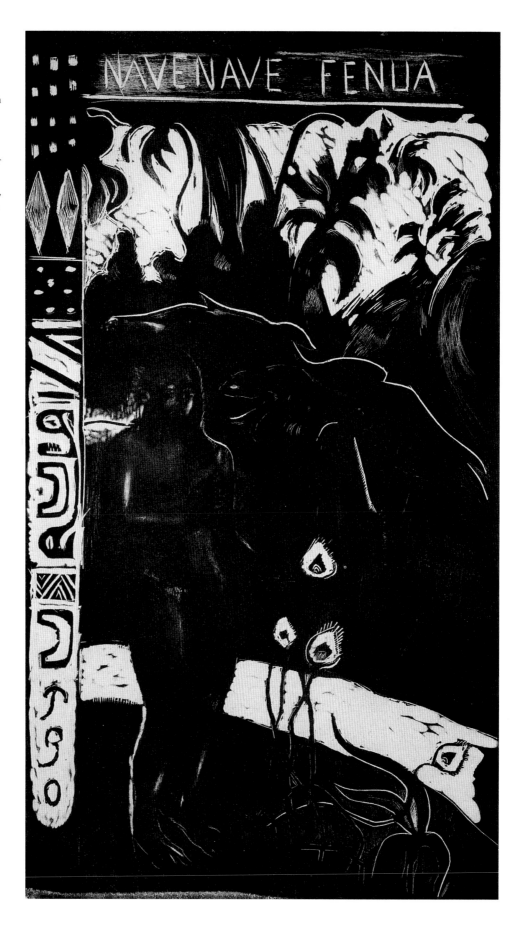

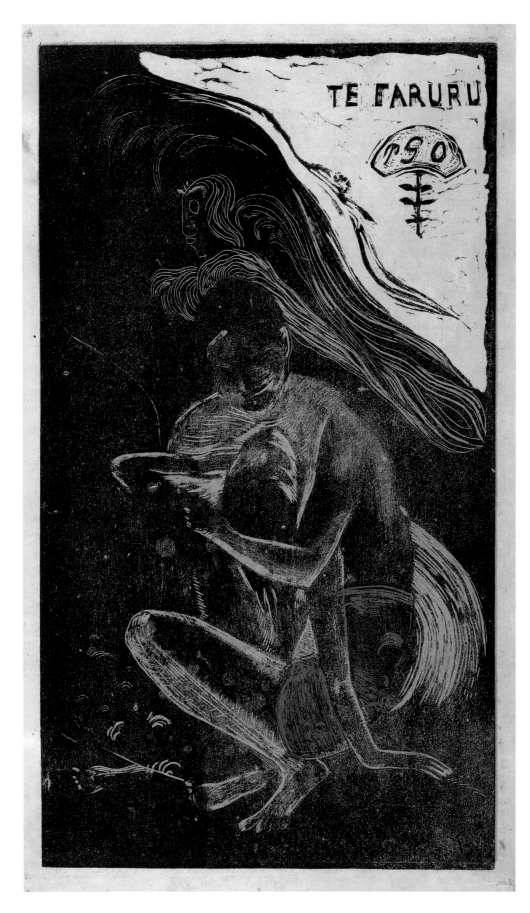

Cat. no. 71
Te faruru
Here We Make Love
1893–94
Woodcut, printed by Louis
Roy in black, red and brown
on Japan paper
35.6 x 20.3 cm, MKJ 15/V
Inscriptions: "TE FARURU",
monogram below title in
upper right corner "PGO"
Sammlung E.W.K., Bern

Cat. no. 72
Auti te pape
The Fresh Water is in Motion
1893–94
Woodcut, printed by Louis
Roy in black, yellow and
orange on Japan paper
20.5 x 35.5 cm, MKJ 16/II/C
Inscriptions: "AUTI TE
PAPE", monogram in lower
left corner "PGO"
Ulmer Museum, Ulm

Cat. no. 73
Te atua
The Gods
1893–94
Woodcut, printed by Gauguin
and Louis Roy in black and
ochre on Japan paper
20.4 x 35.5 cm, MKJ 17/III/C
Inscriptions: "te Alua [sic!]",
monogram in lower left
corner "PGO"
Sammlung E.W.K., Bern

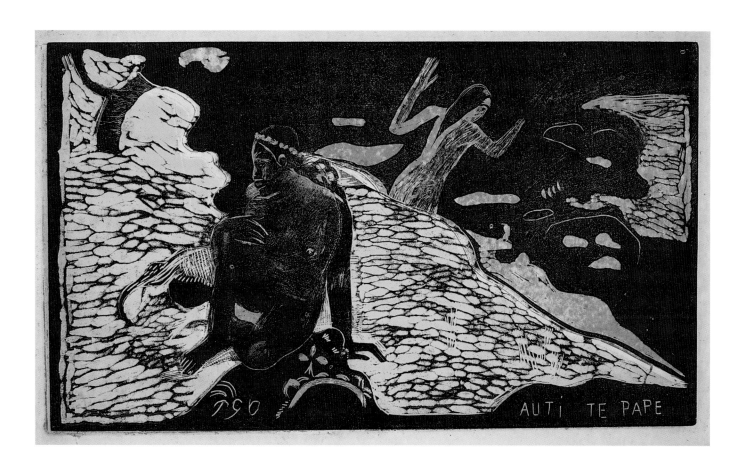

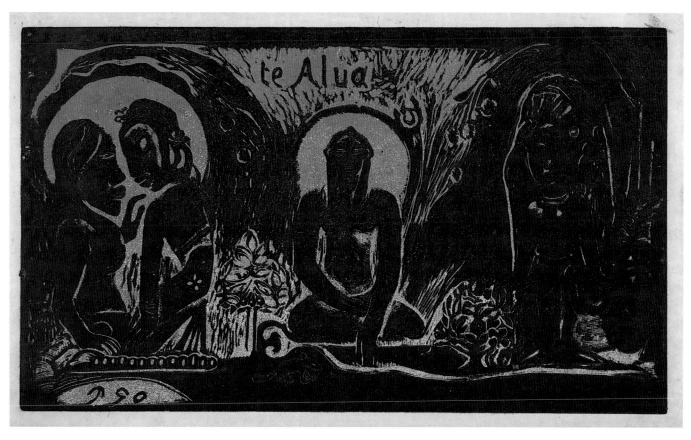

smaller here than in the painting, moves closer to the frightening demon, now much larger, whose wings fill nearly the whole width of the pictorial surface. For the most part, the figures of the gods in *Te atua* are replicas of images originally developed by Gauguin in sculptures done in Tahiti. The vibrant quality of the colour, which also shines through the black print block, deliberately clouds the clearly outlined shapes of the original sculpted figures, lending them an aura of mystery. The lovers in *Te faruru* were adapted as an autonomous group from the painting *Upa upa* and transferred to the protective darkness of a place of impenetrable space. At the point of transition to the light zone on the upper right, flowing lines form the face of a demon who has followed the lovers to their solitary hideaway. *L'Univers est créé* is a compilation of several original motifs from Gauguin's manuscript illustrations for *Ancien culte mahorie*; the group of figures at the right-hand edge of the picture recalls a water-colour on page 21 of the manuscript depicting the *ti'i*, the spirits of nature viewed as subordinate to the gods (Ill. 3). Their domain, as is explained in Moerenhout's text, is that sphere that lies between organic and non-organic life. Thus Gauguin portrayed them in his water-colour as almost surreal hybrid beings: a grotesque face emerges from a pile of sand on the left, two *ti'i* in the shape of deformed fish are seen in communication with one another in the foreground, while in the background a ghostly form with a skull-like head – it resembles the *tupapau* in Gauguin's painting – possibly represents the *ti'i* of darkness and night. The fish in the foreground of the woodcut, partially concealing the figure of the small walking man, is presented in isolation on page 18 of *Ancien culte mahorie*, while the figures shown on a rocky promontory at the left-hand side of the print were adapted from illustrations for the legend of "Roua hatou" (page 37). Enraged by humankind, this god of the sea, roughly equivalent to Neptune, had unloosed a great flood, which only those survived who were able to rescue themselves to the "toa marama", which could mean, as Moerenhout explains, a boat, an island or a chain of mountains. Gauguin interprets this realm of safety in keeping with traditional Christian versions of the great flood as a rocky mountaintop upon which the humans found refuge against the rising flood tides. Thus *L'Univers est créé* unites a number of very different elements of Polynesian mythology, making it impossible to regard the illustration as a myth of creation. Reference to the origin of the world of human beings and spirits is made in the woodcut only through the schematic treatment of forms, which have an iridescent, vibrating quality in the colour print. The hybrid creatures in the right-hand portion of the picture appear more threatening than those in the water-colour version; thus it can be assumed that the surviving human beings remained under the influence of demoniac powers of nature even after their rescue. Gauguin dealt with the subject of the Tahitians' fear of the spirits of the dead, the *tupapau*, in one of his most important paintings from the first sojourn in Polynesia (Ill. 4). The two woodcuts devoted to this theme approach the motif in an entirely new form. In *Manao tupapau*, the entire figure is reinterpreted as a symbol of nameless horrors. The female figure shown turned away from the viewer has assumed a foetal position, while the schematic profile of the spirit flashes out of the darkness. The spatial relationships are dominated entirely by the reclining figure, whose form is isolated from the dark background by a framing oval area. The precarious psychological situation of the frightened native woman is emphasised with signal-like intensity through the marked contrast of the orange sheet with the blackness of the form plate in the print shown here. In *Te po*, the second rendering of the *tupapau* theme, the scene is shifted to a mountainous landscape environment in which the figure of

3 Paul Gauguin: Illustration for the manuscript of *Ancien culte mahorie*, 1892–1893, p. 21, Musée du Louvre, Paris, Cabinet des Dessins.

4 Paul Gauguin: *Manao tupapau* (Watched by the Spirit of the Dead), 1892, oil on canvas, Albright-Knox Art Gallery, Buffalo, New York.

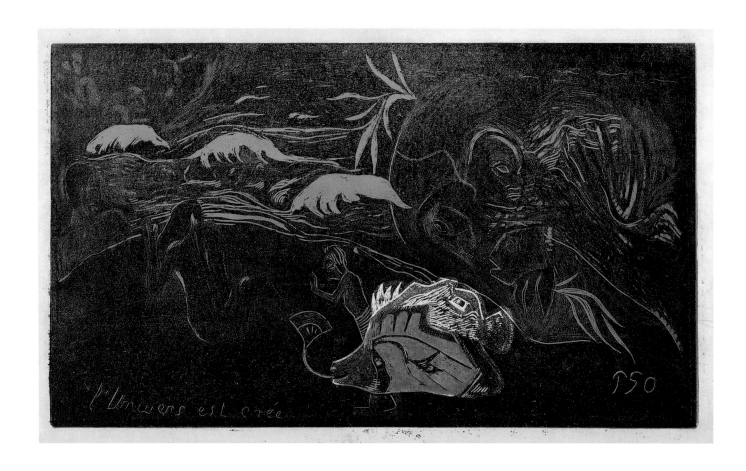

Cat. no. 75
L'Univers est créé
The Creation of the Universe
1893–94
Woodcut, printed by Louis
Roy in black, red and orange
on Japan paper
20.5 x 35.5 cm, MKJ 18/II/D
Inscriptions: "L'Univers est
crée", monogram in lower
right corner "PGO"
Galerie Kornfeld, Bern

Cat. no. 74
L'Univers est créé
The Creation of the Universe
1893–94
Woodcut, printed by Gauguin
in black on pink paper
20.5 x 35.5 cm, MKJ 18/I
Bibliothèque Nationale, Paris,
Cabinet des Estampes

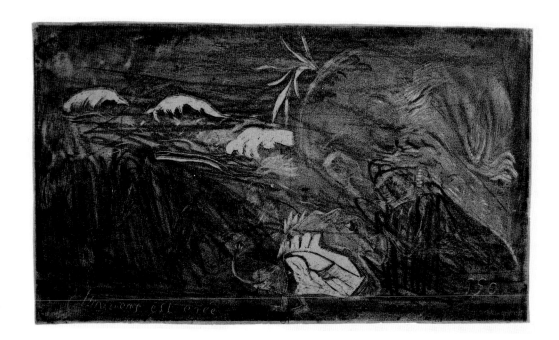

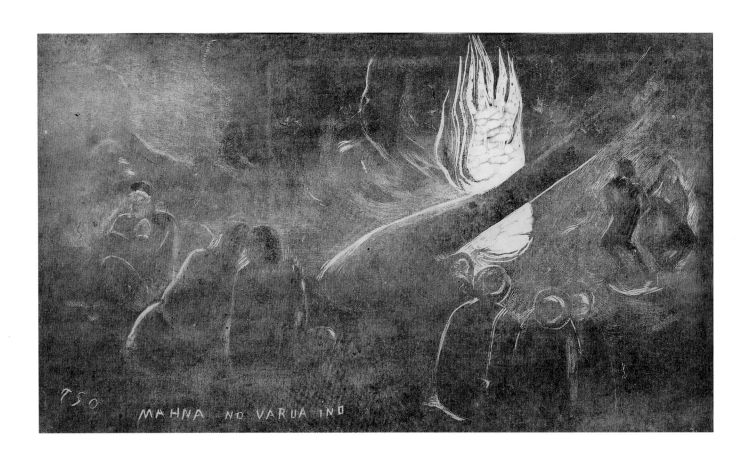

Cat. no. 76
Mahna no varua ino
The Day of the Evil Spirit
1893–94
Woodcut, printed by Gauguin
in ochre and black on Japan
paper
20.2 x 35.6 cm, MKJ 19/III
Inscriptions: "MAHNA NO
VARUA INO", monogram in
lower left corner "PGO"
Musée National des Arts
d'Afrique et d'Océanie, Paris

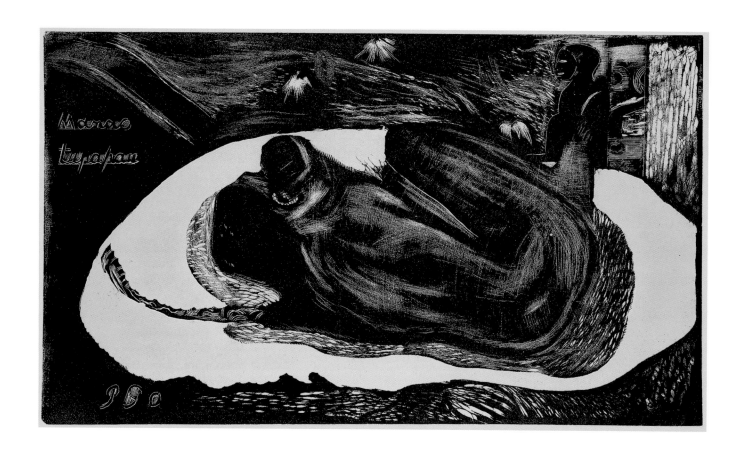

Cat. no. 77
Manao tupapau
Watched by the Spirit of the
Dead
1893–94
Woodcut, printed by Gauguin
in black on orange paper
20.5 x 35.5 cm, MKJ 20/I
Inscriptions: "Manao Tupa-
pau", monogram in lower left
"PGO"
Museum of Fine Arts, Boston,
Bequest of W. G. Russel Allen

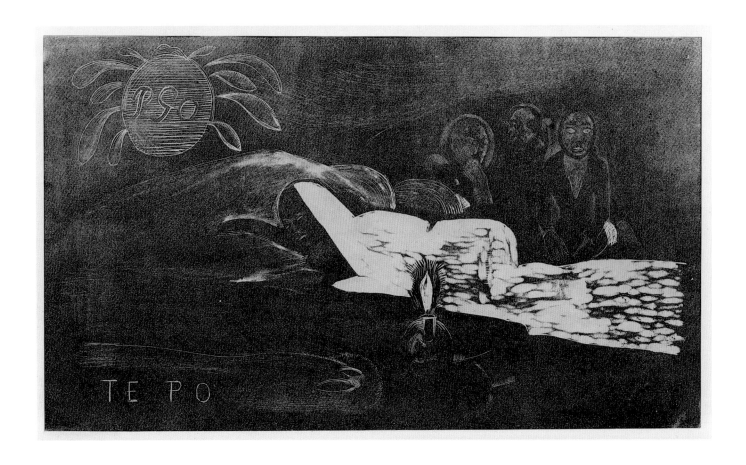

Cat. no. 78
Te po
The Night
1893–94
Woodcut, printed by Gauguin
in brown and black on Japan
paper
20.6 x 35.6 cm, MJK 21/III
Inscriptions: "TE PO", mono-
gram in upper left corner
"PGO"
Musée National des Arts
d'Afrique et d'Océanie, Paris

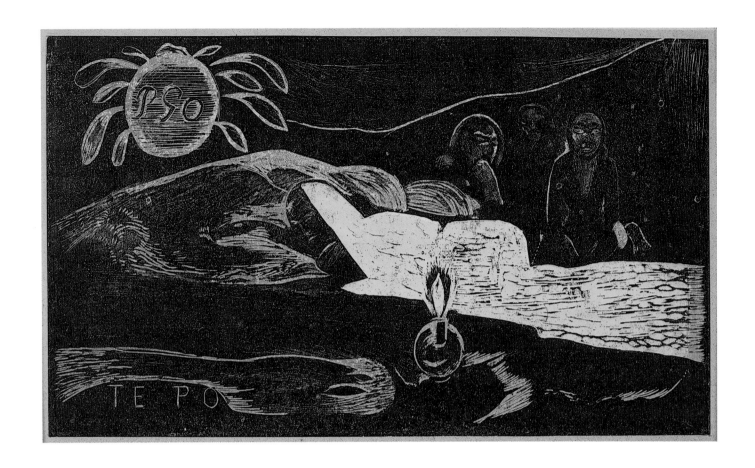

Cat. no. 79
Te po
The Night
1893–94
Woodcut, printed by Louis
Roy in black, yellow and
orange on Japan paper
20.5 x 35.6 cm, MJK 21/IV/C
Inscriptions: "TE PO", mono-
gram in upper left corner
"PGO"
Ulmer Museum, Ulm

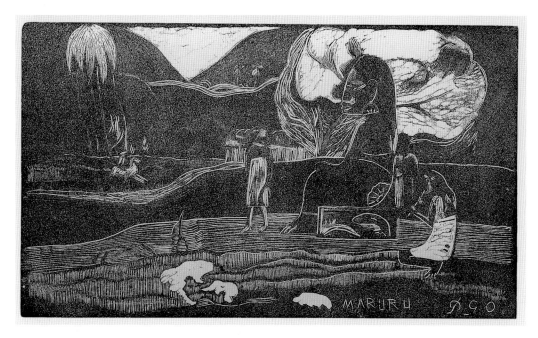

the reclining woman is inscribed. The spirit of the dead watches over her, a figure Gauguin consistently depicted in the form of a small woman with rigid, masklike features. To the spirit's left sits Gauguin himself, who also appears as a spectre of the night. The artist's signature hovers above the scene as a potent talisman framed by a circular form resembling a plant or the sun.

A look at the print *Auti te pape* reveals the extent to which Gauguin's experience with his own original and unconventional approach to the processing of the wood block stimulated him to modify his original pictorial ideas. Here, the figures of the two bathers serve only as the germinal impulse for a composition in which the abstract harmony of the surface areas and their different textures, achieved with a gouge and etching needle, neutralise the anecdotal content of the print. The forms in the upper right quadrant, in particular, have nothing to do with objective depiction and are employed solely for the purpose of generating tension between forms and opposing forms, between positive and negative fields. The autonomy of the formal aspect and its dominance vis-à-vis the content of the print are undoubtedly the product of a complex creative process in the course of which Gauguin was inspired by the characteristics of the graphic techniques at his disposal to explore new visual approaches he himself could not have foreseen. The woodcut, deliberately chosen by Gauguin as a medium that would allow him to imbue existing pictorial ideas with new, primal-primitive potency, encouraged its creator to go beyond the objective, narrative emphasis that had previously characterised his art. The diffuse noctural ambiance engendered by the black colour of the form plates, in which Gauguin imbedded his partially reconstructed and otherwise freely invented Tahitian mythology, provides nourishment for a purely aesthetic, in other words no longer strictly content-oriented poetry. This is particularly evident in Gauguin's handmade prints (Cat. nos. 68, 70, 74, 76, 77, 78, 80). The artist's primitive technique and the exacting, time-consuming work of cutting the boxwood blocks would have made the realisation of a preconceived notion of content very difficult. Thus Gauguin's focus shifted away from the articulation of precise, motif-based forms towards the

Cat. no. 82
Manao tupapau, Femme mao-
rie dans un paysage d'arbres
Watched by the Spirit of the
Dead, Maori Woman in the
Forest
1894–95
Woodcut, printed in 1928 by
Daniel de Monfreid in black
on Japan paper
22.5 x 25.5 cm, MKJ 30/2/b
Bibliothèque Nationale de
France, Paris, Cabinet des
Estampes

largely unpredictable process of discovering unknown formal and chromatic harmonies. A revealing example is found in the handmade print of *Noa Noa*, now in the collection of the Musée National des Arts d'Afrique et d'Océanie, Paris (Cat. no. 68; the original painting is illustrated as Cat. no. 27). The thin coat of colour on the form plate and the excessively low placement of the yellow tone plate on the paper make the objects in the picture extremely difficult to recognise. Instead of the precisely delineated form and colour fields found in the print made later by Louis Roy (Cat. no. 69), this version presents a diffuse impression containing a great deal of light, in which the overlapping of colours and forms creates the effect of spatial depth. None of Gauguin's contemporaries ever produced a print character-ised by such a vivid effect of a state of suspension in which the viewer gains only a vague sense of objective representation as the point of departure for his own associations. The monotype prints done by Edgar Degas (Ill. 5), often cited as comparable examples, lack the suggestion of mystery, the notion of unknown worlds which, until Gauguin, only Turner had achieved in paintings such as his *Sunrise with Sea Monsters* (Ill. 6), using a similar process of alternation between implications of objectivity and abstract surface arrangements devel-oped entirely from within the painting process itself. In the woodcuts of Edvard Munch (Ill. 7), to which the *Noa Noa* series has also been frequently compared, the material quality of the print block as expressed in the animated grain pattern of the long wood is also incor-porated meaningfully into the composition; yet Munch's prints show no evidence of improvisation in the act of inking and pressing the block. Form and colour plates in Munch's woodcuts are each assigned separate functions in the process of generating psy-chological tension, as their clear separation in the prints clearly shows. The *Noa Noa* series deserves to be regarded as Gauguin's boldest and most "modern" work of art – modern, because in these prints the depiction of a familiar iconography is subordinate to the explor-ation of new forms from the perspective of the graphic techniques employed by the artist.

Gauguin continued to explore the potential for new aesthetic solutions from the stand-point of technique in another series of woodcuts, some of which were probably done par-allel to the *Noa Noa* series in 1894 and 1895. In *Oviri*, Gauguin presents his own creation, the idol of his mysterious realm of savagery[17] shining forth out of a dark background in which traces of tropical vegetation can be seen. Here again his improvising approach to the technique of hand pressing produces widely differing interpretations of the same print form. The full effect of the print from the Museum of Fine Arts in Boston (Cat. no. 85) derives from the varied textures on the surface of the print block – traces of the gouge, the etching needle and the grain of the wood – which become clearly visible in the simple print with its relatively thin coat of black colour. In contrast, the colour in the print from the Musée National des Arts d'Afrique et d'Océanie (Cat. no. 84) forms a kind of spotty, extremely dense emulsion that spreads like a veil over the objects in the picture. This delib-erate veiling heightens the sense of mystery, as the bloodthirsty divinity can assume sharper contours only in the viewer's active imagination.

The psychological concentration of the *tupapau* theme within a square format in which the frightened face of the native and the apparition of the spirit of death are juxtaposed in close proximity appears in another print from the Musée National des Arts d'Afrique et d'Océanie (Cat. no. 81) in the immediate vicinity of the image of a woman amidst a land-scape with trees, a work also based upon a Tahiti painting (*Te poi poi*, see Cat. no. 33). Also visible – in the upper right-hand corner of this print – is a representation of a Maohi woman

5 Edgar Degas: *Reading after the Bath*, circa 1877, monotype, Klipstein & Kornfeld, auction 100, Bern, June 8th, 1961, No. 23.

6 William Turner: *Sunrise with Sea Monsters*, circa 1845, oil on canvas, Tate Gallery, London.

7 Edvard Munch: *Moonlight*, 1896, colour woodcut, Staats-galerie Stuttgart, Graphische Sammlung.

Cat. no. 83
Idole tahitienne
Tahitian Idol
1894–95
Woodcut, printed by Gauguin
15.1 x 12 cm, MKJ 32
Inscription: Monogram in lower left corner "PGO"
Sammlung E.W.K., Bern

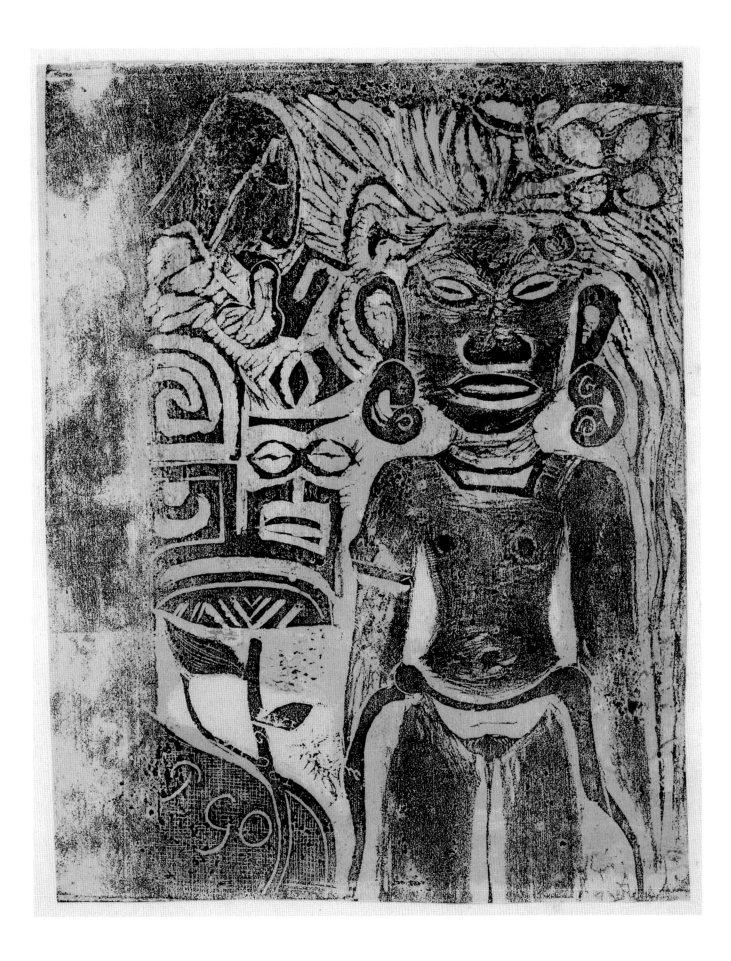

133

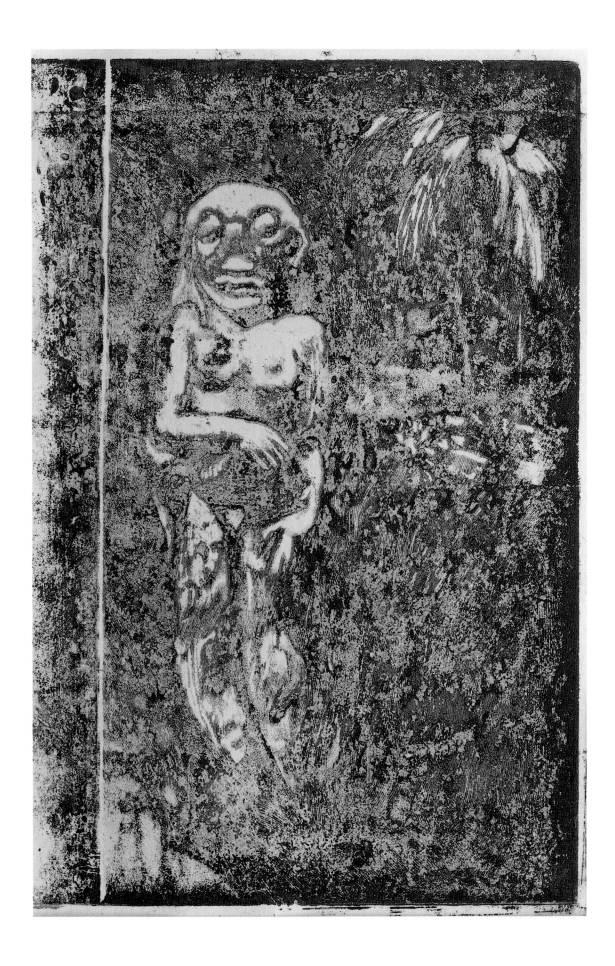

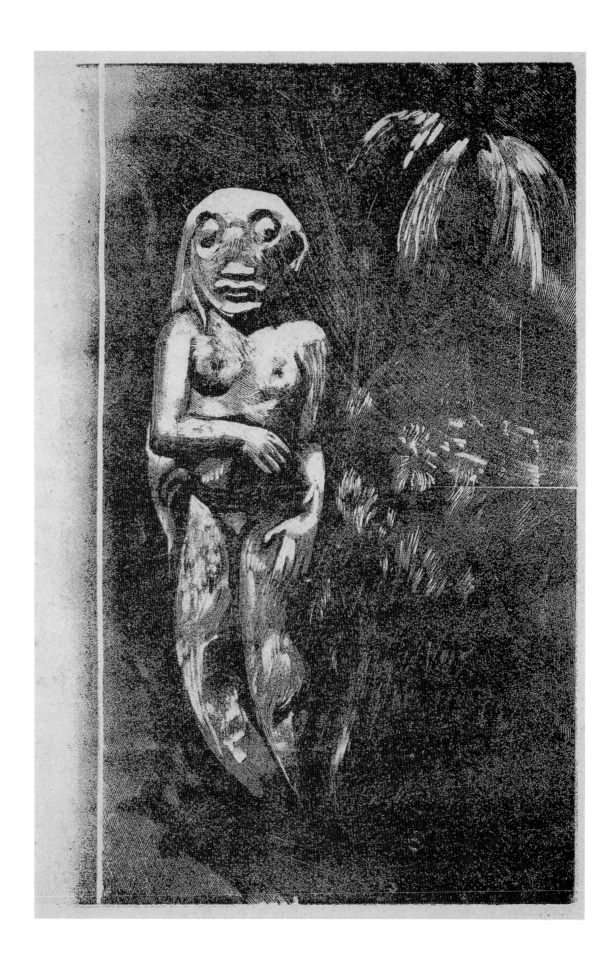

standing, an image that is difficult to interpret. The print form used for this woodcut is the reverse of the block for *Manao tupapau* from the *Noa Noa* series (Cat. no. 77). The combination of such divergent motifs in a single print is presumably the consequence of Gauguin's economical use of material. The artist probably intended to separate the pictures by cutting the printed sheet. The fragment showing the standing woman is absent in the second pressing made from the block, a print which was not made until 1928 by Gauguin's friend and correspondent Daniel de Monfreid (Cat. no. 82). The opposition of three-dimensional and surface-oriented components already seen in the woodcut entitled *Nave nave fenua* (Cat. no. 70) is also present in the print *Idole tahitienne* (Tahitian Idol, Cat. no. 83). The ornaments shown here are based upon Marquesan carvings Gauguin encountered in the South Pacific. The optical vibrancy generated by the combination of the form plate with the orange tone plate gives this loose arrangement of diverse objects both its formal unity and its mysterious vitality.

In the prints *Manao tupapau* (Watched by the Spirit of the Dead) and *Ia orana Maria* (Hail Mary) Gauguin turned once again to the established printmaking techniques of zinc and stone lithography. *Ia orana Maria* (Cat. no. 87) reproduces the figure of the Madonna with child from the painting of the same name now held in the collections of the Metropolitan Museum of Art in New York, completed in 1891–92. The print gains its tension from the contrasts between the succinct shaping lines with the diffuse surface tones in broadly applied lithographic chalk which are loosely distributed over most of the print but condense to form the suggestion of a palm crown behind the heads of the figures. The lithograph *Manao tupapau* (Cat. no. 86) is a largely accurate replica of the painting bearing the same title which is now on exhibit at the Albright-Knox Art Gallery (Ill. 4). Its colour tension is adeptly transported into a rich spectrum of light-and-shadow contrasts which inject an entirely new element of drama into the composition.[18] The sense of danger is evoked less by the spirit figures seen near the right-hand edge of the print – where the *tupapau* of the original painting is joined by a shadowy figure, of which only the grotesque profile and one hand are visible, and a figure representing the moon goddess Hina – than by the dark, semi-circular field, surrounded by fluorescent elements of light, above the woman's bed. As was the case in several of his earlier prints from the *Volpini Suite*, Gauguin's discerning use of chalk, pen and brush wash techniques allowed him to create a pictorial surface that stimulates the viewer's eye.

At Gauguin's exhibition of his prints and water-colours at his studio in Rue Vercingétorix from the 2nd to the 9th of December 1894 the artist showed prints made using the "dessin-empreinte" technique (literally, "printing drawing").[19] The procedure involves a rudimentary copying process in which a sheet of paper containing a drawing or painting done in water-colour, gouache or water-soluble pastel chalk is used as a kind of master. Another sheet of paper soaked in water is laid over the completed master, and the pigments applied to it are rubbed onto the moist paper with the aid of a spoon. The result is a reverse image of the original composition. Gauguin was able to make as many as three such prints from a single master. He then reworked these, using water-colours and chalk, to produce a hybrid form of hand-drawn print.[20] Once again, the printmaking technique employed in these works appears to have had an inspiring effect on the artist in his search for a final form. The transparent, shadowy traces of pigment on the prints provided Gauguin a basis from which to approach an entirely unique reinterpretation of each individual motif,

pages 134–135
Cat. no. 84
Oviri
Savage
1894–95
Woodcut, printed by Gauguin in black and brown with touches of grey wash
20.5 x 12.3 cm, MKJ 35
Musée National des Arts d'Afrique et d'Océanie, Paris

Cat.no. 85
Oviri
Savage
1894–95
Woodcut, printed by Gauguin in reddish brown
20.5 x 12.3 cm, MKJ 35
Museum of Fine Arts, Boston, Bequest of W. G. Russel Allen

8 Paul Gauguin: *Le Manguier* (The Mango Tree), 1894, watercolour transfer, Edward McCormick Blair.

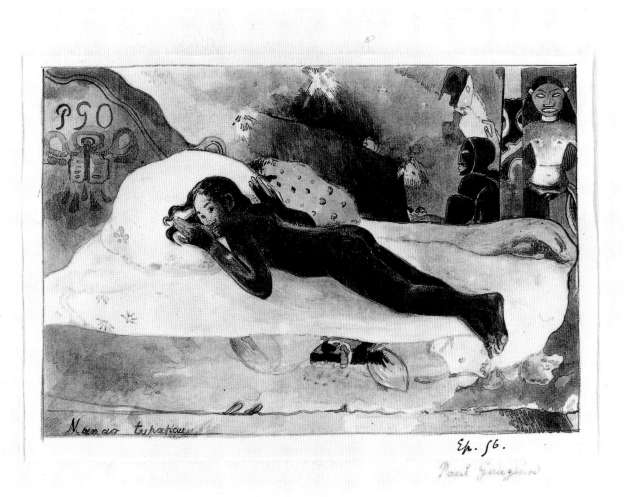

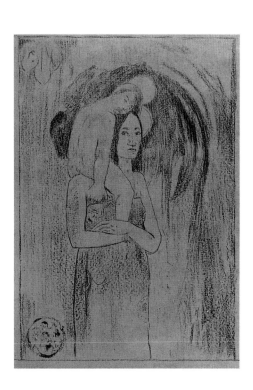

Cat. no. 86
Manao tupapau
Watched by the Spirit of
the Dead
1894
Lithograph in pen, crayon
and wash
18 x 27.1 cm, MKJ 23/B
Inscriptions: Title in lower left
corner "Manao tupapau",
monogram in upper left
corner "PGO"; numbered by
the artist in lower right "Ep 56"
(proof no. 56 of an edition of
100 impressions)
Ulmer Museum, Ulm

Cat. no. 87
la orana Maria
Hail Mary
1894–95
Zincograph
25.6 x 17.7 cm, MKJ 27/B/a
Inscription: Monogram in
lower left corner "PGO"
Museum of Fine Arts, Boston,
Bequest of W. G. Russell Allen

although he remained consistently dedicated to preserving the non-material quality of suspension in the print images. The richer contrasts found in a second pressing (in the Edward McCormick Blair Collection; Ill. 8)[21] showing only the upper half of the print presented here under the title *Le Manguier* (The Mango Tree, Cat. no. 88) were achieved through the addition of chalk and water-colour to the print.

The prints from Gauguin's second sojourn in Tahiti

Gauguin made a substantial number of prints during his second stay in Tahiti (from 1895 to 1901). During the period from 1896 to 1898 alone he completed 17 woodcuts, a group known as the *Suite Vollard*, named for the Paris art dealer Ambroise Vollard. In a letter written in January 1900 Gauguin informed Vollard of the delivery of 475 woodcuts he had printed himself in editions of from 25 to 30 numbered sheets.[22] Most of these prints were reproductions of paintings done during Gauguin's first and second stay in Tahiti and included *Eve* (Cat. no. 89) and *Te arii vahine – Opoi* (Reclining Queen, Cat. no. 90), based on the paintings *Parau na te varua ino* (see Cat. no. 39) and *Te arii vahine* (1896; Moscow, Pushkin Museum). Remarkable in both of these prints is the immediate juxtaposition of three-dimensional elements – the bodies of the women – and flat forms, through which a precise spatial fixation of the objects in the image is avoided. In *Eve* the artist placed a flat projection of the head of the *tupapau* in direct proximity to the figure of his female protagonist, so that it seems to emerge suddenly from a void. The curved outline of the tree stump with the animal sitting upon it combines three-dimensional and surface-oriented forms, while Gauguin's prominent signature emphasises the two-dimensional quality of the image-bearing paper. The composition *Te arii vahine – Opoi* relies upon a similarly autonomous decorative surface effect, presenting the figure embedded in a rhythmic structure of stylised plant shapes. As in the earlier print *Auti te pape* from the *Noa Noa* series (Cat. no. 72) the landscape elements of shoreline and sea familiar from the painting are given new meaning within an abstract harmony of flat forms and counter-forms. The decorative effect evoked by this composition is also achieved in prints such as *Planche au diable cornu* (Plate with the Head of a Horned Devil, Cat. no. 91), which open a view to the world of demons. The threatening grotesques and animals are inscribed in a construction consisting of different-sized circular segments which give the pictorial surface an entirely abstract dynamic vitality. The artist's intention to achieve a harmonious, decorative surface effect in the woodcuts of the *Suite Vollard* finds its parallel in paintings done about the same time, in which he drew from every phase of his previous work in an effort to cultivate a uniquely personal form of classicism. Accordingly, the print entitled *Te atua* (The Gods, Cat. no. 92) combines several motifs from older creations in a new composition. The curved configuration of the visible architecture is based upon the Calvaria Mountains in Brittany, as are the two figures on the left and right sides of the scene. They were adapted from the painting *Nuit de Noël* (Christmas Eve; private collection), which Gauguin presumably completed in Brittany in 1894. The sense of architectural stringency evoked in the composition by the arch segment and the sculptural stillness of the figures is counteracted by the animals and the fairy-tale beings arranged at various levels in the centre of the scene, which appear stacked directly on top of each other in a space totally devoid of perspective. The arched segment is filled almost completely by the masklike pro-

Cat. no. 88
Le Manguier
The Mango Tree
1894
Watercolour transfer (Dessin-empreinte) on wove paper
26.4 x 17.7 cm
Musée du Louvre, Paris, Département des Arts Graphiques (Fonds du Musée d'Orsay)

pages 140–141
Cat. no. 89
Eve
1898–99
Woodcut, printed by Gauguin on Japan paper, numbered by Gauguin (no. 12).
28.3 x 21.5 cm, MKJ 42/II/b
Inscription: Monogram in upper left "PG"
Sammlung E.W.K., Bern

Cat. no. 90
Te arii vahine – Opoi
Reclining Queen
1898
Woodcut, printed by Gauguin on Japan paper
22.5 x 30.2 cm, MKJ 44/A
Inscription: Monogram in upper left "PG"
Staatsgalerie Stuttgart, Graphische Sammlung

Cat. no. 91
Planche au diable cornu
Plate with the Head of a Horned Devil
1898–99
Woodcut, printed by Gauguin on Japan paper
17.5 x 29.7 cm, MKJ 48
Inscription: Monogram in lower right corner "P"
Staatsgalerie Stuttgart, Graphische Sammlung

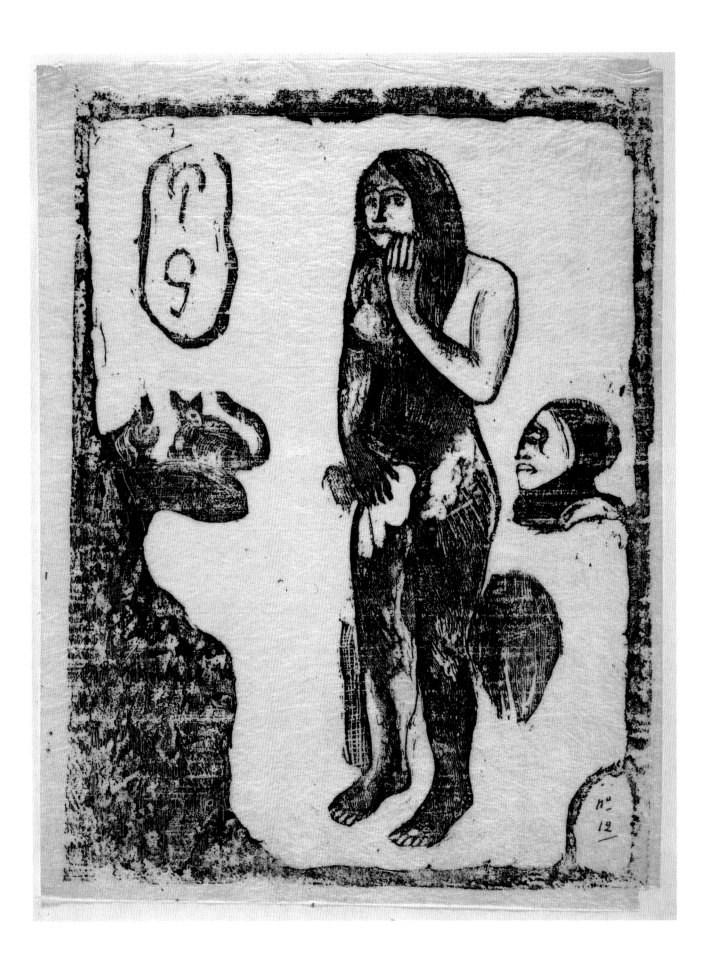

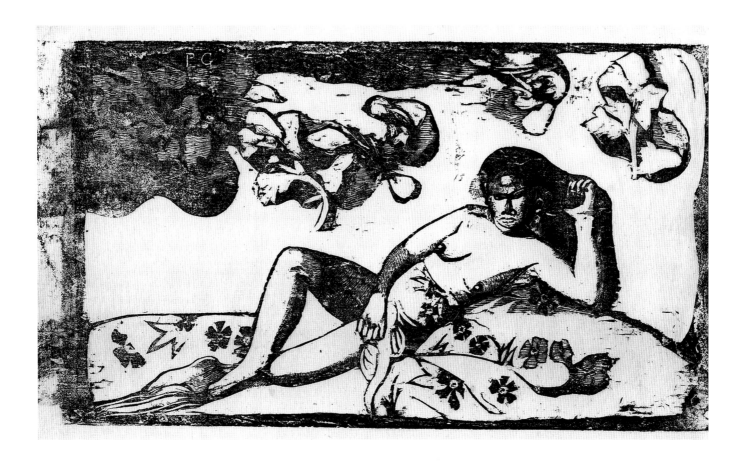

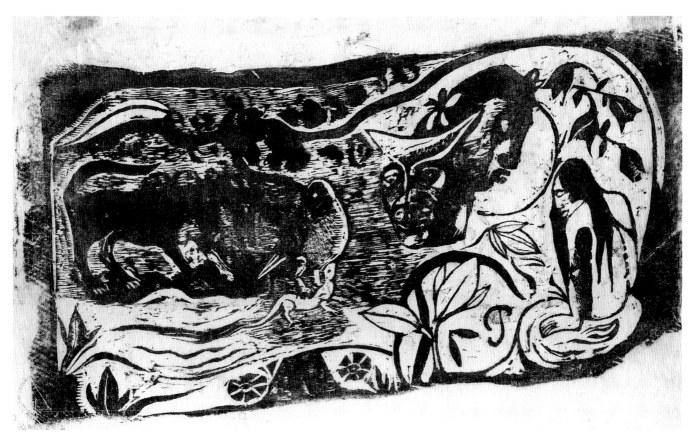

file of an oversized demon's head. Unlike the woodcut of the same title from the *Noa Noa* series (Cat. no. 73), a print featuring only Tahitian divinities, Gauguin creates a syncretistic vision in this work by uniting Christian imagery in the form of the Virgin Mary and child with the realm of Polynesian nature demons. The harmonious interplay of these metaphysical beings is in close accord with the balance achieved in the composition, in which light and shadow are distributed evenly over the entire surface of the picture. The three distinctly different versions of this woodcut that have been preserved are the products of Gauguin's experimental modification of the classical combination of form and tone plate. At first he only roughly processed the print block for *Te atua*, as he had initially conceived this first phase of the printmaking process as a tone plate. Gauguin made two series of prints from this roughly worked block, one on standard paper and the other on transparent Japan paper. Then he reworked the print block, perfecting his composition in complete detail. The finished form plate was then used to produce two more sets of prints on standard and Japan paper. At this point Gauguin joined the separately pressed versions representing the two phases of his print, either by placing the transparent print from the form plate over a grey print from the tone plate (as in Cat. no. 92) or by laying a transparent print from the tone plate over the black print from the form plate made on normal paper. This technique permitted Gauguin to achieve a wealth of nuances through slight shifts in the position of the two print images. When the two images are matched precisely, the grey of the tone plate intensifies the effect of the black lines on the form plate. The farther apart the two phases are, the greater is the formal autonomy of each. In addition to these composite prints there are also versions of *Te atua* in which Gauguin printed the second phase of the work directly over the grey first phase. The grey tone in this version looks denser, as it is not filtered through the Japan paper. The scene appears veiled in the darkness of night, from which only a few isolated elements, among them the Virgin and her child, shine forth.

Each of these variant combinations of form and surface tone gives the print an entirely different effect; each articulates the subject in a new way from the perspective of the suggestive qualities of the particular technique employed. In an interview with Eugène Tardieu conducted shortly before his second departure to Tahiti, Gauguin had emphasised the intended suggestive character of his art: "My simple subject, which I take from life or nature, is merely a pretext that helps me by means of a definite arrangement of lines and colours to create symphonies and harmonies. They have no counterparts at all in reality, in the vulgar sense of that word; they do not give direct expression to any idea, their only purpose being to stimulate the imagination … simply by means of the mysterious affinities that exist between our minds and certain arrangements of colours and lines."[23] It was undoubtedly in the medium of the print, with its mixture of calculation and experimentation, that Gauguin found the purest expression of his liberation from all reference to reality outside the pictorial image and from his own preconceived notions. In the course of the creative process and aided by the reciprocal effect of technique upon the artist's imagination, Gauguin's emphasis shifted away from a strict approach to the realisation of an idealistic concept in favour of the deliberate exploration of the potential for new suggestive effects, thus opening the work of art to a rich ambiguity.

As has already been established, Gauguin's prints stand entirely alone within the context of the period in which they were made. Neither the lithographs nor the woodcuts done by the Nabi group and the representatives of Art Nouveau are comparable in terms of their

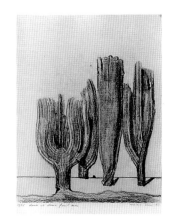

9 Max Ernst: *Deux et deux font un* (Two and Two Make One), 1925, frottage, Staatsgalerie Stuttgart, Graphische Sammlung.

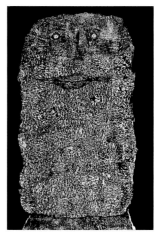

10 Jean Dubuffet: *Head of a Bearded Man*, 1959, print collage, Staatsgalerie Stuttgart, Graphische Sammlung.

Cat. no. 92
Te atua
The Gods
1899
Woodcut, printed by Gauguin, second state impression on thin Japan paper pasted on first state impression
23.5 x 24 cm, MKJ 53/II/B/b
Inscriptions: "TE ATUA" above peacock, monogram "PG" to left of title
Staatsgalerie Stuttgart, Graphische Sammlung

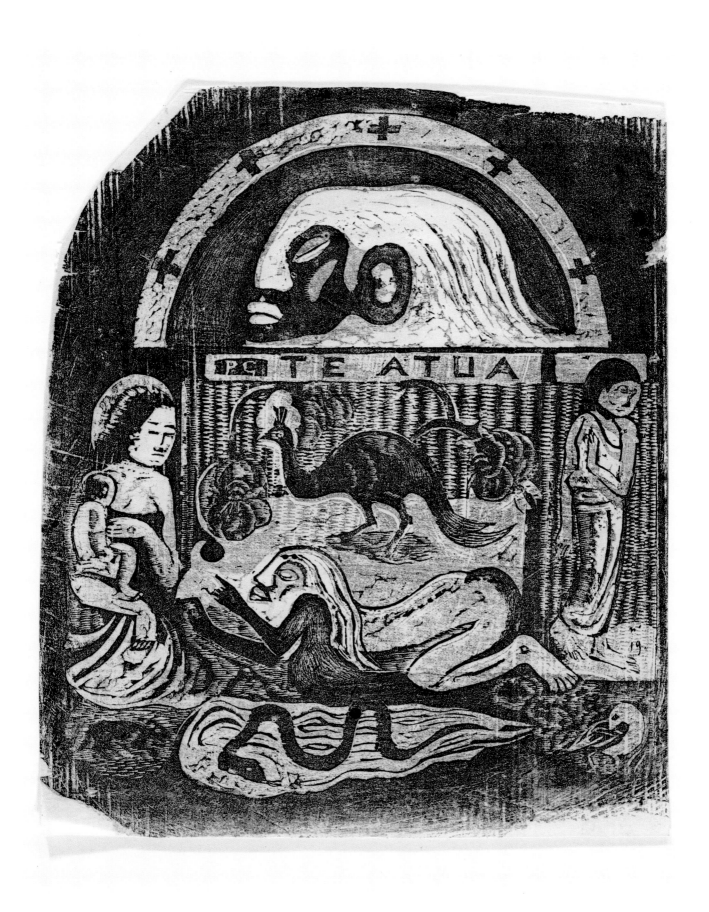

143

openness to the suggestive autonomous influence of particular techniques; even Matisse, Picasso and Braque continued for some time to carry out their experiments in the analysis of form in the classical medium of the oil painting. It was not until the rise of Surrealism that artists once again turned their attention to the stimulating effect of the discovery of unsuspected forms in the course of the creative process. In the *frottages* he began producing in 1925 Max Ernst compounded found textures to arrive at new visual imagery characterised by a state of suspension between an implied mythical world and the autonomous effects of the textures that call to mind several of Gauguin's woodcuts (Ill. 9). This pattern of alternation between the evocation of figural form and the abstract texture of the material employed is also evident in the "assemblage d'empreinte" technique used by Jean Dubuffet beginning in 1953, a procedure in which objective motifs are pieced together from pieces of paper with differing textures created through a process similar to monotype printmaking. The primitivistic, archaic design of Dubuffet's *Head of a Bearded Man* (Ill. 10) produces an image remarkably similar to Gauguin's *Oviri* (Cat. no. 84). Quite recently, the aspect of the further development of previously formulated pictorial ideas on the basis of the specific possibilities inherent in the printmaking process, an issue of critical importance to Gauguin, has attracted new attention. An interesting example is the work of Markus Lüpertz, who in his large two-colour woodcut entitled *Man with a Chicken*, 1986 (Ill. 11), translates a bronze sculpture into an emphatically silhouette-like two-dimensional form whose aggressive vitality derives from patterns of parallel crossed hatching. The examples cited here clearly demonstrate that Gauguin's prints, as combinations of figural representation and texture fully amenable to experimentation, contain prototypical forms of essential features of 20th-century graphic art.

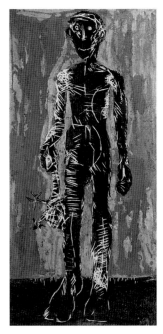

11 Markus Lüpertz: *Man with a Chicken*, 1986, two-colour woodcut with painted green background, Staatsgalerie Stuttgart, Graphische Sammlung.

1 Cited from Prather/Stuckey 1994, p. 109.

2 See Melot 1996, pp. 156–157.

3 It is possible that Theo van Gogh called his attention to this advertising effect, as the Boussod et Valadon art dealership, whose Paris branch van Gogh managed, had already published several series of reproductions of works by Degas and of works by the old masters exhibited at the Louvre; see exhib. cat. Munich/Vienna 1990, pp. 10–11. In any event, Gauguin claimed in a letter to van Gogh dated January 20th, 1889 that it had been Theo who suggested the idea for the lithographs of the *Volpini Suite;* see exhib. cat. Paris 1989, p. 148.

4 In the November 9th, 1889 issue of the journal *Art et Critique* Jules Antoine criticised what he saw as the arbitrary deformation of the human figure in the lithographs; see Prather/Stuckey 1994, p. 130.

5 The same yellow tone was used in Japan in New Year's cards and book bindings, as in the case of Hokusai's *Manga*, for example. French publications on Japanese art issued during the 1880s also made use of this particular yellow. See exhib. cat. Munich/Vienna 1990, p. 41.

6 The reprint of the *Volpini Suite* was undertaken on the initiative of the art dealer Ambroise Vollard, who had acquired the print blocks from Gauguin's friend Schuffenecker; see exhib. cat. Munich/Vienna 1990, p. 44. Mongan, Kornfeld and Joachim, authors of the most recent critical index of Gauguin's prints, concur with Douglas in dating the printing of the second edition after 1900, although 1894 or 1894/95 had previously been cited as possible years of origin; see MKJ 1988, p. 11. The first edition comprised some 30 prints, the second about 50.

7 With respect to possible Japanese models for this unusual use of the fan form see exhib. cat. Stuttgart/ Zurich 1984, p. 154.

8 See Edgar Allan Poe, "A Descent into the Malström", in *The Complete Tales and Poems of Edgar Allan Poe*, New York, 1938, pp. 127–141. As Ina Conzen-Meairs has demonstrated, what probably interested Gauguin most about the scene in question was the idea of awakening from a passive state of trance, which he saw as an analogy to his own struggle for artistic renewal far from western civilisation; see Conzen-Meairs 1989, p. 79.

9 Poe, *op. cit.*, p. 136.

10 See exhib. cat. Paris 1989, p. 316.

11 Cited from Gauguin 1992, p. 92.

12 This assumption is supported by the fact that Gauguin had an edition of about 30 copies of the *Noa Noa* series produced by Louis Roy in the spring or summer of 1894. He kept the edition himself, however, and did not offer it for sale.

13 The manuscript is held at the Getty Center for the History of Art and the Humanities. The most recent critical edition with commentaries was published by Pierre Petit (Paris 1989).

14 Review of the exhibition of prints at Gauguin's Paris studio in *Le Soir*, December 4th, 1894.

15 Adolph von Menzel's illustrations for Franz Kugler's *Geschichte Friedrichs des Großen* (1840), for example, were redone as wood engravings produced by specialised craftsmen.

16 The most important document regarding Gauguin's working methods is the report written by the Hungarian painter Jószef Rippl-Rónai on the reverse of a copy of *Nave nave fenua*. This print, which Gauguin had personally given to Rippl-Rónai on the occasion of the latter's visit to Gauguin's home on the Rue Vercingétorix, is now preserved in the Lessing J. Rosenwald Collection of the National Gallery of Art in Washington. See Field 1968, p. 503.

17 *Oviri* means "savage" in Tahitian. A divinity in Tahitian mythology regarded as a god of death and mourning bears the name "Oviri-mœ-aihere" (The Savage Who Sleeps in the Forest). See exhib. cat. Paris 1989, p. 361.

18 The lithograph was published in the sixth album *L'Estampe originale* in 1894, together with Georges de Feure's colour lithograph *La Source du mal* (The Source of All Evil); see exhib. cat. New Brunswick/Amsterdam 1991, p. 21.

19 See the review of this exhibition by Julien Leclercq in *Mercure de France*, January 1895 (reprinted in Prather/Stuckey 1994, p. 250).

20 See exhib. cat. Paris 1989, p. 347.

21 Field 1973, No. 34.

22 See exhib. cat. Paris 1989, p. 417.

23 The interview was printed in the May 13th, 1895 issue of *L'Echo de Paris*. The author cites the passage from Prather/Stuckey 1994, p. 251. The English version which appears here is based on the translation from the French by Mark Paris in Françoise Cachin, *Gauguin. The Quest for Paradise*, New York, p. 171.

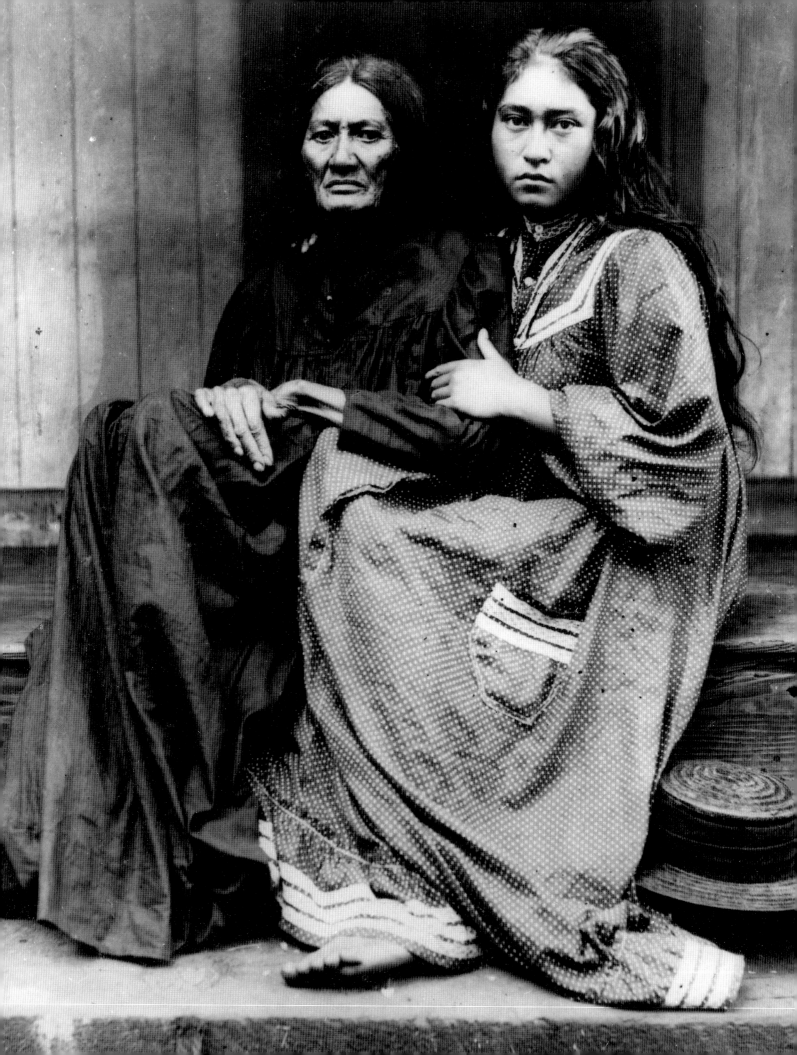

GAUGUIN'S TAHITI –
ETHNOLOGICAL CONSIDERATIONS

Ingrid Heermann

Gauguin's quest for artistic renewal and inspiration awakened in him the vision of life in a primitive culture, in an environment closer to the origins of mankind and untainted by civilisation. In retrospect, it seems virtually inevitable that he should have chosen Tahiti as his destination. Indeed, in the eyes of 19th-century Europeans the South Sea island of Tahiti, the largest of the Society Islands in the heart of eastern Polynesia, had become a vision imbued with a critical view of modern society. Since the publication of the first reports of its discovery in 1768[1] Tahiti was looked upon as the home of "noble savages" existing in harmony with nature, without guile, free and untroubled, who lived life to the full und were devoid of physical modesty. The word *Tahiti* – or *Otaheite* – itself came to represent ideas of earthly paradise, social utopias and island dreams.[2] In European eyes the real Tahiti lost geographical focus in the process as it took on increasingly mythical dimensions.

Gauguin's longing to escape from a spoiled, morbid society, to leave poverty and hunger behind him and to establish a life in surroundings capable of inspiring him was neither unique nor new. It echoes utopian dreams shared nearly a hundred years before him by a group of German artists and writers, who considered emigration for similar reasons. They, however, never proceeded beyond the stage of lamentation and dreaming.[3]

Gauguin was actively looking for a country in which he could realise his dream of a "studio of the tropics". Inspired by the Indochina pavilion at the Paris World's Fair of 1889, he initially saw the French colony of Tonkin (now northern Vietnam) as a desirable destination. When his plan to travel there proved impracticable, he turned his gaze once again to the tropics familiar to him from his journey to Martinique. In this he was encouraged by models of various dwellings from tropical regions on exhibit at the World's Fair which had impressed him greatly. Martinique itself did not strike him as suitable, as it was inhabited by black immigrants rather than an authentic native population. Eventually the focus of his interest shifted to Madagascar, and he attempted to persuade fellow artists to accompany him there. Finally, in the summer of 1890, Emile Bernard, a potential travel companion, suggested Tahiti as a possible destination, prompted by his reading of Pierre Loti's novel *Le Mariage de Loti*. This book was written in the tradition of a romanticised view of Tahiti that had gained widespread popularity by this time. It tells the story of Loti's marriage to a Tahitian woman and makes use of virtually every cliché associated with Tahiti – free sexuality, sensual, hospitable natives and a life without wants in the midst of a benign natural environment.

Wise enough not to confuse fiction with reality, Gauguin sought more information, which he obtained in the form of a description in the official handbook published for the World's Fair. The publication confirmed the positive image of a society in which people lived for the most part without money, envy and hate. As the promotion of the colonial idea was a major objective of French policy, the clearly emerging problem areas in a cul-

Cat. no. 93
Sculpture, Society Islands
(Tahiti) or Tonga
Stone, height 46 cm
Museum der Kulturen, Basle,
Inv. no. Vc 98

Cat. no. 94
Figure of a divinity, Marquesas
Islands (Hiva Oa?)
Stone, 70 x 64 cm
Museum der Kulturen, Basle,
Inv. no. Vc 644

Cat. no. 96
Small canoe adornment
(prow figure)
Wood, height 59 cm
Museum der Kulturen, Basle,
Inv. no. Vc 1521

Cat. no. 95
Sculpture, Society Islands
(Tahiti)
Wood, height 50 cm
Museum der Kulturen, Basle,
Inv. no. Vc 1175

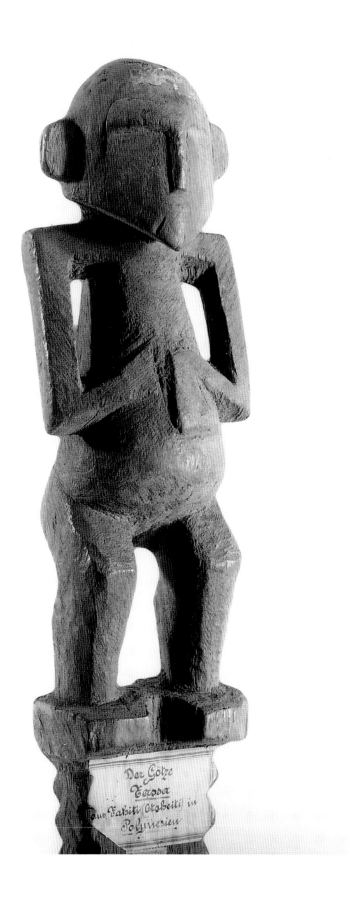

ture affected by radical change were not mentioned.[4] Gauguin appears to have been satisfied with the idealised accounts; at least there is no other evidence of his having undertaken further research.

Tahiti had now become his objective and he pursued it with great energy. His impatience is documented in his letters. As the following, often-quoted passage makes clear, he was intent upon immersing himself but by no means losing himself in a strange culture. What he sought was the freedom that would allow him, "to live there in peace and ecstasy for my art alone. Surrounded by a new family… There in Tahiti, I will be able to listen in the silence of the lovely tropical nights to the soft murmuring music of the movements of my heart in loving harmony with the mysterious beings in my entourage."[5] His intention was to develop his art, not to interpret or comprehend Tahitian culture, and he seems to have intended for his "new family" to preserve its mysterious quality.

The story of his sojourn in Tahiti begins with a sobering experience.[6] In July 1891 Gauguin arrived in Tahiti at an unusually empty pier in Papeete. He found accommodation at first at the home of Lieutenant Jénot, with whom he maintained ties of friendship for the remainder of this stay. Soon he was forced to recognise that he had landed in a colonial town that had lost the last of what he had imagined to be its authentic qualities in the fire of 1884. Instead of the huts he expected, Gauguin encountered only stone and wooden houses with corrugated iron roofs. The French colony, which comprised some 300 persons, was clearly intent upon replicating the culture of its faraway homeland. The Tahitian women themselves – his potential models – revealed but little of their figures, their grace or their appeal under their long, expansive garments.

Apart from these aspects he acutely sensed a state of dejection among the natives of Papeete. King Pomare V, the monarch who had traded his crown to the French government in return for a lifetime pension in 1880, lay on his deathbed, still beloved by his subjects. He died soon after and was given a Christian burial attended by many of his people. During preparations for the funeral Gauguin met – presumably for the first and last time – Pomare's divorced wife Marau, whose charismatic aura left a great impression on him.[7]

Gauguin was presumably the only European who truly mourned the death of the king, a man who had been reduced to insignificance in his waning years and had died of the effects of excessive alcohol consumption. He was a person from whom Gauguin had hoped to receive commissions for work, but in Gauguin's eyes he was also the last representative of the Maori society[8] as it had been prior to Tahiti's final conversion into a French colony.

In *Noa Noa* Gauguin later followed his description of the burial ceremony with the question of whether he would ever be able to revive the traces of such a distant and mysterious past, to return once again to the ancient fire-place and rekindle the fire amongst the ashes.

By this time he had become aware of the true extent of the cultural loss and change that had taken place in Tahiti in the course of the 19th century. The population had been reduced to a tenth of its original size.[9] Imported diseases, alcohol and trade in slaves had taken a horrible toll. Under the influence of the Europeans, the once powerful rival feudal lords had initially been united by Pomare, only to lose much of their power to Europe in the ensuing years. Under the influence of the missions, the once powerful priests' caste had disappeared and along with it the system of *mana* and *tapu*, the divine order which had served to regulate all aspects of human life. The old dances and songs had been banned, as

Cat. no. 97
Tapa, Society Islands (Tahiti)
Barcloth with leaf pattern,
456 x 185 cm
Museum der Kulturen, Basle,
Inv. no. 1178

had the society of the *arioi*, who worshipped the god Oro and practised uninhibited sex, free of social constraints and obligations. Their members had traditionally given great pleasure to spectators as dancers and actors at temple feasts.

The traditional art of Tahiti, once predominantly an art commissioned by rulers and priests, had also been affected by these changes. The anthropomorphic and zoomorphic images of higher divinities such as Tane and Oro, decorated with sacred red feathers, had become obsolete – cast off, burned, banned or driven "underground". The smaller *ti'i* sculptures of wood or stone (Cat. nos. 93, 95), images of local guardian deities or spirits, frequently employed in practices involving magic, were now used only in secret, if at all. The magnificent double-hulled boats with their high, sculptured prows (Cat. no. 96), formerly built in accordance with great ritual procedures by specialists and used by the rulers as war canoes or commissioned by priests to please the gods, had long since disappeared from the visible panorama of Tahitian culture.[10] The outward appearance of the Maohi had also changed significantly – and not only in Papeete. The cloth wraps known as *pareu* and the apronlike *malo*, originally made of local barkcloth (Cat. no. 97),[11] had been replaced by cotton fabrics printed with special "South Sea" patterns and produced in Europe.[12] Forster had described the sound of *tapa* beaters from morning to evening as an ever-present feature of Tahitian life. By Gauguin's time, the production of barkcloth had almost come to a standstill. Since mid-century, even *pareu* made of European fabrics were worn only for work and in private settings. When venturing out in public, women now wore long, wide, high-buttoned dresses – known as "Mother Hubbards" in the South Pacific and often still referred to as *muumuu* today – in keeping with mission fashion. The missionaries had instilled such a strong feeling of modesty in Tahitian women that it had become difficult for photographers to persuade even prostitutes to allow themselves to be photographed wearing only a *pareu*.

Virtually the entire indigenous population had been missionised. People regularly attended religious services. Evening gatherings featuring the telling of Bible stories were popular pastimes. And the diverse forms of traditional dance and song had been replaced by Christian hymns, sung with great devotion by men and women alike (Cat. no. 35).

Gauguin lived and worked in Papeete for three months. The European colony provided no commissioned work, however, and his circle of European friends was soon limited to some few. He sought compensation and amusement in Tahitian society, to which the Anglo-Tahitian woman Titi belonged. She became his mistress for a brief period.

Having used up much of his savings sooner than expected – a French lifestyle was much more expensive in Papeete than at home – Gauguin decided to enter Tahitian village life. In Mataïea, some five hours away from Papeete, he found a village that looked suitable to him. In Papeete he had become acquainted with Tetuanui, its district chief and both a Francophile and a speaker of French. Gauguin was fascinated by the beauty of the village and the view across the sea to the neighbouring island of Moorea. The availability of a "modern" house for rent helped finalise his decision, although the actual solution was somewhat odd: the owner agreed to move into the newly constructed European-style house himself, permitting Gauguin to occupy his traditional abode. In keeping with Tahitian custom, the living area was furnished only with mats, fabrics and a pile of hay on the floor. The cooking house, located in traditional fashion apart from the living quarters, housed an earthen oven, but Gauguin was unable to manage its use.

The simplicity of the furnishings of the house should not lead one to forget that Gauguin had chosen a place that was much more closely oriented to French ways than was the case in other districts of Tahiti. Both the Catholic and Protestant missions were very active in Mataïea. The Catholic mission even maintained an elementary school staffed by nuns there – the only such school outside the island capital. Given his dreams of a simple, original lifestyle, Gauguin could certainly have chosen a location less subject to European influences – albeit at the expense of opportunities for communication and with greater pressure to adapt to local structures.[13] One cannot rule out the possibility that Gauguin – despite statements to the contrary in his letters home – had by this time recognised his own personal limitations with respect to the fulfilment of his dreams. Regular contact with Papeete was as important to him as the services of a local Chinese merchant, who conveniently supplied him with everything he needed.

Gauguin furnished his quarters with several pieces of European furniture, kitchen utensils and other items. He was not long in discovering that even a traditional lifestyle in Tahiti was not easy to maintain – and furthermore, that it was not to be had for nothing at that particular time and place. The rifle he owned was useless, as there was no game on the island. The supply of food from the sea was available only to those who had the time and the skill to fish. Wild bananas, a basic food staple, could be harvested by anyone but only at the expense of tiring treks into the mountains. There were no local fruit and vegetable markets. Although a money economy had been introduced along with the limited production of copra (dried coconut meat), most of the 516 people continued to live from the products of their own subsistence cultivation. Gauguin could have accepted garden products as gifts but was too proud to do so, possibly because he was apprehensive with regard to the unforeseeable social consequences and obligations that might arise from such exchange transactions.

The management of his daily life cost him considerable effort. In traditional Tahiti, daily work was distributed equally between the genders. Cooking chores, for example, were shared by men and women alike, and one may assume that Gauguin, no longer a guest but a neighbour, was expected to care for himself. Linguistically, he was still isolated for the most part. And as far as his dream of acquiring a "new family" and recruiting models for his painting was concerned, he was forced to realise that most women were married and had little interest in modelling for him. Young, unmarried women, on the other hand, confronted him in such an open and self-assured manner that, by his own admission, he felt intimidated by them. He sent for his girlfriend Titi from Papeete, but this turned out to be an unfortunate choice. The rural, Christianised surroundings of Gauguin's new home offered her too little by way of amusement, and she was not accepted by the local people. Gauguin found her too light-skinned to serve him as a model. Before long she left permanently for Papeete.

Gauguin's living circumstances changed radically following an exploratory tour of the island, during which he not only became acquainted with the traditional hospitality of the islanders but admitted spontaneously, when asked about the reason for his journey, that he was looking for a wife. Shortly afterwards his host offered his thirteen-year-old daughter as a candidate for marriage.[14] She herself took a little time to consider her answer, then turned up ready to depart with him. Her name was Teha'amana. Gauguin called her Tehura in *Noa Noa*, Tehamana in his painting titles.[15]

Gauguin embarked on his return trip in the company of the girl's relatives, having dispensed with the relatively uncomplicated customary ceremonies that traditionally accompanied marriages in the lower and middle social strata of the Tahitian population. As a result, neither Gauguin – who was called Koki by the Maohi – nor Teha'amana received a new name that would have documented their new identities as partners in marriage. On the return journey the party stopped over in Taravarao, where Gauguin was introduced to a "second" mother of Teha'amana, both natives of Rarotonga.[16] It has never been determined with certainty whether the two women referred to as mothers were classificatory mothers – sisters, that is, who were simply identified with the same term of relationship – or the girl's biological and adoptive mothers, respectively.[17] One may assume that Gauguin's painting entitled *Tehamana has Many Ancestors* (Cat. no. 44) alludes in part to this experience.

Teha'amana had no difficulty integrating herself into her new environment. Not only was she a tender mistress and devoted and capable housewife – she fished and gathered food, cooked and kept house – she also served Gauguin successfully as a model. Gauguin's life on the island of Tahiti had entered a new phase characterised by great artistic productivity.

In view of his determination to regard himself as a savage and to present himself accordingly, one can hardly fault Gauguin for excluding the recognisably European aspects of his environment from his paintings and focusing exclusively upon the Tahitian themes he had collected in Papeete as sketches and studies. Apart from that, however, he remained true to observable reality in his paintings, to "modern Tahiti". The images of everyday life – his observations of boat-builders, for example, or of the houses in the midst of tropical surroundings with their roofs of pandanus or coconut leaves and their partially open-walled construction – conformed to actual village realities.[18] In *I raro te oviri* (Beneath the Pandanus Tree, Cat. no. 27), a painting done in 1891, Gauguin portrays aspects of everyday life.

We see women with pandanus baskets and a carrying stick on which fish or fruits are hanging – obviously engaged in the daily work of gathering food. In *Black Pigs* (Cat. no. 24) he shows both an imported horse and – Polynesian – pigs. The hut that appears in the background of *E haere oe i hia* (Where are you going?, Cat. no. 52) conforms to the description of his house in Mataïea.[19]

Many scenes show Maohi women in the typical crouching posture: at work or conversing, dressed in *pareu* or mission-style dresses and blouses and occasionally – in contrast to what can be assumed as authentic circumstances – nude from the waist up. With the exception of flower blossoms[20] and shell necklaces, the models – or Gauguin himself – dispensed with traditional jewellery and adornments. The subjects rarely meet our gaze directly but always have serious, sometimes even sad facial expressions. Gauguin found Tahitian women very attractive but did not regard them as particularly beautiful. Unlike the still very young Teha'amana, some of the models show a certain robustness which reflects a prevailing female type in Tahiti and deviates significantly from the European ideal of female beauty. One aspect of this type is a certain degree of masculine aura that is especially evident in the female figure seen in the foreground (which presumably also served as a model for the sculpture *Oviri*) of the painting *Where Are You Going?* (Cat no. 52). Forster remarked upon the powerful statures of some Tahitian women. He found their large feet and broad, often flat noses particularly remarkable.[21] Robert Levy quotes Henry Adams on the subject of sexual identity: "Polynesian women resemble Polynesian men so closely that the difference is not enough to permit recognition of emotional differences or anything other than physical dissimilarities." He goes on to add: "Paul Gauguin, who wrote about Tahiti during the same time, described the Tahitian man as 'androgynous' … Adams and Gauguin were obviously referring to qualities of personal style and mobility as well as aspects of physical stature."[22]

The most questions left unanswered are posed by those paintings of Gauguin's that deal with the mythical concepts of the Maohi, with the themes, that is, which undoubtedly concerned him the most during the second half of his first stay in Tahiti. It was not, as Gauguin himself claimed, Teha'amana who provided him access to this particular world of ideas.[23] He gained it instead from a book he discovered and borrowed in Papeete. It was entitled *Voyages aux îles du Grand Océan* and written by the Belgian author Jacques-Antoine Moerenhout, who had served as consul general in Tahiti for many years. Moerenhout's accounts, necessarily based in part on hearsay as a result of the rapid process of cultural change, served Gauguin as a key to a very special perspective on the conceptual world of Tahiti and as a source of inspiration for him and – as he hoped – his European public. He copied the passages he considered important from the two volumes of Moerenhout's book and incorporated them practically word-for-word in his own text entitled *Ancien culte mahorie*.[24]

The conceptual structure he erected upon this foundation centred essentially around the creator-god Ta'aroa, the creation of the *arioi* society by the god Oro *(Te aa no areois)*, two other divinities of Tahitian mythology, Hina and Te Fatu, and around the *tupapau*, or spirits of the dead, whose cult remained the only aspect of traditional religion still vital in Gauguin's time and even into our own century.

The Maohi traditionally worshipped an extensive pantheon of gods organised on different levels based upon a strict hierarchical system. Many people regarded Ta'aroa as the

true creator god, progenitor of the subordinate divinities – among them Te Fatu, mentioned fourth in one myth – and creator of many parts of nature, including – indirectly – the human race through his "daughter" Hina. Hina is a figure of importance at all levels of creation, the additional names given to her as descriptive designations serving either to denote specific aspects of her "quality" or to assign her a fitting rank in the genealogical hierarchy. She is associated with many different spheres of life – portrayed in her role as the model woman and travel companion, named as the inventor of *tapa* art and not least of all associated with the moon. Along with other gods, Hina was the recipient of appeals on the *marae* and also the heroine of legends and mythical tales. There is no evidence of the presence of a Hina cult, however, nor was she regarded as a goddess of the dead in Tahiti. Compared to Hina Te Fatu, known primarily as the god of seafarers, to whom appeals were made on the *marae* during ceremonies related to boat-building and sea voyages, remains a relatively pale "divine personality". The role of "father of humanity" attributed to him in the mythical version recorded by Moerenhout, of a god who opposes the continuous renewal of human life, was ordinarily assigned by the Maohi to the divine being Ti'i, who in turn – in one variant version of the myth – was fathered by Te Fatu.[25]

These different versions already indicate that even at the time when Tahitian religion was still actively practised Gauguin could hardly have learned a version of the story of Hina, Te Fatu or the creation of mankind to which all Maohi or the entire priesthood would have subscribed. There existed neither a uniform body of thought nor a reliable exegesis binding upon everyone. The different noble families, who traced their origins through extended family trees back to individual gods, justified their stations to an appreciable degree on the basis of the relative position of their respective gods. Certain gods, on the other hand, rose or fell in importance according to the status of their descendants, replacing others in the process. And now that the traditional religion was no longer practised publicly, Gauguin obviously had no access to knowledgeable sources, neither among the descendants of the old priestly caste nor in the more tradition-oriented noble class. Thus he was relieved of the necessity or robbed of the possibility – depending upon one's point of view – of testing his insights and interpretations against empirical observations. And so, while he did indeed rekindle a fire "at the old fire-place" in his imagination and in his paintings, it was not a fire likely to have been recognised by the Maohi as their own.

The segment of Moerenhout's version of the mythology that most interested Gauguin related to Hina's attempt to persuade Te Fatu (or Ti'i) to give new life to the dead, which Te Fatu refused to do. "The earth will die, the plants will die, everything will die from which man takes nourishment, the land will die, the earth will die, the earth will pass away, pass away for all time. And Hina said, then do what you think is good. But I shall bring the moon back to life again and again. And what Hina ruled remained. What Fatu ruled passed away. Man passed away."[26]. Hina is seen here as a source of life in the cycle of death and rebirth, a role interpreted eloquently by Gauguin in his painting *Hina and Te Fatu*, in which he portrayed Hina from the rear facing Te Fatu, who is shown as a half-figure hovering above a spring from which she draws water. A variation on this theme is found elsewhere as well, in the sculpture *Hina and Te Fatu* (Cat. no. 37), for example, and in various different graphic forms, although Te Fatu is not so readily interpretable as the embodiment of passivity and symbol of the earth and its transitory nature in these works. Gauguin, who also saw Te Fatu's role as symbolic of the transitory nature of Tahitian culture, which could not

be preserved, felt a much closer affinity to Hina in his striving to reawaken that very culture.

He portrayed her alone in a second sculpture (Cat. no. 36) and "saw" her in *Noa Noa* as well as a central sculpture in a small valley, ringed by women dancing to the accompaniment of a flute player. Gauguin's inspiration here – his "dream" as one would say in the South Pacific – is an obvious one. Stimulated by the mythical tradition, on the one hand, and the landscape, on the other, he composed an image that communicates his idea vividly yet fails to establish a link to the culture of the Maohi beyond the inspiration itself. Apart from the fact that neither a cult of the moon goddess Hina nor sculptures of the kind he conceived existed on the island of Tahiti, it must be noted that women were excluded from all religious rites performed on the temple grounds.

Gauguin showed such a temple complex in his painting *Parahi te marae* (There Lies the Temple, Cat. no. 34). He had learned in his reading of Moerenhout about the importance of temple grounds as centres of traditional religion and had also gained some experience of it first hand. He visited the ruins of the *marae* of Mataïea with the district chief Tetuanui and incorporated a sketch and a description, quoted from Moerenhout, in his *Ancien culte mahorie*. He was disappointed in the condition of the *marae*, however, which is probably why he replaced the traditional stone wall with a fence bearing heads. Near the centre of the scene he positioned a large, compactly arranged sculpture intended to represent a Tahitian *ti'i* god image on a pedestal.

While the idea behind this painting was undoubtedly derived from Tahitian sources and inspirations, the formal aspects of the pictorial elements are clearly influenced by the art of the neighbouring Marquesas Islands (Cat. no. 94). The model for the design of the fence with its stylised heads connected by rods was clearly taken from a piece of ear jewellery, and the sculpture also contains features of Marquesan origin.

An important reason for Gauguin's use of non-Tahitian forms was the absence or the unavailability of original works of religious art in Tahiti. As it is highly unlikely that Gauguin studied forms of Tahitian art – in the Trocadéro collection in Paris, for example – prior to his departure for Tahiti, he was probably familiar with everyday utensils only (Cat. nos. 99–101). Sculptures from the surrounding islands were on display in Tahiti, however, both in private collections and in a small museum maintained by the Catholic mission.[27] New carvings, primarily from the Marquesas islands, were imported for sale in the local curiosity shops. Gauguin had already encountered one particular example of Marquesan art while in Paris – the extraordinarily elaborate Marquesan tattoos. He admired the work so much that he brought along a photograph of such a tattoo to Tahiti. In Tahiti he was equally impressed with the surface design of the bowls (Cat. nos. 105, 106) and clubs, the earrings and the wood and stone sculptures known in the Marquesas as *tiki* (Cat. no. 107).[28] He made a number of sketches from original items, and his fascination for this kind of art is documented with equal emphasis by the fact that he carved imitations of bowls in the Marquesan style[29] and incorporated elements of Marquesan figural design again and again into his paintings and sculptures. His sculpture *Hina and Te Fatu* (Cat. no. 37), for example, clearly shows the influences of Marquesan art. The forms, postures and proportions he discovered in Marquesan sculpture (Cat. nos. 103, 104) were reproduced almost exactly in two figures positioned at each side of an image of a god, which itself possesses certain features of faces found on Easter Island (Cat. no. 102).

Cat. no. 103
Stilt step, Marquesas Islands
Wood, height 40 cm
Museum für Völkerkunde,
Vienna, Sammlung Aubry Le-
comte, 1879, Inv. no. 8.955

Cat. no. 104
Stilt step, Marquesas Islands
Wood, height approx. 40 cm
Museum für Völkerkunde,
Vienna, Sammlung Schiff-
mann, 1879, Inv. no. 9.792

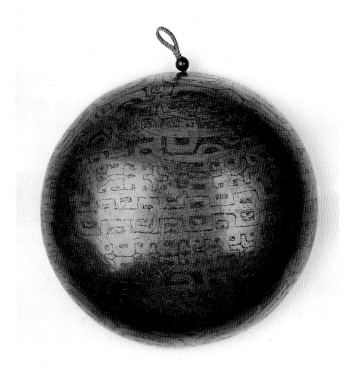

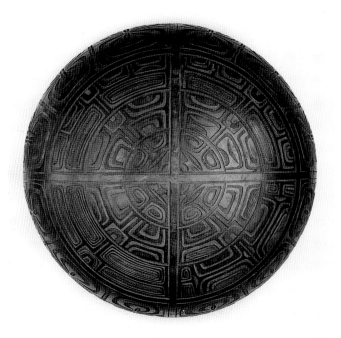

Cat. no. 105
Bowl, Marquesas Islands
Wood, polished burnt inlay,
diameter 28 cm
Linden-Museum, Stuttgart,
Inv. no. 65.017

Cat. no. 106
Bowl, geometric decor in
bas-relief, Marquesas Islands
Wood, diameter 38.5 cm
Linden-Museum, Stuttgart,
Inv. no. 49.619

Cat. no. 107
Tiki, ancestor figure,
Marquesas Islands
Stone
Linden-Museum, Stuttgart,
Inv. no. 65.020

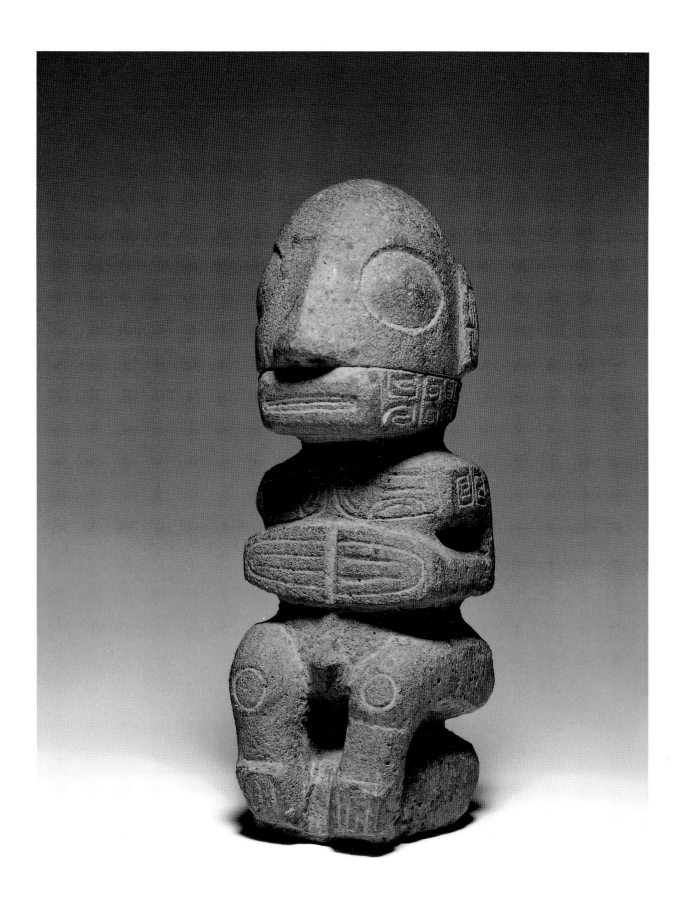

In most cases – the painting *There Lies the Temple* is a good example – Gauguin used forms of Marquesan art merely as points of departure in creating his own works. While the eyes of the figures of divinities are rather oval in form and do not necessarily correspond to the more common rounded eyes, his representations of gods – viewed from the rear or in profile – are almost always more voluminous than the models. One even has the impression that Gauguin imagined a large statue of the size found only on Easter Island. In the wood-cut *Maruru* (Content, Cat. no. 80) Gauguin adapted another very similar divinity figure, shown sitting upon a pedestal as well but dressed in a *pareu* and accompanied by a female flutist. The woodcut entitled *Te atua* (The Gods, Cat. no. 92) is yet another portrayal of Hina and Te Fatu joined by a third figure, with a Buddha in their midst performing the gesture of touching the earth.[30] This provides clear evidence of the extent to which a variety of different ideas were interwoven to form a composite image in Gauguin's art.

Gauguin's use of elements from a variety of Polynesian art forms was not confined to his treatment of purely religious themes, as he integrated such components into other images as well. In the painting *Tehamana has Many Ancestors* (Cat. no. 44), he incorporated a small sculpture into the left portion of the background. Not only does the sculpted female form, with its extremely narrow waist, contrast strongly with the figure in the foreground, it also reveals influences from Hawaiian sculpture in the proportions of the torso, the position of the arms and the form of the face. At the same time, the background is covered with written characters from Easter Island,[31] and the fan held by Tehamana corresponds to the Samoan form.

A theme frequently used by Gauguin as a painting motif was that of the spirits of the dead, or *tupapau*.[32] In his painting *Manao tupapau* (1892, Albright-Knox Gallery), a spirit of the dead dressed in a black cape appears behind a naked woman lying on a bed. The translation of the title has been the subject of a great deal of discussion. *Manao tupapau* could mean either "Watched by the spirit of the dead" or "She thinks of the spirit of the dead", thus posing the possibility for differing interpretations of the content of the picture.[33] It is quite probable, however, that Gauguin did not intend in his title to make a clear statement about the relationship between the spirit of the dead and the reclining woman. He is more likely to have been fascinated by the suggestion of mystery and impending danger. In a letter to his wife he emphasised that he had introduced the theme in order to ensure that the nude did not evoke a sense of indecency. Thus it appears that in this case Gauguin used an element of Tahitian religion as a prop, without regard to its more concrete meaning, in order to increase the likelihood of acceptance of daring pictorial themes in the Parisian public by casting an exotic veil over them.

Gauguin took up many of these religious themes once again in his illustrations for *Noa Noa*. His claim to have based his artistic treatment of such themes on his own impressions and insights and to have obtained interpretations from knowledgeable sources brought severe attacks from later critics, who expected greater scientific rigour and precision from him. Ethnologists' assessments of Gauguin's performance as an observer have ranged from Hans Nevermann's devastating "Gauguin never once heard the heartbeat of Polynesia"[34] to Teilhet-Fisk's affirmation of his excellent powers of observation and his elevation of Gauguin to the rank of an amateur ethnologist.[35]

There is no doubt that Gauguin was inspired by the culture of the Maohi – both the contemporary and the past – and that he showed considerable sensitivity in his exploration

Cat. no. 108
Fan, Marquesas Islands
Reed strips, carved bone,
wood, height 37.5 cm
Linden-Museum, Stuttgart,
Inv. no. S 40.592 L

Cat. no. 109
Fan, Samoa
Coconut palm fronds, wood,
fibre string, height 49.5 cm
Linden-Museum, Stuttgart,
Inv. no. 34.945

of issues of interest to ethnologists as well. His claim to have become a savage, an *oviri*, and as such to have adapted himself to native customs, however, does not bear up to scrutiny. Tahiti and Tahitian culture as a complex of mystery and myth were both interesting and meaningful to him as past ideals he wished to rediscover. Gauguin's existence in Tahiti was characterised by many aspects of a threshold existence, features of a life "on the outside" and "in between". He undoubtedly lived in a Tahitian environment and experienced aspects of Tahitian life, as his description of fishing expeditions and excursions into the interior document convincingly. Yet he remained consistently conscious of and true to his French origin, seeking the recognition he needed in France and Europe. With his self-proclaimed status as a savage he held himself outwardly aloof from such a view and avoided identification with it. The Maohi knew *oviri moe'aa'ihere* as "the wild man who sleeps beneath the bushes" and used the term to designate one of the gods of mourning whose priests had performed at burial ceremonies for the nobility in the uninhabited mountain regions in ancient times.[36] Had Gauguin known of this god, he would presumable have drawn inspiration from him and depicted him in a manner not entirely compatible with indigenous views. Gauguin approached Tahiti through his art, adapting it and reinterpreting it for his own purposes. Thus the real, historical Tahiti can contribute but little to an understanding of his work.

1 Tahiti was discovered by Wallis and Bougainville at practically the same time in the course of English and French voyages of discovery during the 18th century. Further important insights were acquired during the explorations of James Cook (1770), who was accompanied on his second voyage (1772–1775) by Johann Reinold and Georg Forster.

2 Tahiti was described as an Arcadia on earth, as the island of love and harmony and as the contemporary image of ancient ideals. These views are summarised in Heermann 1987, pp. 22f. and 1997.

3 This included the so-called Geheime Tübinger Gesellschaft and a group of writers close to Zachariä and Gerstenberg, who sought to gain the support of Claudius, Miller, Von Stollberg, Klopstock and others for their idea.

4 Early criticism of this idealised view was voiced in the first years of the 18th century. Tahiti soon came to be regarded by many as the "Paradise of Pain". Imported diseases had already begun to spread rapidly towards the end of the 17th century.

5 Malingue 1960, pp. 103f.

6 See Danielsson 1964 for a detailed account of his sojourn and his contacts.

7 Marau Taaroa Salmon, the daughter of Arii Taimais, was among the women who were actively engaged in the preservation of their people's traditions. She would undoubtedly have been a valuable source of information, yet although she lived only nine miles from Gauguin's village he made no attempt to become acquainted with her, as her family were regarded as anglophiles. Marau may have gained access to such knowledge through women who had once belonged to the *arioi* society. Rohde 1988, p. 70.

8 Gauguin consistently refers in his letters to Maori or Mahorie. This designation, employed today with reference to the Polynesian population of New Zealand, is used in Tahitian to designate generally the Polynesians: *ma* is a free person not associated with a taboo, and *ori* signifies many aspects of creative work, restoration or reuniting. The Tahitians' own term is *ma'ohi*, *ohi* meaning sprout or shoot (of a plant) that has already grown roots. The association is that *ohi* can be traced back to a tribe and ultimately to the earth, unlike *hutu painu*, the foreigner. *Maohi* stands for the community of all those who share a common history, culture, language and destiny. Raapoto 1988, pp. 5f.

9 The Maohi population, originally estimated at between 70 000 and 100 000, numbered only 9 000 according to estimates made towards the end of the 19th century. Aside from the causes mentioned here, Peltier also mentions a psychological response to the sense of feeling hopelessly trapped.

10 The missionaries, who had prohibited the use of traditional objects, had copies of such items made in some regions. Evidence of such activity in Tahiti was not available until the 1900 World's Fair. In contrast to the 1889 presentation, then a Tahiti show was exhibited featuring Tahitian jewellery and *tapa*, accompanied for the most part by Marquesan carvings. See Peltier 1984, p. 106 and footnote 29.

11 Production had ceased almost entirely in Gauguin's time, but dresses made of *tapa* (*ahu* in Tahitian) and cut to European patterns were offered for sale. Gauguin mentioned pounded bark as the material for *tapa*. One may presume that no *tapa* production was carried out where he lived.

12 The cotton fabrics were decorated with patterns designed especially for the South Pacific and manufactured in England, France and Switzerland. They are now regarded by uninitiated observers as a typical aspect of South Seas culture. Gauguin modified the patterns and coloration of these cloths slightly in every case, however. Varnedoe 1984, p. 216, footnote 60.

13 Henry Adams and Robert Louis Stevenson had visited Tahiti shortly before Gauguin's arrival and found the northern region of Little Tahiti much less Europeanised.

14 This suggestion, surprising from a European point of view, was based upon the assumption that the Frenchman Gauguin was probably rich and influential. Aside from this, the risk was only small for the woman, as marriages could be dissolved without difficulty by both parties at any time.

15 The name Tehaura is also mentioned in the literature; Rohde 1988, p. 80, footnote 69.

16 Gauguin at first understood "Tonga". Her home island was Rarotonga, however, one of the Cook Islands.

17 Gauguin described their first encounter and his confusion in *Noa Noa*. He probably regarded one of the two women as the adoptive mother, as he had read about the extensive adoption system from Loti's novel.

18 For a thorough discussion of the ethnographic details see Rohde 1988, pp. 113–132.

19 Rohde 1988, p. 131, with respect to the painting *Ea haere ia oe*, The Hermitage, St. Petersburg, in the same context.

20 Blossoms or chains of blossoms were traditionally regarded as necessary adornments for a well-groomed, attractive woman, as were coconut oil and scents.

21 The ideal of a flat, broad nose in women was achieved through a minor deformation of the cartilage in the nose. Another method involved the stretching of the nostrils.

22 Robert Levy, "Self and Identity", in Pollock/Crocombe 1988, pp. 22–27. Levy concludes that gender roles were and still are regarded as very similar and equal, but that gender lines were frequently crossed by men assuming female roles. According to Levy, the existence of the *malu* (transvestites) is accepted as natural by both sexes, and their role bears no stigma. See also the recent publication by Stephen F. Eisenman, *Gauguin's Skirt*, London, 1997.

23 Women were traditionally excluded from rituals at the *marae*, with the exception of those who belonged to the arioi society. Information about the genealogies of the gods and forms of appeal to the divinities was part of the specialised knowledge available to members of the priesthood only.

24 Rohde 1988, p. 91.

25 For a detailed description of the world of Tahitian and Polynesian gods see Oliver 1974, Henry 1951 and Williamson 1933 as well as a summary in Heermann 1987, pp. 54–58.

26 Cited from the translation by Berger 1978, p. 19.

27 The police chief possessed a collection of which Gauguin knew. Examples of Marquesan art as well as objects from Easter Island, the New Hebrides and New Britain (Melanesia) have been identified. See the letter of Lady Brassely, 1882, quoted in Teilhet-Fisk 1983, p. 30.

28 The term *tiki* was used to designate the typical human figures that appeared either as fully three-dimensional objects or as reliefs on items of jewellery, for example. The sculptures ordinarily show compact figures with legs bent, arms crossed in front of the body and disproportionately large heads, often with round eyes. They represent ancestors (elevated to divine status) and never known persons. Individual *tiki* were given individual names.
In addition, *tiki* were represented on utilitarian objects such as stilt steps and clubs. A detailed description of Marquesan art can be found in Karl von den Steinen, *Die Marquesaner und ihre Kunst*, Berlin, 1925.

29 Two bowls done in the typical Marquesan fashion and traditional oval form were probably completed early in his stay. Rotschi 1995, p. 89.

30 The figure is shown touching the earth with the wrong arm, iconographically speaking, presumably a reversal caused by the printing process.

31 A plaque bearing Easter Island writing (rongo rongo) is mentioned by Lady Brassely. Pater Colette of the mission museum in Papeete had plaques bearing Easter Island inscriptions copied. Peltier 1984, p. 121, footnote 29.

32 He describes the fear of the *tupapau*, also shared by Teha'amana. *Tupapau* are the spirits of the dead, who pose a danger only in darkness, which is why humans keep lights burning. In some cases they are represented with long, sharp teeth.

33 For a discussion regarding the title of the painting see also Nevermann 1956, pp. 222f.

34 Nevermann 1956, p. 231.

35 Teilhet-Fisk 1983, p.167.

36 Henry 1951, pp. 299 and 389.

CATALOGUE OF WORKS

Cat. no. 1
Tropical Landscape
1887
Oil on canvas, 115 x 88.5 cm, W 232
National Gallery of Scotland, Edinburgh,
Inv. no. NGS 2220

Cat. no. 2
The Gate (The Swineherd)
1889
Oil on canvas, 92.5 x 73 cm, W 353
Kunsthaus Zürich, bequest of Hilde
Hausmann-Aebi

Cat. no. 3
Houses in Le Pouldu
1890
Oil on canvas, 92 x 73 cm, W 393
Staatliche Kunsthalle Karlsruhe,
Inv. no. 2503

Cat. no. 4
Blue Trees
1888
Oil on canvas, 92 x 73 cm, W 311
Ordrupgaardsamlingen, Copenhagen

Cat. no. 5
Breton Landscape, Le Pouldu
1889
Oil on canvas, 72 x 91 cm, W 356
Nationalmuseum, Stockholm, Inv. no.
NM 2156

Cat. no. 6
Fields near Le Pouldu
1890
Oil on canvas, 73 x 92 cm, W 398
National Gallery of Art, Washington,
Collection of Mr. and Mrs. Paul Mellon,
Inv. no. 1983.1.20

Cat. no. 7
Seaside Harvest: Le Pouldu
1890
Oil on canvas, 73.5 x 92 cm, W 396
Tate Gallery, London, Inv. no. T00895

Cat. no. 8
Flutist on the Cliffs
1889
Oil on canvas, 73 x 92 cm, W 361
Josefowitz Collection

Cat. no. 9
Landscape with Cow among the Cliffs
1888
Oil on canvas, 73 x 60 cm, W 282
Musée des Arts Décoratifs, Paris

Cat. no. 10
Vase in the shape of a fish
1891
Clay, glazed, 23 x 32 cm, G 93
Kunstindustrimuseet, Copenhagen,
Inv. no. B3/1931

Cat. no. 11
Ondine (II)
1889
Pastel, 12 x 36.5 cm, W 337
Josefowitz Collection

Cat. no. 12
Still Life Fête Gloanec
1888
Oil on wood, 38 x 53 cm, W 290
Musée des Beaux-Arts, Orléans, Inv. no.
MO 1405

Cat. no. 13
Still Life with Print after Delacroix
1888/89 (1895?)
Oil on canvas, 40 x 30 cm, W 533
Musée d'Art Moderne et Contemporain,
Strasbourg, Inv. no. 55.974.0.662

Cat. no. 14
Roses and Statuette
1890
Oil on canvas, 73 x 54 cm, W 407
Musée des Beaux-Arts de Reims, Inv. no.
943.1.1

Cat. no. 15
Portrait of Aline Gauguin
1890
Oil on canvas, 41 x 33 cm, W 385
Staatsgalerie Stuttgart, Inv. no. 2554

Cat. no. 16
Self-Portrait with Idol
1891
Oil on canvas, 46 x 33 cm, W 415
The Marion Koogler McNay Art Museum,
San Antonio, Texas

Cat. no. 17
The Little Valley
1891/92
Oil on canvas, 42 x 67 cm, W 488
Private collection, Courtesy Galerie Beyeler,
Basle

Cat. no. 18
Tahitians Resting
circa 1891
Oil, charcoal and coloured chalks on paper,
mounted on canvas, 85.2 x 102 cm, W 516
Tate Gallery, London, Inv. no. N03167

Cat. no. 19
Atiti
1891/92
Oil on canvas, 30 x 21 cm, W 425
Rijksmuseum Kröller-Müller, Otterlo,
Inv. no. 1221-51

Cat. no. 20
front: Heads of two Tahitian women en face
and in profile; reverse: Portrait of Teha'amana
1891/92
Double-sided drawing, Charcoal, partially
wiped and washed, 41.4 x 32.6 cm
The Art Institute of Chicago, David Adler
Collection, Gift of David Adler and His
Friends 1956.1215

Cat. no. 21
front: Tahitian girl; reverse: Woman sitting
and Study for a head
circa 1892
Pencil on yellowed sketchbook sheet,
16.5 x 11 cm
Staatsgalerie Stuttgart, Graphische Samm-
lung, Inv. no. C73/2328

Cat. no. 22
front: Head of a Tahitian with profile of
another head; reverse: Two figures
1891/92
Double-sided drawing, charcoal, chalk and
water-colour, 35.2 x 36.9 cm
The Art Institute of Chicago, Gift of Mrs.
Emily Crane Chadbourne, Inv. no.
1922.4797 verso

Cat. no. 23
Te raau rahi
The Big Tree
1891
Oil on canvas, 73 x 91.5 cm, W 438
The Art Institute of Chicago, Gift of Kate L.
Brewster, Inv. no. 1949.513

Cat. no. 24
Black Pigs
1891
Oil on canvas, 91 x 72 cm, W 446
Szépmüvészeti Múzeum, Budapest,
Inv. no. 355.B.

Cat. no. 25
Haere mai venez!
Come Here!
1891
Oil on canvas, 74 x 92 cm, W 447
The Solomon R. Guggenheim Museum,
New York, Thannhauser Collection, Gift of
Justin K. Thannhauser, 1978

Cat. no. 26
Le Cheval blanc (Le Rendez-vous)
The White Horse (The Rendezvous)
1891
Oil on canvas, 73 x 91 cm, W 443
The Solomon R. Guggenheim Museum,
New York, Thannhauser Collection, Gift of
Justin K. Thannhauser, 1978

Cat. no. 27
I raro te oviri
Beneath the Pandanus Tree
1891
Oil on canvas, 68 x 90 cm, W 431
Dallas Museum of Art, Foundation for the
Arts Collection, Gift of Adèle R. Levy Fund,
Inc., 1963.58 FA

Cat. no. 28
Tahitian Bathers
1891/92
Oil on canvas, 110 x 89 cm, W 462
The Metropolitan Museum of Art, New York,
Robert Lehman Collection, Inv. no.
1975.1.179

Cat. no. 29
Mahana maa I
The Moment of Truth I
1892
Oil on canvas, 53 x 30 cm, W 490
Cincinnati Art Museum, Bequest of John W.
Warrington

Cat. no. 30
Mahana maa II
The Moment of Truth II
1892
Oil on canvas, 45 x 31 cm, W 491
The Finnish National Gallery Ateneum,
Helsinki

Cat. no. 31
Women at the Riverside
1892
Oil on canvas, 43 x 31 cm, W 482
Rijksmuseum Vincent van Gogh, Vincent
van Gogh Foundation, Amsterdam,
Inv. no. 222

Cat. no. 32
Fatata te mouà
At the Big Mountain
1892
Oil on canvas, 68 x 92 cm, W 481
State Hermitage, St. Petersburg,
Inv. no. 8977

Cat. no. 33
Te poi poi
Morning
1892
Oil on canvas, 68 x 92 cm, W 485
Collection of Joan Whitney Payson

Cat. no. 34
Parahi te marae
There Lies the Temple
1892
Oil on canvas, 68 x 91 cm, W 483
Philadelphia Museum of Art, Gift of Mrs.
Rodolphe Meyer de Schauensee, Inv. no.
1980-001-001

Cat. no. 35
Te fare hymenee
The House of Song
1892
Oil on canvas, 50 x 90 cm, W 477
Private collection

Cat. no. 36
Cylinder with the goddess Hina
circa 1892
Tamanu wood, painted and gold-plated,
37.1 x 23.4 x 10.8 cm, G 93, FM 250
Hirshhorn Museum and Sculpture Garden,
Smithsonian Institution, Washington;
Museum purchase with funds provided
under the Smithsonian Institution's
Acquisitions Program, 1981

Cat. no. 37
Hina and Te Fatu
circa 1892
Tamanu wood, 32.7 x 14.2 cm, G 96, FM 200
Toronto, Collection of the Art Gallery of
Ontario, Gift from the Volunteer Committee
Fund, 1980

Cat. no. 38
Rectangular vase with Tahitian gods
circa 1894
Terra-cotta, 33.7 x 13.5 cm, G 115
Kunstindustrimuseet, Copenhagen,
Inv. no. B 45/1932

Cat. no. 39
Parau na te varua ino
Words of the Devil
1892
Oil on canvas, 91.7 x 68.5 cm, W 458
National Gallery of Art, Washington, Gift of
the W. Averell Harriman Foundation in
Memory of Marie N. Harriman, Inv. no.
1972.9.12

Cat. no. 40
Study for "Parau na te varua ino"
Words of the Devil
1892
Pastel on paper, 76.5 x 34.5 cm
Öffentliche Kunstsammlung Basel, Kupfer-
stichkabinett, Inv. no. 1928.17

Cat. no. 41
Parau parau (II)
Whispered Words (II)
1892
Oil on canvas, 76 x 96 cm, W 472
New Haven, Yale University Art Gallery, John
Hay Whitney, B.A. 1926, Hon. M.A. 1956,
Collection

Cat. no. 42
Nave nave fenua, l'Eve tahitienne
Beautiful Land, Tahitian Eve
1892
Water-colour, 40 x 32 cm
Musée de Peinture et de Sculpture,
Grenoble

Cat. no. 43
Te faruru
The Encounter
1892
Oil and gouache on paper, 44 x 21 cm
Museum of Fine Arts, Springfield, The
James Philip Gray Collection

Cat. no. 44
Merahi metua no Tehamana
Tehamana has Many Ancestors
1893
Oil on canvas, 76.3 x 54.3 cm, W 497
The Art Institute of Chicago, Bequest of
Mr. and Mrs. Charles Deering McCormick

Cat. no. 45
Head of a Tahitian Woman (Portrait of
Tehura)
1892
Pua wood, 25 x 20 cm, G 98
Musée d'Orsay, Paris, Don de Mme Huc de
Monfreid, 1968, Inv. no. OA 9528

Cat. no. 46
Women on the Beach
1891
Oil on canvas, 69 x 91 cm, W 434
Musée d'Orsay, Paris, Legs du comte Guy de
Cholet, 1923, Inv. no. RF 2765

Cat. no. 47
Parau api
What News?
1892
Oil on canvas, 67 x 91 cm, W 466
Staatliche Kunstsammlungen Dresden,
Gemäldegalerie Neue Meister, Inv. no. 2610

Cat. no. 48
Nafea faa ipoipo
When Will You Marry?
1892
Oil on canvas, 105 x 77.5 cm, W 454
Rudolf Staechelin'sche Familienstiftung,
Basle

Cat. no. 49
front: Crouching Tahitian Woman, study for
"Nafea faa ipoipo"
When Will You Marry?
1892
Double-sided drawing, pastel chalk and
charcoal, partially wiped, squared,
55.5 x 48 cm
The Art Institute of Chicago, Gift of Tiffany
and Margaret Blake, Inv. no. 1944.578

Cat. no. 50
Study for "Aha oe feii"
Why Are You Jealous?
1894
Monotype in water-colours, partially raised
with brush in water-colours, brown ink and
white chalk, 19.5 x 24.2 cm
Edward McCormick Blair, Inv. no. RX
16171/2r

Cat. no. 51
Study for "Nafea faa ipoipo"
When Will You Marry?
Water-colour and pen in black over
pencil, 13 x 15.9 cm
Private collection

Cat. no. 52
E haere oe i hia
Where Are You Going?
1892
Oil on canvas, 96 x 69 cm, W 478
Staatsgalerie Stuttgart, Inv. no. 3065

Cat. no. 53
Self-Portrait with Palette
circa 1894
Oil on canvas, 92 x 73 cm, W 410
Private collection

Cat. no. 54
The Sacrifice
1902
Oil on canvas, 68 x 78 cm, W 624
Stiftung Sammlung Emil G. Bührle, Zurich

Cat. no. 55
Two Tahitian Women
1899
Oil on canvas, 94 x 73 cm, W 583
The Metropolitan Museum of Art, New York,
Gift of William Church Osborn, 1949

Cat. no. 56
Saint Orang
circa 1902
Wood, height 92 cm
Musée d'Orsay, Paris, Don Lucien Vollard,
1943, Inv. no. A.F. 143291

Cat. no. 57
Projet d'assiette – Leda
Design for a China plate – Leda
1889
Zincograph, second edition on white Simili-
Japan paper, printed after 1900
22.1 x 20.4 cm, MKJ 1/B
Inscriptions (in reverse): Underneath com-
position "Projet d'As[s]iet[t]e 89", within
composition "Homis [sic!] soit qui mal y
pense" (the motto of the English Order of
the Garter, which translates as "Shamed be he
who thinks evil of it") and signature "PGO."
Staatsgalerie Stuttgart, Graphische
Sammlung

Cat. no. 58
Les Drames de la mer, Bretagne
Dramas of the Sea, Brittany
1889
Zincograph, second edition on white Simili-
Japan paper, printed after 1900
17.6 x 22.2 cm, MKJ 2/B
Inscriptions: Dated and signed in lower left
corner "89 (in reverse) Paul Gauguin",
underneath composition "Les Drames de la
mer Bretagne"
Staatsgalerie Stuttgart, Graphische
Sammlung

Cat. no. 59
Les Drames de la mer – Une descente dans le
Maelström
Dramas of the Sea: Descent into the
Maelström
1889
Zincograph, second edition on white Simili-
Japan paper, printed after 1900
18 x 27.2 cm, MKJ 3/B
Inscriptions: Underneath composition "Les
drames de la mer" and signature "P Gau-
guin"
Staatsgalerie Stuttgart, Graphische
Sammlung

Cat. no. 60
Baigneuses bretonnes
Bathers in Brittany
1889
Zincograph, second edition on white Simili-
Japan paper, printed after 1900
24.5 x 20 cm, MKJ 4/B
Inscription: Signed below borderline in
lower left corner "P Gauguin"
Staatsgalerie Stuttgart, Graphische
Sammlung

Cat. no. 61
Les Cigales et les fourmis – Souvenir de la
Martinique
Grasshoppers and Ants – A Memory of
Martinique
1889
Zincograph. Second edition on white Simili-
Japan paper, printed after 1900
21.6 x 26.1 cm, MKJ 5/B
Inscriptions: Lower left corner beneath
borderline "Les Cigales et les fourmis",
above signature "Paul Gauguin"
Staatsgalerie Stuttgart, Graphische
Sammlung

Cat. no. 62
Pastorales Martinique
Martinique Pastorals
1889
Zincograph, second edition on white Simili-
Japan paper, printed after 1900
18.5 x 22.2 cm, MKJ 6/B
Inscriptions: Beneath lower borderline
"Pastorales Martinique" and signature "Paul
Gauguin"
Staatsgalerie Stuttgart, Graphische Samm-
lung

Cat. no. 63
Joies de Bretagne
The Pleasures of Brittany
1889
Zincograph, second edition on white Simili-
Japan paper, printed after 1900
20.1 x 24.1 cm, MKJ 7/B
Inscriptions: Lower left corner "Paul
Gauguin" and title "Joiee [sic!] de Bretagne"
Staatsgalerie Stuttgart, Graphische
Sammlung

Cat. no. 64
Bretonnes à la barrière
Breton Women Beside a Fence
1889
Zincograph, second edition on white Simili-
Japan paper, printed after 1900
17 x 21.5 cm, MKJ 8/B
Inscription: Signed in lower left corner
"P Gauguin"
Staatsgalerie Stuttgart, Graphische
Sammlung

Cat. no. 65
Les vielles filles à Arles
Old Maids of Arles
1889
Zincograph, second edition on white Simili-
Japan paper, printed after 1900
19.2 x 20.8 cm, MKJ 9/B
Inscription: Signed in lower left corner
"P. Gauguin"
Staatsgalerie Stuttgart, Graphische
Sammlung

Cat. no. 66
Les Laveuses
Women Washing Clothes
1889
Zincograph, second edition on white Simili-
Japan paper, printed after 1900
21.2 x 26.5 cm, MKJ 10/B
Inscription: Signed in lower right corner
"P. Gauguin"
Staatsgalerie Stuttgart, Graphische
Sammlung

Cat. no. 67
Misères humaines
Human Sorrow
1889
Zincograph, second edition on white Simili-
Japan paper, printed after 1900
29.4 x 23.7 cm, MKJ 11/B
Inscription: Signed in lower right corner
"P. Gauguin 89" (in reverse)
Staatsgalerie Stuttgart, Graphische
Sammlung

Cat. no. 68
Noa Noa
Fragrance
1893–94
Woodcut, printed by Gauguin in yellow,
black and red
35.8 x 20.4 cm, MKJ 13/III/B
Inscriptions: "NOA NOA", monogram in
top center "PGO"
Musée National des Arts d'Afrique et
d'Océanie, Paris

Cat. no. 69
Noa Noa
Fragrance
1893–94
Woodcut, printed by Louis Roy in black, red,
orange and yellow on Japan paper
35.8 x 20.4 cm, MKJ 13/III/D
Inscriptions: "NOA NOA", monogram in
top center "PGO"
Sammlung E.W.K., Bern

Cat. no. 70
Nave nave fenua
Delightful Land
1893–94
Woodcut, printed by Gauguin in black on
vellum
35.5 x 19.9 cm, MKJ 14/II/1
Inscriptions: "NAVE NAVE FENUA",
monogram in lower left corner "PGO"
Museum of Fine Arts, Boston, Bequest of
W. G. Russel Allen

Cat. no. 71
Te faruru
Here We Make Love
1893–94
Woodcut, printed by Louis Roy in black, red
and brown on Japan paper
35.6 x 20.3 cm, MKJ 15/V
Inscriptions: "TE FARURU", monogram
below title in upper right corner "PGO"
Sammlung E.W.K., Bern

Cat. no. 72
Auti te pape
The Fresh Water is in Motion
1893–94
Woodcut, printed by Louis Roy in black,
yellow and orange on Japan paper
20.5 x 35.5 cm, MKJ 16/II/C
Inscriptions: "AUTI TE PAPE", monogram
in lower left corner "PGO"
Ulmer Museum, Ulm

Cat. no. 73
Te atua
The Gods
1893–94
Woodcut, printed by Gauguin and Louis Roy
in black and ochre on Japan paper
20.4 x 35.5 cm, MKJ 17/III/C
Inscriptions: "te Alua [sic!]", monogram in
lower left corner "PGO"
Sammlung E.W.K., Bern

Cat. no. 74
L'Univers est créé
The Creation of the Universe
1893–94
Woodcut, printed by Gauguin in black on
pink paper
20.5 x 35.5 cm, MKJ 18/I
Inscriptions: "L'Univers est crée", mono-
gram in lower right corner "PGO"
Bibliothèque Nationale, Paris, Cabinet des
Estampes

Cat. no. 75
L'Univers est créé
The Creation of the Universe
1893–94
Woodcut, printed by Louis Roy in black, red and orange on Japan paper
20.5 x 35.5 cm, MKJ 18/II/D
Inscriptions: "L'Univers est crée", monogram in lower right corner "PGO"
Galerie Kornfeld, Bern

Cat. no. 76
Mahna no varua ino
The Day of the Evil Spirit
1893–94
Woodcut, printed by Gauguin in ochre and black on Japan paper
20.2 x 35.6 cm, MKJ 19/III
Inscriptions: "MAHNA NO VARUA INO", monogram in lower left corner "PGO"
Musée National des Arts d'Afrique et d'Océanie, Paris

Cat. no. 77
Manao tupapau
Watched by the Spirit of the Dead
1893–94
Woodcut, printed by Gauguin in black on orange paper
20.5 x 35.5 cm, MKJ 20/I
Inscriptions: "Manao Tupapau", monogram in lower left "PGO"
Museum of Fine Arts, Boston, Bequest of W. G. Russel Allen

Cat. no. 78
Te po
The Night
1893–94
Woodcut, printed by Gauguin in brown and black on Japan paper
20.6 x 35.6 cm, MJK 21/III
Inscriptions: "TE PO", monogram in upper left corner "PGO"
Musée National des Arts d'Afrique et d'Océanie, Paris

Cat. no. 79
Te po
The Night
1893–94
Woodcut, printed by Louis Roy in black, yellow and orange on Japan paper
20.5 x 35.6 cm, MJK 21/IV/C
Inscriptions: "TE PO", monogram in upper left corner "PGO"
Ulmer Museum, Ulm

Cat. no. 80
Maruru
Content
1893–94
Woodcut, printed by Gauguin in black
20,5 x 35,5 cm, MKJ 22/III/A
Inscriptions: "MARURU", monogram in lower right corner "PGO"
Musée National des Arts d'Afrique et d'Océanie, Paris

Cat. no. 81
Manao tupapau, Femme maorie dans un paysage d'arbres, Femme maorie debout
Watched by the Spirit of the Dead, Maori Woman in the Forest, Standing Maori Woman
1894–95
Woodcut, printed by Gauguin in reddish brown on oatmeal coloured paper
22.8 x 52.7 cm, MJK 30/1
Musée National des Arts d'Afrique et d'Océanie, Paris

Cat. no. 82
Manao tupapau, Femme maorie dans un paysage d'arbres
Watched by the Spirit of the Dead, Maori Woman in the Forest
1894–95
Woodcut, printed in 1928 by Daniel de Monfreid in black on Japan paper
22.5 x 25.5 cm, MKJ 30/2/b
Bibliothèque Nationale de France, Paris, Cabinet des Estampes

Cat. no. 83
Idole tahitienne
Tahitian Idol
1894–95
Woodcut, printed by Gauguin in black and reddish brown
15.1 x 12 cm, MKJ 32
Inscription: Monogram in lower left corner "PGO"
Sammlung E.W.K., Bern

Cat. no. 84
Oviri
Savage
1894–95
Woodcut, printed by Gauguin in black and brown with touches of grey wash
20.5 x 12.3 cm, MKJ 35
Musée National des Arts d'Afrique et d'Océanie, Paris

Cat. no. 85
Oviri
Savage
1894–95
Woodcut, printed by Gauguin in reddish brown
20.5 x 12.3 cm, MKJ 35
Museum of Fine Arts, Boston, Bequest of W. G. Russel Allen

Cat. no. 86
Manao tupapau
Watched by the Spirit of the Dead
1894
Lithograph in pen, crayon and wash
18 x 27.1 cm, MKJ 23/B
Inscriptions: Title in lower left corner "Manao tupapau", monogram in upper left corner "PGO"; numbered by the artist in lower right "Ep 56" (proof no. 56 of an edition of 100 impressions)
Ulmer Museum, Ulm

Cat. no. 87
Ia orana Maria
Hail Mary
1894–95
Zincograph
25.6 x 17.7 cm, MKJ 27/B/a
Inscription: Monogram in lower left corner "PGO"
Museum of Fine Arts, Boston, Bequest of W.G. Russell Allen

Cat. no. 88
Le Manguier
The Mango Tree
1894
Watercolour transfer (Dessin-empreinte) on wove paper
26.4 x 17.7 cm
Musée du Louvre, Paris, Département des Arts Graphiques (Fonds du Musée d'Orsay)

Cat. no. 89
Eve
1898–99
Woodcut, printed by Gauguin on Japan paper, numbered by Gauguin (no. 12).
28.3 x 21.5 cm, MKJ 42/II/b
Inscription: Monogram in upper left "PG"
Sammlung E.W.K., Bern

Cat. no. 90
Te arii vahine – Opoi
Reclining Queen
1898
Woodcut, printed by Gauguin on Japan
paper
22.5 x 30.2 cm, MKJ 44/A
Inscription: Monogram in upper left "PG"
Staatsgalerie Stuttgart, Graphische
Sammlung

Cat. no. 91
Planche au diable cornu
Plate with the Head of a Horned Devil
1898–99
Woodcut, printed by Gauguin on Japan
paper
17.5 x 29.7 cm, MKJ 48
Inscription: Monogram in lower right
corner "P"
Staatsgalerie Stuttgart, Graphische
Sammlung

Cat. no. 92
Te atua
The Gods
1899
Woodcut, printed by Gauguin, second state
impression on thin Japan paper pasted on
first state impression
23.5 x 24 cm, MKJ 53/II/B/b
Inscriptions: "TE ATUA" above peacock,
monogram "PG" to left of title
Staatsgalerie Stuttgart, Graphische
Sammlung

WORKS FROM ETHNOLOGICAL
COLLECTIONS

Cat. no. 93
Sculpture, Society Islands (Tahiti) or Tonga
Stone, height 46 cm
Museum der Kulturen, Basle, Inv. no. Vc 98

Cat. no. 94
Figure of a divinity, Marquesas Islands
(Hiva Oa?)
Stone, 70 x 64 cm
Museum der Kulturen, Basle, Inv. no. Vc 644

Cat. no. 95
Sculpture, Society Islands (Tahiti)
Wood, height 50 cm
Museum der Kulturen, Basle, Inv. no.
Vc 1175

Cat. no. 96
Small canoe adornment (prow figure)
Wood, height 59 cm
Museum der Kulturen, Basle, Inv. no.
Vc 1521

Cat. no. 97
Tapa, Society Islands (Tahiti)
Barkcloth with leaf pattern,
456 x 185 cm
Museum der Kulturen, Basle, Inv. no. 1178

Cat. no. 98
Pestle for poi,
Marquesas Islands
Stone, height 19 cm
Museum der Kulturen, Basle, Inv. no. Vc 666

Cat. nos. 99, 100, 101
Three pestles for poi, Society Islands
Stone, height 19 cm
Museum der Kulturen, Basle, Inv. nos.
Vc 372, Vc 660, Vc 656

Cat. no. 102
Ceremonial paddle, Easter Island
Wood, with Janus-head-shaped upper
segment, length 220 cm
Museum für Völkerkunde, Vienna, Samm-
lung Westenholz, 1886, Inv. no. 22845

Cat. no. 103
Stilt step, Marquesas Islands
Wood, height 40 cm
Museum für Völkerkunde, Vienna, Samm-
lung Aubry Lecomte, 1879, Inv. no. 8.955

Cat. no. 104
Stilt step, Marquesas Islands
Wood, height approx. 40 cm
Museum für Völkerkunde, Vienna,
Sammlung Schiffmann, 1879, Inv. no. 9.792

Cat. no. 105
Bowl, Marquesas Islands
Wood, polished burnt inlay, diameter 28 cm
Linden-Museum, Stuttgart, Inv. no. 65.017

Cat. no. 106
Bowl, geometric decor in bas-relief,
Marquesas Islands
Wood, diameter 38.5 cm
Linden-Museum, Stuttgart, Inv. no. 49.619

Cat. no. 107
Tiki, ancestor figure, Marquesas Islands
Stone
Linden-Museum, Stuttgart, Inv. no. 65.020

Cat. no. 108
Fan, Marquesas Islands
Reed strips, carved bone, wood,
height 37.5 cm
Linden-Museum, Stuttgart, Inv. no.
S 40.592 L

Cat. no. 109
Fan, Samoa
Coconut palm fronds, wood, fibre string,
height 49.5 cm
Linden-Museum, Stuttgart, Inv. no. 34.945

Eugène Henri Paul Gauguin was born in Paris on June 7th, 1848 as the son of Aline-Marie Chazal (1825–1867) and Clovis Gauguin (1814–1849).

1848–1864 Childhood

When Gauguin was still but a year old his family emigrated to Peru. Gauguin's father died of a stroke. Paul and his older sister Marie-Marcelline lived with an uncle until 1855. After returning to France, the family took up residence in Orléans, where Paul attended a private boarding school. In 1860 Aline Gauguin moved to Paris and took up work as a seamstress. Paul followed her in 1862 and attended a middle school in Paris.

1865–1872 Early travels

Gauguin made several major voyages that took him to South America and other parts of the world during and after his military service. The news of his mother's death on July 7th, 1867 was delivered to him while he

Paul Gauguin with his children Clovis and Aline in Copenhagen, 1885.

Mette Gauguin in Copenhagen, 1885.

was en route to Brazil. After completing military service he secured a job with a Paris stock broker on the recommendation of Gustave Arosa. Arosa introduced him to the art of the Impressionists, regarded as modern at the time. He met the 22-year-old Danish woman Mette Gad.

1873–1883 Paris – Family life

Paul and Mette married in November 1873. They had five children: Emile (*1874), Aline (*1877), Clovis (*1879), Jean-René (*1881) and Paul-Rollon (*1883). With the encouragement of Gustave Arosa, Gauguin began painting and collecting Impressionist art. He spent the summer months working with Camille Pissarro in Pontoise. During this period he took part in several exhibitions alongside Impressionist artists. In 1883 he gave up his position as an insurance agent.

1884–1890 Brittany

Gauguin moved to Rouen, where he could live more cheaply. In 1885 the family settled in Copenhagen, but Gauguin returned to Paris with his son Clovis after only a few months. He spent the summer of 1886 in the artists' colony in Pont-Aven, Brittany, where he lived in the Gloanec Inn. In April 1887 Gauguin journeyed in the company of his friend and fellow artist Charles Laval (1862–1894) to Martinique in the Antilles. After his return in November 1887 he met Georges-Daniel de Monfreid (1856–1929) in Paris. During the following years he spent every summer in Pont-Aven and the nearby village of Le Pouldu, from where he embarked on a trip to visit Vincent van Gogh in Arles in 1888. The Colonial Exhibition captured his particular interest at the 1889 Paris World's Fair. He exhibited his work along with the Syntheticists at the Café Volpini. During this period he met the writer and critic Charles Morice (1861–1919) and associated with intellectuals close to the poet Stéphane Mallarmé (1842–1898).

1891–1893 The journey to Tahiti
Gauguin applied to the French Ministry of
Culture for an official commission to travel
to Tahiti as a painter. Having received
approval for the trip, he departed for Mar-
seille on March 31st, 1891, proceeding from
there by sea to the Suez Canal and Aden,
which he reached in April 1891. From Aden
the voyage took him to the Seychelles and
on to Australia, where he made brief stop-
overs in the cities of Adelaide, Melbourne
and Sydney before continuing his journey
to Noumea, New Caledonia. On May 12th,
1891 he embarked on the last leg of his
journey to Tahiti. A benefit matinee was
held in honour of Paul Gauguin and Paul
Verlaine at the Vaudeville Theatre in Paris.
Gauguin arrived in Papeete, the Tahitian
capital, on June 9th, 1891. After a period of
several months he left the city in the com-
pany of Titi, an Anglo-Tahitian woman, for
Mataïea, a village forty miles to the south. In
November 1891 he met Teha'amana, who
became his mistress. Gauguin suffered from
haemorrhages in early 1892 but left the
hospital in Papeete prematurely due to lack
of funds. His financial misery forced him to
begin planning his return to Europe in May
of 1892. He did not receive a visa until a
year later, however. On June 4th, 1893 he
left Tahiti, bound for Noumea. Gauguin
arrived in Marseille, completely broke, in
August 1893.

1893–1895 Returning home
After his return, Gauguin, who had pre-
viously been represented at group exhibi-
tions in Copenhagen and Paris, presented
his Tahiti paintings at the Galerie Durand-
Ruel in Paris. Although the exhibition was a
financial failure, it attracted great attention
in French critical circles. Gauguin lived at
this time with Annah, a Javanese woman. In
May 1894 his leg was badly broken in a fight
in Concarneau. In December of the same
year he presented an exhibition of his Tahiti
paintings in his own studio. Gauguin began

The Gloanec Inn in Pont-Aven, circa 1885.

Gauguin and friends in the artist's studio in the Rue Vercingétorix, 1895. In the background is the Javanese woman Annah.

work on a series of woodcuts for the narra-
tive *Noa Noa*, which he had written in Tahiti.
He made the decision to return to Tahiti.

1895–1903 Tahiti and the Marquesas
On July 3rd, 1895 Gauguin left France per-
manently. His journey took him first to New
Zealand, where he made a closer study of
Maori culture. He arrived in Papeete on
September 9th. Disappointed by the advan-
ces of modernisation in Tahiti, he resolved
to travel to the Marquesas but then changed
his plans and leased a plot of land in the
Punaauia District on the west coast of Tahiti.
The year 1897 witnessed the development
of a variety of symptoms of illness that kept
him from working. His narrative *Noa Noa*
appeared in Paris in October and Novem-
ber. In January 1898 he took arsenic in an
attempt to commit suicide. Following ex-
tended periods of illness he began work as
the author and editor of the journals *LLes
Guêpes* (The Wasps) and *L Le Sourire* (The
Smile). On September 10th, 1901 he jour-
neyed to the Marquesas, where he took up
residence on the island of Hiva Oa.

Paul Gauguin died on May 8th, 1903 after a
long battle with illness and was buried at the
Catholic cemetery in Hiva Oa.

Paul Gauguin's grave in Hiva Oa, with the
ceramic sculpture *Oviri*, 1903.

The following frequently quoted catalogues of Gauguin's works are cited under the abbreviations listed below:

F = Field 1977
Richard S. Field, "Paul Gauguin: The paintings of the First Trip to Tahiti", Ph.D. Diss. Harvard University, Cambridge, 1963; New York und London, 1977.

G = Gray 1963
Christopher Gray, *Sculpture and Ceramics of Paul Gauguin*, Baltimore, 1963.

Gu = Guérin 1927
Marcel Guérin, *L'Œuvre gravé de Gauguin*, Paris, 1927 (second edition, San Francisco, 1980).

MKJ = Mongan, Kornfeld, Joachim 1988
Elizabeth Mongan, Eberhard Kornfeld and Harold Joachim, *Paul Gauguin: Catalogue raisonné of his Prints*, Bern, 1988.

W = Wildenstein 1964
Georges Wildenstein, *Gauguin*, edited by Raymond Cogniat and Daniel Wildenstein, Paris, 1964.

Adam 1893
Paul Adam, "Critique des mœurs", in *Entretiens politiques et littéraires*, Vol. 6, No. 38, March 10th, 1893, pp. 234–235.

Alexandre 1894
Arsène Alexandre, "L'Artiste", in *La Revue blanche*, Vol. 7, No. 37, November 1894, pp. 408–410.

Amishai-Maisels 1973
Ziva Amishai-Maisels, "Gauguin's Philosophical Eve", in *Burlington Magazine*, 115, No. 843, June 1973, pp. 373–382.

Amishai-Maisels 1985
Ziva Amishai-Maisels, "Gauguin's Religious Themes", Ph.D. Diss. Hebrew University, Jerusalem, 1969; New York, London, 1985.

Amishai-Maisels 1995
Ziva Amishai-Maisels, "Gli antichi idoli tahitiani di Gauguin", in exhib. cat. Ferrara 1995, pp. 167–179.

Andersen 1971
Wayne V. Andersen, *Gauguin's Paradise Lost*, New York, 1971.

Arosa 1878
Catalogue des tableaux modernes composant la collection de M. G. Arosa, sales catalogue, Paris, February 25th, 1878.

Artur 1982
Gilles Artur, "Notice historique du Musée Gauguin de Tahiti suivie des quelques lettres inédites de Paul Gauguin", in *Journal de la Société des Océanistes*, 38, Nos. 74–75, 1982, pp. 7–17.

Augustoni/Lari 1972
Fabrizio Augustoni und Giulio Lari, *Catalogo completo dell'opera grafica di Paul Gauguin (I classici dell'incisione 1)*, Milan, 1972.

Balland 1966, see Gauguin 1966

Bacou 1960, see Gauguin 1960

Barskaya 1995
Anna Barskaya, Marina Bessonova and Asya Kantor-Gukovskaya, *Paul Gauguin: Mysterious Affinities*, Bournemouth and St. Petersburg, 1995.

Berger 1978
Renate Berger, *Maui überlistet den Feuergott: Mythen, Gesänge und Berichte der Maori*, Kassel, 1978.

Bernard 1942, see Gauguin 1942

Bismarck 1989
Beatrice von Bismarck, "Die Gauguin-Legende. Die Rezeption Paul Gauguins in der französischen Kunstkritik 1880–1903", Diss. Freie Universität Berlin, Münster and Hamburg, 1989; published in 1992.

Bodelsen 1970
Merete Bodelsen, "Gauguin the Collector", in *Burlington Magazine*, 112, No. 810, September 1970, pp. 590–615.

Borofsky/Howard 1989
Robert Borofsky and Alan Howard (eds.), *Developments in Polynesian Ethnology*, Honolulu and Hawaii, 1989.

Bouge 1956
L.-J. Bouge, "Traduction et interprétations des titres en langue tahitienne inscrits sur les œuvres océaniennes de Paul Gauguin", in *Gazette des Beaux-Arts*, VI, No. 47, January – April 1956 (publ. 1958), pp. 161–164.

Brettell 1988
Richard Brettell, "The Return to France", in exhib. cat. Chicago/Washington 1988, pp. 297–305.

Brettell 1988a
Richard Brettell et al., *The Art of Paul Gauguin*, Boston, Massachussetts, 1988.

Bronnec, see Le Bronnec

Burnett 1911
Frank Burnett, *Through Polynesia and Papua*, London, 1911.

Cachin 1988
Françoise Cachin, *Gauguin*, Paris, 1988.

Cachin 1990
Françoise Cachin, *Gauguin: "Ce malgré moi de sauvage"*, Paris, 1990.

Chartier, see le Chartier

Conzen-Meairs 1989
Ina Conzen-Meairs, *Edgar Allan Poe und die Bildende Kunst des Symbolismus*, Worms, 1989.

Cooper 1983
Douglas Cooper (ed.), *Paul Gauguin: 45 Lettres à Vincent, Théo et Jo van Gogh*, (Collection Rijksmuseum Vincent van Gogh, Amsterdam), Le Hague and Lausanne, 1983.

Cat. no. 56
Saint Orang
circa 1902
Wood, height 92 cm
Musée d'Orsay, Paris, Don
Lucien Vollard, 1943, Inv. no.
A.F. 143291

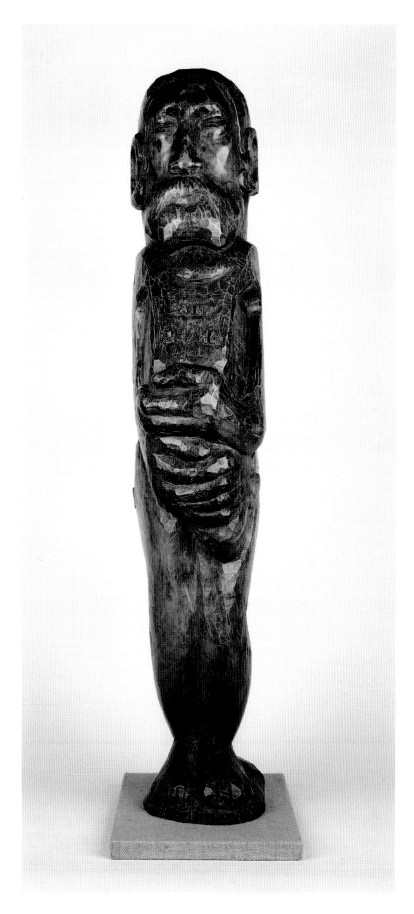

Craighill Handy 1930
E. S. Craighill Handy, *Marquesan Legends*, Honolulu and Hawaii, 1930.

Damiron 1963, see Gauguin 1963

Danielsson 1964
Bengt Danielsson, *Gauguin in the South Seas*, London, 1964 (New York, 1965).

Danielsson 1967
Bengt Danielsson, "Gauguin's Tahitian Titles", in *Burlington Magazine*, 9, No. 760, April 1967, pp. 228–233.

Danielsson/O'Reilly 1966
Bengt Danielsson and P. O'Reilly (eds.), *Gauguin: Journaliste à Tahiti et ses articles des "Guêpes"*, Paris, 1966.

Danielsson 1975
Bengt Danielsson, *Gauguin à Tahiti et aux Iles Marquises*, Papeete, 1975.

de Monfreid, see Monfreid

Denvir 1992, see Gauguin 1992b

Dorival 1951
Bernard Dorival, "Sources of the Art of Gauguin from Java, Egypt and Ancient Greece", in *Burlington Magazine*, 93, No. 577, April 1951, pp. 118–122.

Dorra 1953
Henri Dorra, "The First Eves in Gauguin's Eden", in *Gazette des Beaux-Arts*, VI, No. 40, March 1953, pp. 189–202.

Druick/Zegers 1989
Douglas Druick and Peter Zegers, "Le Kampong et la Pagode: Gauguin à l'exposition de 1889", in *Actes du colloque Gauguin*, Paris Musée d'Orsay/Ecole du Louvre, January 11th–13th, 1989, pp. 101–142.

Eisenman 1997
Stephen F. Eisenman, *Gauguin's Skirt*, London, 1997.

Esielonis 1993
Kary Elisabeth Esielonis, "Gauguin's Tahiti: The Politics of Exoticism", Ph.D. Diss. Harvard University, Cambridge, 1993.

Exhib. cat. Auckland 1995
Paul Gauguin. Pages from the Pacific, Auckland City Art Gallery, August 4th – October 15th, 1995, edited by Douglas Druick and Peter Zegers, Auckland, 1995.

Exhib. cat. Chicago/Washington 1988
The Art of Paul Gauguin, National Gallery of Art, Washington, May 1st – July 31st, 1988, The Art Institute of Chicago, September 17th – December 11th, 1988, Grand Palais, Paris, January 10th – April 20th, 1989, edited by Richard Brettell, Françoise Cachin, Claire Frèches-Thory, Charles F. Stuckey, Peter Zegers; Washington, 1988 and Paris, Editions de la Réunion des musées nationaux, 1989.

Exhib. cat. Ferrara 1995
Paul Gauguin e l'avanguardia russa, Palazzo dei Diamanti, Ferrara, 1995, edited by Ziva Amishai-Maisels, Marina Bessonova, Albert Kostenevic and Maria Grazia Messina.

Exhib. cat. Ingelheim 1997
Paul Gauguin, Emil Nolde and die Kunst der Südsee. Ursprung and Vision, edited by Patricia Rochard, Internationale Tage Ingelheim, Mainz, 1997.

Exhib. cat. Liège 1995
Gauguin. Les XX et la Libre Esthétique, Musée d'Art moderne et d'Art contemporain de la Ville de Liège, 1995, edited by Françoise Dumont.

Exhib. cat. Munich/Vienna 1990
Gauguin and die Druckgraphik der Schule von Pont-Aven, Villa Stuck, Munich, Graphische Sammlung Albertina, Vienna, 1990, edited by Caroline Boyle-Turner in cooperation with Samuel Josefowitz, Munich, 1990.

Exhib. cat. New Brunswick/Amsterdam 1991
L'Estampe originale. Artistic Printmaking in France 1893–1895, The Jan Voorhees Zimmerli Art Museum, New Brunswick, Van Gogh Museum, Amsterdam, 1991, edited by Patricia Eckert Boyer, Philipp Dennis Cate.

Exhib. cat. New York 1984
Primitivism in Twentieth Century Art, Museum of Modern Art, New York, 2 vols., edited by William Rubin, New York, 1985; German edition: *Primitivismus in der Kunst des zwanzigsten Jahrhunderts*, Munich, 1985.

Exhib. cat. Paris 1989, see exhib. cat. Chicago/Washington 1988

Exhib. cat. Paris 1995
Trésors des îles Marquises, Musée de l'Homme (Muséum national d'histoire naturelle), edited by Michel Panoff, Paris, 1995.

Exhib. cat. Stockholm 1970
Gauguin i Söderhavet, Ethnografiska Museet, Nationalmuseum, Stockholm, 1970.

Exhib. cat. Stuttgart/Zurich 1984
Kompositionen im Halbrund. Fächerblätter aus vier Jahrhunderten, Staatsgalerie Stuttgart, Graphische Sammlung; Museum Bellerive; Zurich, 1984.

Exhib. cat. Stuttgart 1987
Exotische Welten, Mythos Tahiti. Südsee – Traum und Realität, Linden-Museum, edited by Ingrid Heerman, Stuttgart, 1987.

Exhib. cat. Zurich/Ratzeburg/Bietigheim-Bissingen 1995
Von Corot bis Matisse. Französische Druckgraphik aus den Beständen der Werner Coninx-Stiftung, Coninx-Museum, Zurich, Ernst Barlach-Museum, Ratzeburg, Städtische Galerie Bietigheim-Bissingen, 1995.

Fénéon 1893
Félix Fénéon, "Expositions (L'Agitation)", in *La Revue anarchiste*, November 15th, 1893; reprinted in Félix Fénéon, *Œuvres plus que complètes*, edited by Joan U. Halpertin, 2 vols., Geneva, 1970.

Fezzi 1980
Elda Fezzi, *Gauguin: Every Painting*, 2 vols., New York, 1980.

Fezzi/Monervino 1974
Elda Fezzi and Fiorella Monervino, *Noa Noa e il Primo Viaggio a Tahiti di Gauguin*, Milan, 1974.

Field 1968
Richard S. Field, "Gauguin's Noa Noa Suite", in *The Burlington Magazine*, Vol. 110, No. 786, September 1968, pp. 500–511.

Field 1973
Richard S. Field, *Paul Gauguin: Monotypes*, Philadelphia, 1973.

Field 1977
Richard S. Field, "Paul Gauguin: The paintings of the First Trip to Tahiti", Ph.D. Diss. Harvard University, Cambridge, 1963; New York and London, 1977.

Fontainas 1899
André Fontainas, "Art moderne: Exposition Gauguin", in *Mercure de France*, January 29th, 1899.

Garnier 1871
Jules Garnier, *Océanie*, Paris, 1871.

Garnier 1871
Jules Garnier, »Océanie«. Paris 1871.

Gauguin 1889
Paul Gauguin, ›Notes sur l'art à l'Exposition
universelle, 1, 2‹. In: »Le Moderniste
illustré«, 4. Juli 1889 und 13. Juli 1889,
S. 84–86 und S. 90–91.

Gauguin 1920
»Paul Gauguin. Briefe an Georges-Daniel de
Monfreid«, hrsg. von Victor Segalen.
Potsdam 1920.

Gauguin 1920a
Paul Gauguin, »Vorher und Nachher«
(Franz.: Avant et après), hrsg. von Erik-Ernst
Schwabach. München 1920.

Gauguin 1921
Emil Gauguin und Van Wyck Brooks, »Paul
Gauguin's Intimate Journals«.
New York 1921 (Nachdruck: New York
1997).

Gauguin 1932
»Paul Gauguin: Briefe«, hrsg. von Hans
Graber. Basel 1932.

Gauguin 1942
Emile Bernard (Hrsg.), »Lettres de Vincent
van Gogh, Paul Gauguin, Odilon Redon,
Paul Cézanne, Elémir Bourges, Léon Bloy,
Guillaume Apollinaire, Joris-Karl Huysmans,
Henry de Groux à Emile Bernard«. Brüssel
1942.

Gauguin 1949
»Lettres de Gauguin à sa femme et à ses
amis«, hrsg. von Maurice Malingue. Paris
1949 (Erste Ausgabe: Paris 1946).

Gauguin 1951
»Paul Gauguin, Ancien culte mahorie«.
Faksimile des um 1893 entstandenen
Manuskripts, hrsg. von René Huyghe.
Paris 1951.

Gauguin 1960
»Lettres de Gauguin, Gide, Huysmans,
Jammes, Mallarmé, Verhaeren... à Odilon
Redon«, hrsg. von Roseline Bacou und Ari
Redon. Paris 1960.

Gauguin 1963
»Paul Gauguin, Cahier pour Aline«.
Faksimile hrsg. von Suzanne Damiron.
Paris 1963.

Gauguin 1966
»Paul Gauguin, Noa Noa«, hrsg. von André
Balland. Paris 1966.

Gauguin 1970
»Paul Gauguin: Briefe und Selbstzeugnisse«,
hrsg. von Kuno Mittelstädt. München 1970.

Gauguin 1978
»Paul Gauguin, The Writings of a Savage«,
hrsg. von Daniel Guérin. New York 1978.

Gauguin 1984
»Correspondance de Paul Gauguin
1873–1888«, hrsg. von Victor Merlhès. Paris
1984.

Gauguin 1985
»Paul Gauguin: Noa Noa«, hrsg. von Nicho-
las Wadley. Salem und New Haven 1985.

Gauguin 1989
»Paul Gauguin, ›A ma fille Aline ce cahier
est dédié‹«. Faksimile des »Cahier pour
Aline« von 1893, hrsg. von Victor Merlhès.
Bordeaux 1989.

Gauguin 1992
»Paul Gauguin: Noa Noa«, hrsg. von Pierre
Petit. München 1992.

Gauguin 1992a
»Gauguin's Letters from the South Seas«,
hrsg. von Frederick O'Brien. New York
1992.

Gauguin 1992b
»Paul Gauguin: The Search for Paradise.
Letters from Brittanny and the South Seas.«,
hrsg. von Bernard Denvir, London 1992.

Gauguin 1994
»Paul Gauguin, Racontars de Rapin«.
Faksimile hrsg. von Victor Merlhès. Taravao,
Tahiti 1994.

Gauguin 1995
»Gauguin's Noa Noa«, hrsg. von Marc Le
Bot. London 1995.

Geffroy 1891
Gustave Geffroy, ›Paul Gauguin‹. In: »La
Justice«, 22. Februar 1891.

Geffroy 1893/1900
›Paul Gauguin, 12. November 1893‹. In:
Gustave Geffroy, »La vie artistique«, Bd. 6,
Paris 1900.

Geffroy 1898
Gustave Geffroy, ›Gauguin‹. In: »Le
Journal«, Paris, 20. November 1898.

Ginies 1941
L. Ginies, ›A propos d'un portrait inconnue
de Gauguin‹. In: »Le Feu« Aix-en-Provence,
Bd. 37, Juli 1941, Nr. 5.

Gray 1963
Christopher Gray, »Sculpture and Ceramics
of Paul Gauguin«. Baltimore 1963.

Guérin 1927
Marcel Guérin, »L'Œuvre gravé de Gau-
guin«. Paris 1927 (Zweite Auflage: San
Francisco 1980).

Hanson 1955
Lawrence und Elisabeth Hanson, »Noble
Savage: The Life of Paul Gauguin«. New
York 1955.

Heermann 1987
Ingrid Heermann, ›Mythos Tahiti. Südsee –
Traum und Realität‹. In: Ausst.Kat. Stuttgart
1987.

Heermann 1997
Ingrid Heermann, ›Tahiti – Ein europäi-
scher Traum‹. In: Ausst.Kat. Ingelheim
1997, S. 78–84.

Henry 1951
Teuira Henry, »Tahiti aux temps anciens«.
Paris 1951.

Hermann 1959
Fritz Hermann, »Die ›Revue Blanche‹ und
die ›Nabis‹«, 2 Bände. München 1959.

Hirsch 1892
Charles-Henry Hirsch, ›Notes sur l'impres-
sionnisme et le symbolisme des peintres‹. In:
»La Revue blanche«, Bd. 2, Februar 1892,
S. 103–108.

Hollmann 1996
Eckhard Hollmann, »Paul Gauguin: Images
from the South-Seas«. München und New
York 1996.

Hoog 1987
Michel Hoog, »Paul Gauguin: Life and
Work«. London 1987.

Huret 1891
Jules Huret, ›Paul Gauguin: Devant ses
tableaux‹. In: »Echo de Paris«, 23. März
1891.

Huyghe (Hrsg.), siehe Gauguin 1951

Inboden 1978
Gudrun Inboden, »Mallarmé und Gauguin.
Absolute Kunst als Utopie«. Stuttgart 1978.

Jacquier 1957
Henri Jacquier, ›Histoire locale: le dossier de la succession Paul Gauguin‹. In: »Bulletin de la Société des Etudes Océaniennes«, Bd. X, Nr. 7, 7. September 1957, S. 673–711.

Jaworska 1971
Wladijslawa Jaworska, »Paul Gauguin et l'école de Pont-Aven«, Paris 1971.

Jénot 1956
Lieutenant Jénot, ›Le premier séjour de Gauguin à Tahiti d'après le manuscrit Jénot (1891-1893)‹. In: »Gazette des Beaux-Arts«, VI, Januar–April 1956 (veröffentlicht 1958), S. 115–126.

Le Bot (Hrsg.), siehe Gauguin 1995

Le Bronnec 1954
Guillaume Le Bronnec, ›La Vie de Gauguin aux Iles Marquises«. In: »Bulletin de la Société des Etudes Océaniennes«, Bd. IX, Nr. 5, März 1954, S. 198–211.

le Chartier 1887
Henri le Chartier, »Tahiti et les colonies françaises de la Polynésie«. Paris 1887.

Leclerq 1895
Julien Leclerq, ›Exposition Paul Gauguin‹. In: »Mercure de France«, Bd. 13, Nr. 61, Januar 1895, S. 121–122.

Leprohon 1975
Pierre Leprohon, »Paul Gauguin«. Paris 1975.

Lévy 1973
Robert I. Lévy, »Tahitians: Mind and Experience in the Society Islands«. Chicago und London 1973.

Lipton 1965
Eunice Lipton, »Gauguin's Contemporary Criticism«, M.A., New York University 1965.

M. 1903
G.M., ›Paul Gauguin et l'école tahitienne‹. In: »La Gazette de France«, 3. September 1903.

Malingue 1949
Malingue (Hrsg.), siehe Gauguin 1949

Malingue 1948
Maurice Malingue, »Gauguin: le Peintre et son Œuvre«. Paris 1948.

Malingue 1960
Paul Gauguin. Briefe, hrsg. von Maurice Malingue. Berlin 1960.

Marks-Vandenbroucke 1956
Ursula Marks-Vandenbroucke, »Paul Gauguin«, Diss. Université de Paris, 1956.

Marx 1891
Claude-Roger Marx, ›Paul Gauguin‹. In: »Le Voltaire«, 20. Februar 1891, S. 1–2.

Marx 1891a
Claude-Roger Marx, ›Arts décoratifs et industriels aux Salons du Palais de l'Industrie et du Champs de Mars‹. In: »La Revue Encyclopédique«, 15. September 1891, S. 586–587.

Marx 1894
Claude-Roger Marx, ›Exposition Paul Gauguin‹. In: »La Revue encyclopédique«, 1. Februar 1894, S. 33–34 (Wiederabdruck in Marx 1914, S. 325–333).

Marx 1914
Claude-Roger Marx, »Maîtres d'hier et d'aujourd'hui«. Paris 1914.

Mathieu 1983
Pierre-Louis Mathieu, ›Huysmans, inventeur de l'impressionnisme‹. In: »L'Œil«, Nr. 341, Dezember 1983, S. 38–45.

Mathews 1997
Nancy Mowll Mathews, »The Erotic Life of Paul Gauguin«. Unpubliziertes Manuskript, Williams College Museum of Art, 1997.

Mauclair 1893
Camille Mauclair, ›Les choses du prochain siècle‹. In: »Essais d'art libre«, 4, 1893, S. 117–121.

Mauclair 1895
Camille Mauclair, ›Choses d'art‹. In: »Mercure de France«, Bd. 13, Nr. 62, Februar 1895, S. 235–238.

Mauclair 1895a
Camille Mauclair, ›Choses d'art‹. In: »Mercure de France«, Bd. 14, Nr. 66, Juni 1895, S. 357–359.

Melot 1996
Michel Melot, »The Impressionist Print«. New Haven und London 1996.

Merki 1893
Charles Merki, ›Apologie pour la peinture‹. In: »Mercure de France«, 8, Nr. 42, Juni 1893, S. 139–153.

Merlhès 1984, 1989, 1994
Merlhès (Hrsg.), siehe Gauguin 1984, 1989, 1994

Merlhès 1989
Victor Merlhès, »Paul Gauguin et Vincent van Gogh, 1887–1888«. Taravao, Tahiti 1989.

Messina 1995
Maria Grazia Messina, ›Biografia, Distanza, Memoria nelle opere tahitiane di Gauguin‹. In: Ausst.Kat. Ferrara 1995, S. 145–165.

Mirbeau 1891
Octave Mirbeau, ›Paul Gauguin‹. In: »L'Echo de Paris«, 16. Februar 1891 (Veröffentlicht als Vorwort in: Catalogue d'une vente de 30 tableaux de Paul Gauguin, Paris 1891, S. 3–12. Wiederabdruck in: L'Art moderne, 22. März 1891, S. 92–94).

Mirbeau 1891a
Octave Mirbeau, ›Paul Gauguin‹. In: »Le Figaro«, 18. Februar 1891.

Mirbeau 1893
Octave Mirbeau, ›Retour de Tahiti‹. In: »L'Echo de Paris«, 14. November 1893.

Mittelstädt (Hrsg.), siehe Gauguin 1970

Moerenhout 1837
J. A. Moerenhout, »Voyages aux Iles du Grand Océan«, 2 Bände, Paris 1837 (Reprint 1942).

Monfreid 1903
Daniel de Monfreid, ›Sur Paul Gauguin‹. In: »L'Ermitage«, 3, Dezember 1903, S. 265–283.

Mongan, Kornfeld, Joachim 1988
Elizabeth Mongan, Eberhard Kornfeld und Harold Joachim, »Paul Gauguin: Catalogue raisonné of his Prints«. Bern 1988.

Morice 1893
Charles Morice, ›Paul Gauguin‹. In: »Mercure de France«, 9, Nr. 48, Dezember 1893, S. 289–300.

Morice 1893a
Charles Morice, Einführung zu: »Exposition d'œuvres récentes de Paul Gauguin«. Kat. Galerie Durand-Ruel, Paris 1893.

Morice 1894
Charles Morice, ›L'Atelier de Paul Gauguin‹. In: »Le Soir«, 4. Dezember 1894.

Morice 1895
Charles Morice, ›Le départ de Paul Gauguin‹. In: »Le Soir«, 28. Juni 1895.

Morice 1896
Charles Morice, ›Paul Gauguin‹. In: »Les hommes d'aujourd'hui«, Bd. 9, 1896.

Morice 1903
Charles Morice, ›Paul Gauguin‹. In: »Mercure de France«, Bd. 8, Nr. 166, Oktober 1903, S. 100–135.

Morice 1903a
Charles Morice, ›Quelques opinions sur Paul Gauguin‹. In: »Mercure de France«, Bd. 48, Nr. 167, November 1903, S. 413–433.

Natanson 1893
Thadée Natanson, ›Expositions: Œuvres récentes de Paul Gauguin‹. In: »La Revue Blanche«, Bd. 5, Nr. 29, Dezember 1893, S. 418–422.

Nevermann 1956
Hans Nevermann, ›Polynesien und Paul Gauguin‹. In: »Baseler Archiv«, NF Bd. 6, Berlin 1956, S. 222–231.

Nevermann 1957
Hans Nevermann, »Götter der Südsee: Die Religion der Polynesier«. Stuttgart 1957.

Newbury 1980
Colin Newbury, »Tahiti Nui. Change and Survival in French Polynesia 1767–1945«. Honolulu 1980.

O'Brien (Hrsg.), siehe Gauguin 1992a

Olin 1891
Pierre-M. Olin, ›Les XX‹. In: »Mercure de France«, Bd. 2, Nr. 16, April 1891, S. 236–240.

Oliver 1974
Douglas L. Oliver, »Ancient Tahitian Society«, 3 Bände. Honolulu 1974.

Peltier 1984
Philippe Peltier, ›The Arrival of Tribal Objects in the West from Oceania‹. In: Ausst.Kat New York 1984.

Perruchot 1961
Henri Perruchot, »La vie de Gauguin«. Paris 1961 (dt. Ausg.: München 1961).

Petit (Hrsg.), siehe Gauguin 1992

Pickvance 1970
Ronald Pickvance, »The Drawings of Gauguin«. London und New York 1970.

Platte 1959
Hans Platte, »Paul Gauguin: Der Markt«, Stuttgart 1959.

Pollock 1993
Griselda Pollock, »Avant-Garde Gambits 1888-1893: Gender and the Colour of Art History«. London 1993.

Pollock/Crocombe 1988
N. J. Pollock und R. Crocombe (Hrsg.), »French Polynesia«. Suva 1988.

Pope 1981
Karen Pope, »Gauguin and Martinique«, Ph.D. Diss. University of Texas, Austin 1981.

Prather/Stuckey 1987
Marla Prather und Charles Stuckey (Hrsg.), »Paul Gauguin 1848–1903«. New York 1987.

Prather/Stuckey 1994
Marla Prather und Charles Stuckey (Hrsg.), »Paul Gauguin 1848–1903«. Köln 1994.

Radiguet 1860
Max Radiguet, »Les Derniers Sauvages: Souvenirs de l'occupation française aux Iles Marquises«. Paris 1860.

Raapoto 1988
Turo A. Raapoto, ›Maohi: On being Tahitian‹. In: Pollock/Crocombe 1988, S. 3–7.

Rewald 1938
John Rewald, »Gauguin«. Paris 1938.

Rewald 1959
John Rewald, »Gauguin Drawings«. New York und London 1959.

Rewald 1956
John Rewald, »Post-Impressionism. From van Gogh to Gauguin«. New York 1956.

Rewald 1967
John Rewald, »Von van Gogh bis Gauguin. Die Geschichte des Nachimpressionismus«. Köln 1967.

Rey 1928
Robert Rey, ›Les bois sculptées de Paul Gauguin‹. In: »Art et Décoration«, Februar 1928, S. 57–64.

Rohde 1988
Petra-Angelika Rohde, »Paul Gauguin auf Tahiti. Ethnographische Wirklichkeit und künstlerische Utopie«, Phil. Diss. Freiburg 1987; Rheinfelden 1988.

Rookmaaker 1972
H. R. Rookmaaker, »Gauguin and 19th Century Art Theory«. Amsterdam 1972.

Rothschild 1981
Ruth Deborah Rothschild, »A Study in the Problems of Self-Portraiture: The Self Portrait of Paul Gauguin«, Ph. D. Diss., The University of Texas, Austin 1981; publiziert 1983.

Rotschi 1995
Agnès Rotschi, ›Paul Gauguin et l'art marquisien‹. In: Ausst.Kat. Paris 1995.

Rubin 1985
William Rubin, Primitivism in Twentieth Century Art, 2 Bde. New York 1985 (dt. Ausg.: Primitivismus in der Kunst des Zwanzigsten Jahrhunderts, München 1985)

Salmon 1980
T. Salmon (Hrsg.), »H. Adams: Lettres de Tahiti«, Papeete 1980.

Schmalenbach 1961
Werner Schmalenbach, »Die Kunst der Primitiven als Anregungsquelle für die europäische Kunst bis 1900«, Diss. phil.-hist. Basel 1955; Köln 1961.

Segalen (Hrsg.), siehe Gauguin 1920

Segalen 1918
Victor Segalen, ›Hommages à Gauguin‹. In: »Lettres de Paul Gauguin à Georges-Daniel de Monfreid«. Paris 1918, S. 1–77.

Segalen 1982
Victor Segalen, »Paul Gauguin in seiner letzten Umgebung«. Frankfurt am Main und Paris 1982.

Séguin 1903
Armand Séguin, ›Paul Gauguin‹. In: »L'Occident«, Nr. 16, März 1903, S. 158–167 und Nr. 17, April 1903.

Simpson 1995
Juliet A. Simpson, ›Albert Aurier and Symbolism: From Suggestion to Synthesis in French Art‹. In: »Apollo«, Nr. 404, Oktober 1995, S. 23–27.

Staller 1994
Natascha Staller, ›Babel: Hermetic Languages, Universal Languages, and Anti-Languages in ›Fin de Siècle‹ Parisian Culture‹. In: »The Art Bulletin«, Bd. LXXVI, Nr. 2, June 1994, S. 348–354.

Steinen, siehe von den Steinen

Stuckey 1988
Charles Stuckey, ›The First Tahitian Years‹.
In: Ausst.Kat. Chicago/Washington 1988,
S. 210–216.

Sweetman 1995
David Sweetman, »Paul Gauguin – A Com-
plete Life«. London 1995.

Tardieu 1895
Eugène Tardieu, ›M. Paul Gauguin‹. In:
»L'Echo de Paris«, 13. 5.1895, S. 2.

Teilhet-Fisk 1983
Jehanne Teilhet-Fisk, »Paradise Reviewed:
An Interpretation of Gauguin's Polynesian
Symbolism«, Ph.D. Diss., University of Cali-
fornia at Los Angeles 1975; Ann Arbor,
Michigan 1983.

Thiébault-Sisson 1893
François Thiébault-Sisson, ›Les Petits
Salons‹. In: »Le Temps«, 2.12.1893.

Thirion 1956
Yvonne Thirion, ›L'influence de l'estampe
japonaise dans l'œuvre de Gauguin‹. In:
»Gazette des Beaux-Arts«, 6me série, 47,
Januar–April 1956, S. 95–114.

Thomson 1987
Belinda Thomson, »Gauguin«. London
1987.

Thomson 1993
Belinda Thomson (Hrsg.), »Gauguin by
himself«. Boston 1993.

Toullelan 1984
Pierre-Yves Toullelan, »Tahiti Colonial«.
Paris 1984.

Vance 1983
Mary Lynn Z. Vance, »Gauguin's Polynesian
Pantheon as a Visual Language«, Ph.D. Diss.
University of California, Santa Barbara 1983.

Varnedoe 1984
Kirk Varnedoe, ›Gauguin‹. In: Ausst.Kat.
New York 1984.

Vieilliard 1893
Fabien Vieilliard, ›Paul Gauguin‹. In: »L'Art
littéraire«, Nr. 13, Dezember 1893, S. 51.

Vollard 1937
Ambroise Vollard, »Souvenirs d'un mar-
chand de tableaux«, Paris 1937 (dt. Ausg.:
»Erinnerungen eines Kunsthändlers«,
Zürich 1957).

von den Steinen 1930
Karl von den Steinen, ›Marquesianische
Mythen‹. In: »Zeitschrift für Ethnologie«,
Bd. 65, 1930, S. 1–44 und 326–373; Bd. 66,
S. 191–240.

Wadley 1985, siehe Gauguin 1985

Wauters 1891
A. J. Wauters, ›Aux XX.‹ In: »La Gazette«,
20. Februar 1891.

Wildenstein 1956
Georges Wildenstein, ›Le premier séjour de
Gauguin à Tahiti d'après le manuscrit Jénot
(1891–1893)‹. In: »Gazette des Beaux-Arts«,
VI, Bd. 47, Januar–April 1956.

Wildenstein 1956a
Georges Wildenstein, ›Gauguin in Breta-
gne‹. In: »Gazette des Beaux-Arts«, VI,
Januar–April 1956 (veröffentl. 1958),
S. 83–94.

Wildenstein 1964
Georges Wildenstein, »Gauguin«. Hrsg.:
Raymond Cogniat, Daniel Wildenstein, Paris
1964.

Williamson 1933
R. W. Williamson, »Religious and Cosmic
Beliefs of Central Polynesia«, 2 Bände. Cam-
bridge 1933.

PHOTONACHWEIS

Franziska Adriani, Stuttgart: Kat. 15, 21, 52, 57–67, 90–92.
Amsterdam, Van Gogh Museum (Vincent van Gogh Foundation): Kat. 31.
© 1997 The Art Institute of Chicago. All Rights reserved: Kat. 20, 22, 23, 44, 50, 51.
Ateneum, Helsinki, The Central Art Archives, Hannu Aaltonen: Kat. 30.
Courtesy Galerie Beyeler, Basel: Kat. 17.
Phot. Bibliothèque Nationale de France Paris: Kat. 74, 82.
Stiftung Sammlung Emil G. Bührle, Zürich: Kat. 54.
Cincinnati Art Museum: Kat. 29.
Collection Kröller-Müller Museum, Otterlo, The Netherlands: Kat. 19.
Collection of Joan Whitney Payson: Kat. 33.
Collection of the Art Gallery of Ontario, Toronto: Kat. 37.
Dallas Museum of Art: Kat. 27.
Mario Gastinger, München: Kat. 72, 79.
Sammlung Josefowitz: Kat. 8, 11.
Bernd Kegler, Ulm: Kat. 86.
© 1997 by Kunsthaus Zürich. Alle Rechte vorbehalten: Kat. 2.
Peter Lauri Photographie, Bern: Kat. 69, 71, 73, 75, 83, 89.
The McNay Art Museum, San Antonio: Kat. 16.
Photograph © 1997 The Metropolitan Museum of Art, New York: Kat. 28, 55.
Musée d'Art Moderne et Contemporain de Strasbourg: Kat. 13.
Musée de Peinture et de Sculpture, Grenoble: Kat. 42.
Photo Musée des Arts Décoratifs, L. Sully Jaulmes - Paris, Tous droits réservés: Kat. 9.
© photo Musée des Beaux-Arts de la Ville de Reims, Photo Devleeschauwer: Kat. 14.
Musée des Beaux-Arts, Orléans: Kat. 12.
Courtesy, Museum of Fine Arts, Boston: Kat. 70, 77, 85, 87.
The Museum of Fine Arts, Springfield: Kat. 42.
© 1997 Board of Trustees, National Gallery of Art, Washington: Kat. 6, 39.
National Gallery of Scotland, Edinburgh: Kat. 1.
Photo Nationalmuseum, SKM, Stockholm: Kat. 5.

Öffentliche Kunstsammlung Basel, Kupferstichkabinett: Kat. 40.
Philadelphia Museum of Art: Kat. 34.
© Photo RMN, Paris: Kat. 45, 46, 56, 68, 76, 78, 80, 81, 84, 88.
Sächsische Landesbibliothek – Staats- und Universitätsbibliothek Dresden, Dezernat Deutsche Fotothek: Kat. 47.
The Solomon R. Guggenheim Museum, New York: Kat. 25, 26.
Staatliche Eremitage, St. Petersburg: Kat. 32.
Lee Stalsworth, Washington: Kat. 36.
Rudolf Staechelin'sche Familienstiftung Basel: Kat. 48.
Szépmüvészeti Múzeum, Budapest: Kat. 24.
© Tate Gallery, London 1997: Kat. 7, 18.
Vereinigung der Freunde der Staatlichen Kunsthalle Karlsruhe e.V.: Kat. 3.
Yale University Art Gallery: Kat. 41.
Ole Woldbye, Kopenhagen: Kat. 4, 10, 38.

Katalogbuch zur Ausstellung
»Paul Gauguin – Tahiti«
in der Staatsgalerie Stuttgart
vom 7. Februar bis zum 1. Juni 1998

Ausstellung und Katalog
Christoph Becker,
in Zusammenarbeit mit Christofer Conrad,
Ingrid Heermann und Dina Sonntag

Verlagslektorat
Jürgen Geiger

Herstellung
Christine Müller

Gesetzt aus der Baskerville

Reproduktionen
C+S Repro, Filderstadt

Gesamtherstellung
Dr. Cantz'sche Druckerei, Ostfildern bei
Stuttgart

© 1998 Staatsgalerie Stuttgart,
Verlag Gerd Hatje und Autoren

Erschienen im
Verlag Gerd Hatje, Senefelderstraße 12,
73760 Ostfildern-Ruit
Tel. (0)711/4 40 50
Fax (0)711/4 40 52 20

ISBN 3-7757-0741-7
Printed in Germany

Umschlagabbildung
Wohin gehst du?, 1892 (Kat. 52)

Abb. vor dem Beitrag von Christoph Becker
Portrait von Tohotauna, Aufnahme im
Atelier Gauguins in Hivaoa (Photographie,
1901)

Abb. S. 84
Besucher der Kolonialausstellung mit einer
Afrikanerin aus dem Kongo, Paris, Welt-
ausstellung (Photographie, 1889)

Abb. S. 106
Ansicht von Papeete
(Ausschnitt, Photographie, 1890er Jahre)

Abb. S. 146
Zwei Frauen von Tahiti (Photographie von
Henri Lemasson, 1894)

Vorsatz
Weltausstellung Paris, Rekonstruktion eines
Dorfes der Südsee (Photographie 1889)

Nachsatz
Weltausstellung Paris, 1889, Rekonstruktion
eines Dorfes der Südsee (aus: Monod,
»L'Exposition universelle«, Bd. 2, S. 167)